Tattoo Art & Design

Edited by Viction:ary

UNIVERSE

contents

preface

From photographic spreads of the inscribed bodies of Hollywood celebrities, to scholarly texts on the cultural analysis of tattoos, much has been published on the deeply historical tattoo art form. The web alone hosts numerous flash art of tattoo images as options for tattooists and the tattooed. But little do we see of fresh tattoo icons that differ from the prevailing tribal, floral, gothic and pop-cultural motifs. Even rarer are tattoos presented and explored through the eyes of contemporary graphic art and design.

Tattoo Art & Design — an anthology of 460 unique tattoo design created by over 60 of today's most iconic graphic artists and designers traversing across mediums and cultures — is thus Victionary's bid to celebrate and bridge the seemingly distant worlds of tattoo art and contemporary graphic design. By including designers' reflections on the tattoo art form and photos of their tattoos transferred on the body, the book is a passage to the minds of the designers and a showcase of how these tattoos come alive. By going beyond mere visual presentations, we hope to reconstruct familiar notions of tattoos and invite you to ponder with us on the following musings : What is it about that bluish-green marks on a stranger's arm or neck that never fail to grab our attention? What creeps in our minds at the sight of them, and why? How much do we perceive tattoos as graphic art form as opposed to their usual social and cultural connotations? Does a fake tattoo make its impact or appeal any less? What does the fake and the real each offer?

Be it traditional or modern, fake or real, from ancient tribal tattooing practice to tattoo's inception from Tahiti to the English gentry in 1769 and its prevalence today amongst trailblazers of style and the common man, tattoo remains an art of body decoration. The range, grace and complexity of graphically striking tattoo styles have given tattooing the status of men's most sophisticated artistic genre. As much as it's a formidable aesthetic movement, tattoos as graphic art of color, form and text permanently inscribed on the canvas of human skin, are also the ultimate cultural and personal insignia. They go beyond the decorative to the symbolic, articulating the identity of a group or an individual as they carry symbols of spirituality, personal growth, passion and belief. Tattoos are a passion for some, an art form for others, and for most, a popular fashion trend. But despite its prevalence in mainstream popular culture, tattoos' relation with social deviance is still hard to shake off. Though this may largely be attributed to

tattoo's historical association with prisoners, members of the Hong Kong and Japanese triads, bikers, head-bangers, and heavy metal rockers, the dark formal qualities of these tattoos in the form of dragons, roses, thorns, gothic themes, and bare-breasted women inevitably communicate the morbid, the violence, and the subversive rebel. However as tattoos become personal flights of fancy rather than permanent convictions, tattoo design has thus become more playful, bright and even temporary.

Today, tribal style tattoo traditions have joined with new approaches coming from the influences of modern and abstract art, street style and pop culture, with a widening color palette. It's thus been a re-interpretation of existing design and motifs rather than an overthrow of conventional themes and forms. In this book, some icons still echo traditional designs of a central figure and symmetrical composition, such as Insect's Frankenstein's head. Musical overtones still resonate in the form of icons such as Jorge Alderete's skeletal Elvis and the use of electric guitars in his design. Animal icons also remain, such as those by Jody Barton, with sparrows on a tree, while his other designs include a more abstract and typographic digital rendering of the word "peace." Differences lie in the sleekness of vector illustration and the themes of current phenomenon such as video-game culture and digital animation, as shown in the animated whimsical figures designed by Rinzen. Icons in this book are imaginative counterpoints to the traditional icons of rock and roll, flowers and porn star, with a modern digital edge and outfitted with new meanings of youth and animation. As products of digital illustration, these designs also afford more complexity and variety in pattern, form and color. By reinterpreting the classic and inventing new ones, these icons are far from the hackneyed and standardized flash drawings, adding innovative and original touch to the existing tattoo design lexicon for a new breed of tattooists.

The tattoo icons here may not be representative of all modern tattoo graphics, and featured designers and artists are not speaking on behalf of official tattooists. They nonetheless represent a new perspective on tattoos and the skin art they'd like to see in today's postmodern and digital visual and design culture, thus stretching the stylistic possibilities of the tattoo. We hope that with this set of icons, tattoos can create new associations of fun and play and a celebration of graphic design, instead of the grim and the serious.

Yet how much of tattoos' aesthetic value extends to tattoo icons designed by illustrators and graphic designers whose canvas has never been the skin? Real tattooists traditionally have technical and fine art training and are most appealing for their ability to create designs in the context of the body. Some of the tattoo icons in this book deserve praise for their aesthetic quality and design that complement a particular part of the body, especially those seen through the photographs; while some designs may not be much different from those that go on any other surface. Not to say that these designs are mediocre, but it shows the challenge of tattoo art with respect to the body.

And with all of tattoos' symbolic value, how much of it extends to transfer or fake tattoos? The visual and symbolic effects may still remain, but the fact that they don't last reduces them to mere stickers that scream little of what one is trying to communicate. The word "tattoo" itself, transliterated from "tatu" in Tahitian, means to mark or strike the skin; "tattoo" in Japanese (irezumi) similarly means "insertion of ink." Going for the ink assumes tattoos cut deep as painful and permanent marks that come to life as loud signs of self-invention, expression and indulgence. Pain and blood inherent in the tattooing process made it an act that demands a high level of commitment and courage, that it's seen as a radical approach to communicating an identity in an age of non-committers and fleeting existence.

But while some believe that there is emotional resonance only when the tattoo involves blood, pain and permanence, some prefers a form of body decoration that is here today and gone tomorrow, with no risk of allergic reaction or difficulty in tattoo removal. In some of the interviews, some designers like VictionWorkshop thinks tattoos mean "power, commitment and memory," while Klaus Haapaniemi doesn't want to see anyone suffering from having to remove a permanent tattoo when they tire of it, thus preferring fake ones. For those like Haapaniemi, fake tattoo allows for experimentation with what works before getting the real one — which real tattoo won't allow. Without the needles, one can also afford a more complex and multicolored design, even that of repeated motifs that cover a large area of the skin, pain- and blood-free. Perhaps the main draw of well-designed fake tattoos is for those who consider getting the ink as not their sole means of self-adornment or communicating personal convictions. To them, tattoos are flights of fancy rather than permanent whimsy, a passing fashion statement, and even more importantly, a celebration of the ever-evolving art of graphic design.

Tattoo Art & Design makes no attempt to be definitive in endorsing fake or modern tattoos over real and traditional ones. It's been a project whose value lies in the process and the fruits of our collaborative effort with the designers. We've left this project as open and free for creative liberty in their conception of the tattoo graphics, so as to stretch the boundaries of both the art of tattoo and contemporary graphic design through cross-pollination between mediums and styles. But how much it means to us is also about how much it will mean for the readers.

In these pages, printed on varying papers to best express each distinct visual work, *Tattoo Art & Design* offers you a collection of fresh and unique tattoo icons made up of symbols, characters and typography unlike any conventional tattoos. Created by leading designer/artists of various mediums ranging from fashion, print, digital and web such as Kinpro, Benjamin Güedel, Eighthourday, TAKORA kimiyoshi futori, MusaCollective, Jon Burgerman, Rinzen and Swigg, these images show how their multimedia and multi-cultural experience translate to their design in the tattoo medium. Every artist's work is punctuated with three sections : the first two sections feature individual tattoo icons and patterns, as well as their design in full-page format to bring out the design's visual effect over a larger area and the third section, as part of the project's experimental purpose, presents photographs of the designers' tattoo graphics applied as fake tattoos on bodies, thus unveiling the dynamics between tattoos and the body. Selected removable tattoos are also attached at the bookend for readers to partake the experience of having these custom-designed tattoos in action on themselves!

For the tattooists and prospective tattoo fans scouring for new tattoo designs, graphic design buffs and interested observers of contemporary design culture, *Tattoo Art & Design* aspires to inspire as it yields surprising results through this visual feast.

kinpro

Hokkaido, Japan

Do you have any tattoos? What does tattoo mean to you?

I have a tattoo. It's a part of my body and an experience I don't want to forget.

What is the first thing that comes to mind when you think of tattoos?

Tattoo in Japanese is called "irezumi," and "irezumi" reminds me of "yakuza" (Japanese gangsters), but "Tattoo" reminds me of Red Hot Chili Peppers.

Where do you have your tattoo? Why?

I have a tattoo on my belly. Since I was little, I feel relieved when someone strokes my belly.

Would you like to get your "tattoo icon" as a real tattoo? Why or why not?

I would not like to get "tattoo icon" as a real tattoo. I made it as a fashion with playful sense.

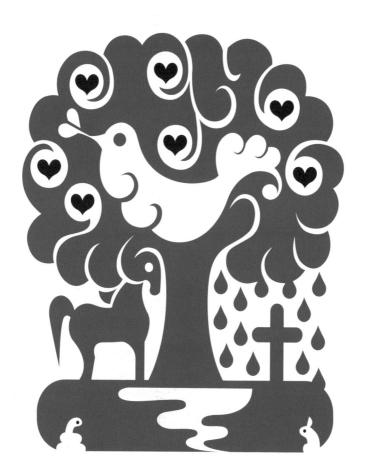

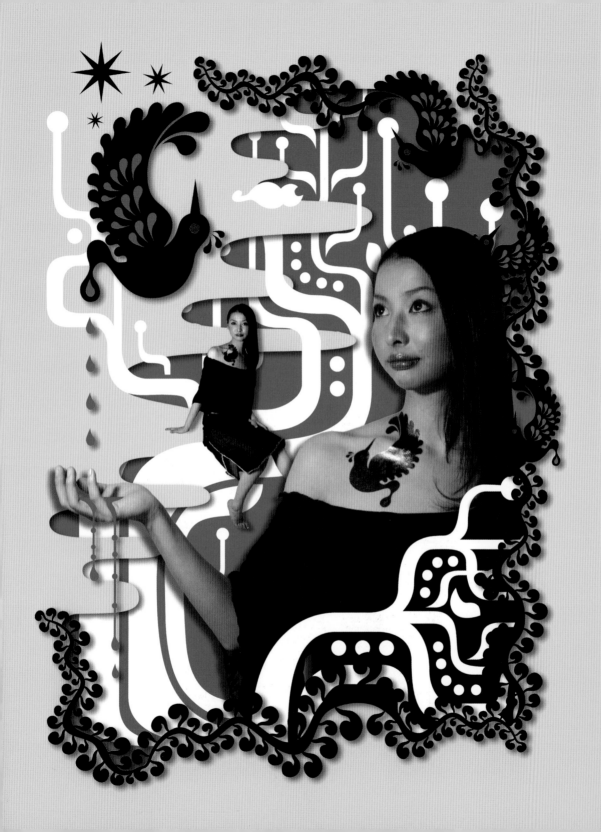

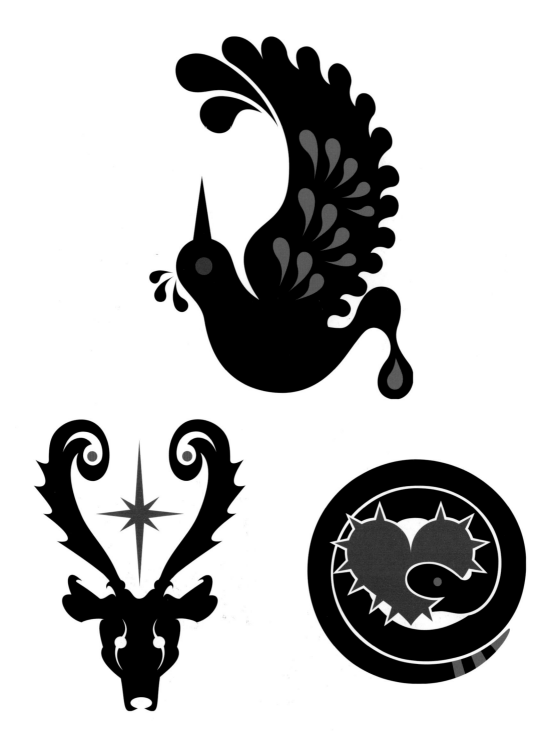

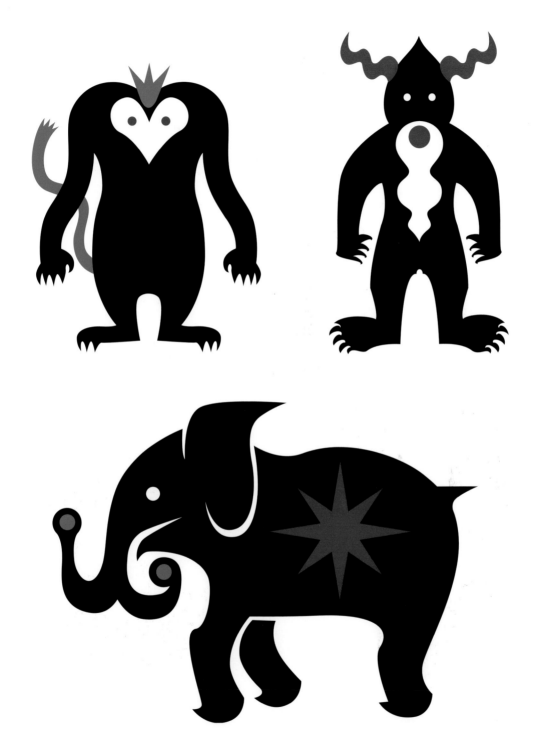

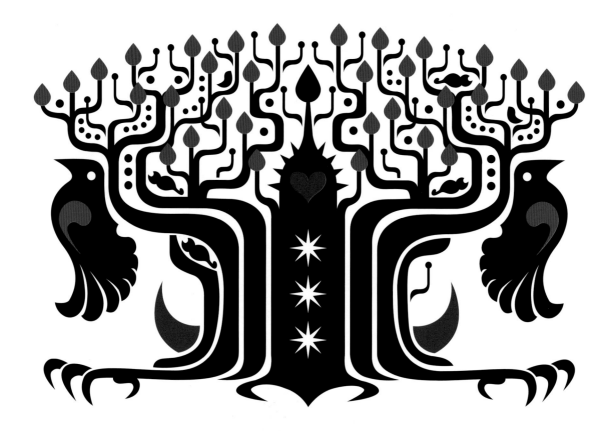

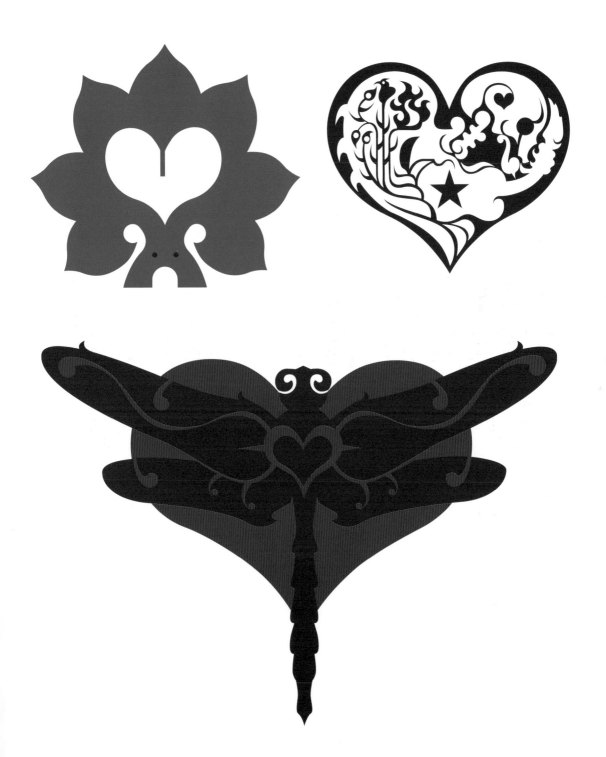

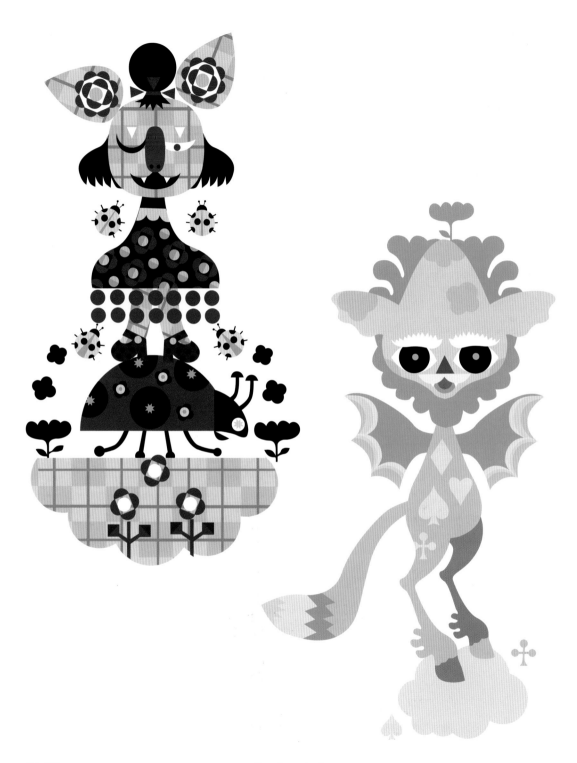

klaus haapaniemi

klaus haapaniemi

London, UK

Do you have any tattoos? What does tattoo mean to you?

I don't have any tattoos. Whole idea of tattoo doesn't really appear so important to me.

What is the first thing that comes to mind when you think of tattoos?

First thing that comes to my mind is Russian prisoners.

Where do you want to have your tattoo(s)? Why?

I really hope people like my fake tattoo designs and I would prefer to see somebody else wear it on her face.

Would you like to get your "tattoo icon" as a real tattoo? Why or why not?

I wouldn't like to see anybody suffering by trying to remove it later, after getting tired of wearing it. That's why I prefer fake ones.

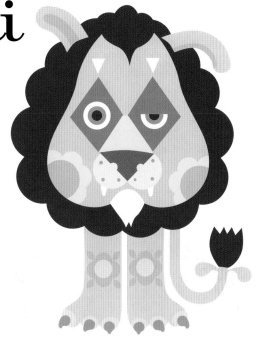

klaus haapaniemi

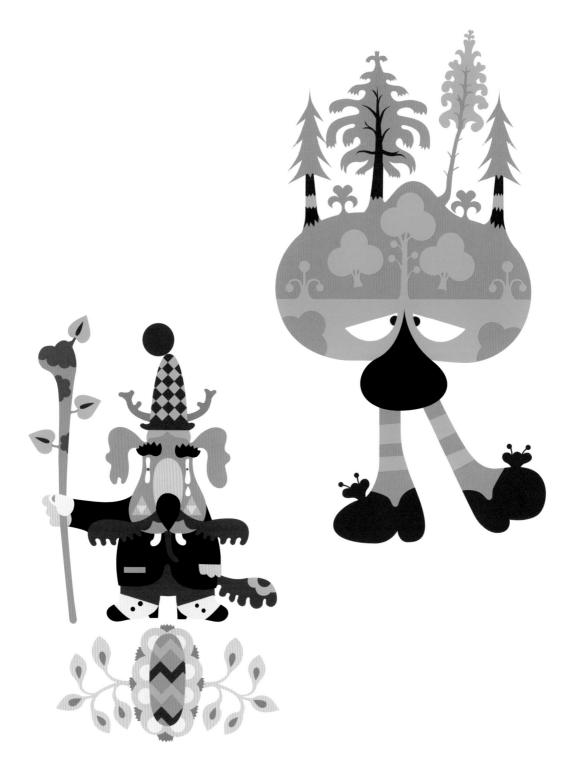

klaus haapaniemi

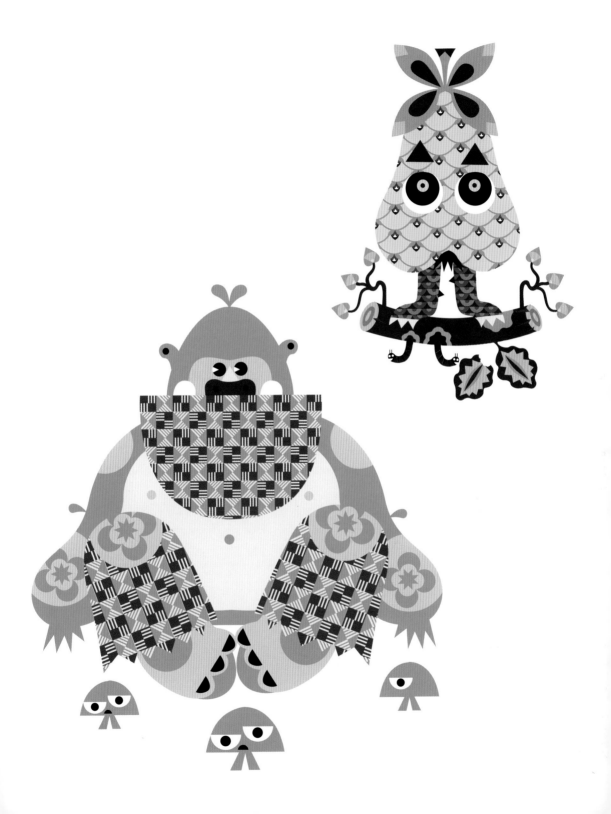

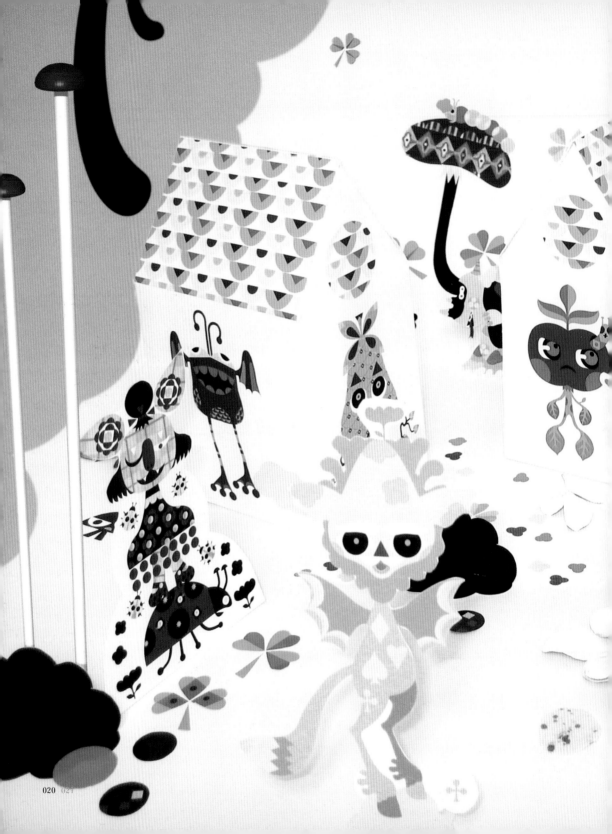

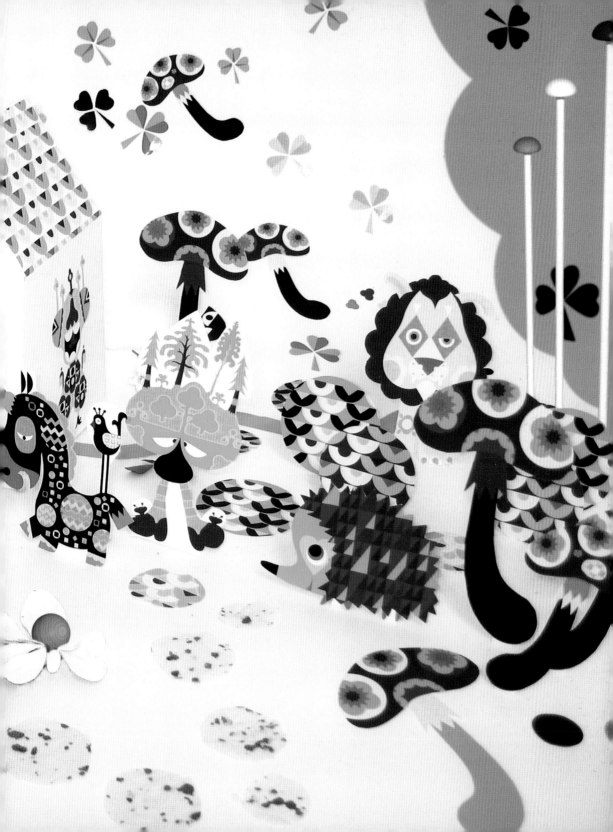

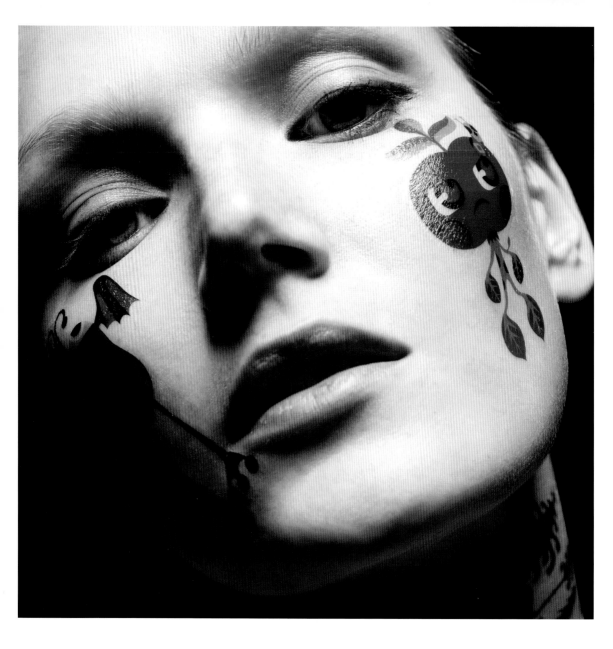

klaus haapaniemi

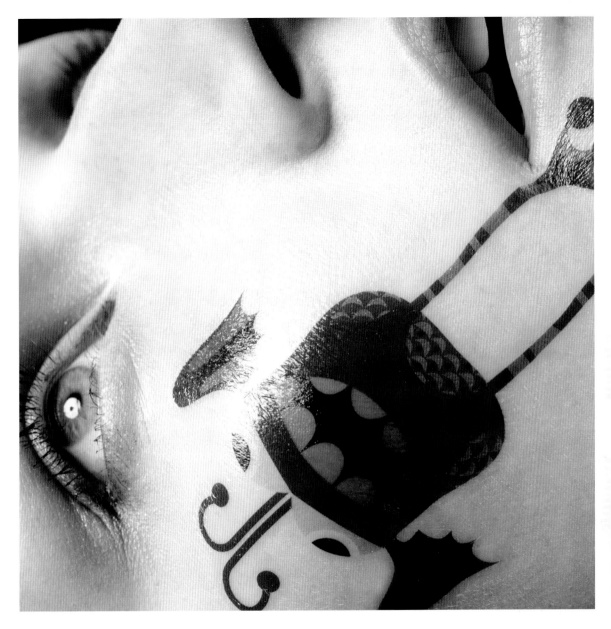

takora kimiyoshi futori

Tokyo, Japan

Do you have any tattoos? What does tattoo mean to you?
No, I don't! It means spirit or just a mark!

What is the first thing that comes to mind when you think of tattoos?
"Yakuza" (Japanese mafia) that I met in the public bath in my childhood. When I stared at their back, they always let me touch it. I really loved their color! It's fantastic and pop!

Where do you want to have your tattoo(s)? Why?
On my neck! So that people can recognize me from behind!

Would you like to get your "tattoo icon" as a real tattoo? Why or why not?
All my works come from an image of final production, so it's made for this book only! I took photos of my friends with my tattoos and they all loved it and treated them as their fashion statements!

©2005 grAphic tAkorA

©2005 grAphic tAkorA

©2005 grAphic tAkorA

takora

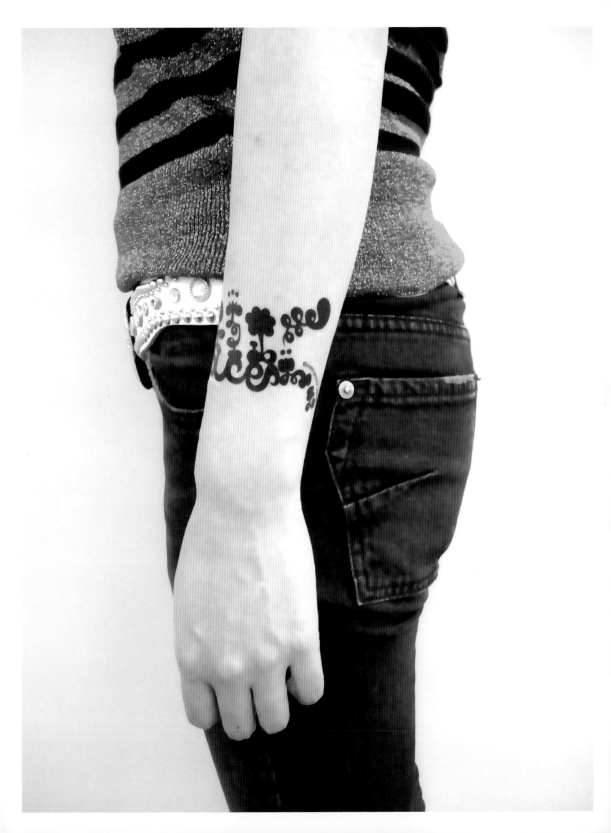

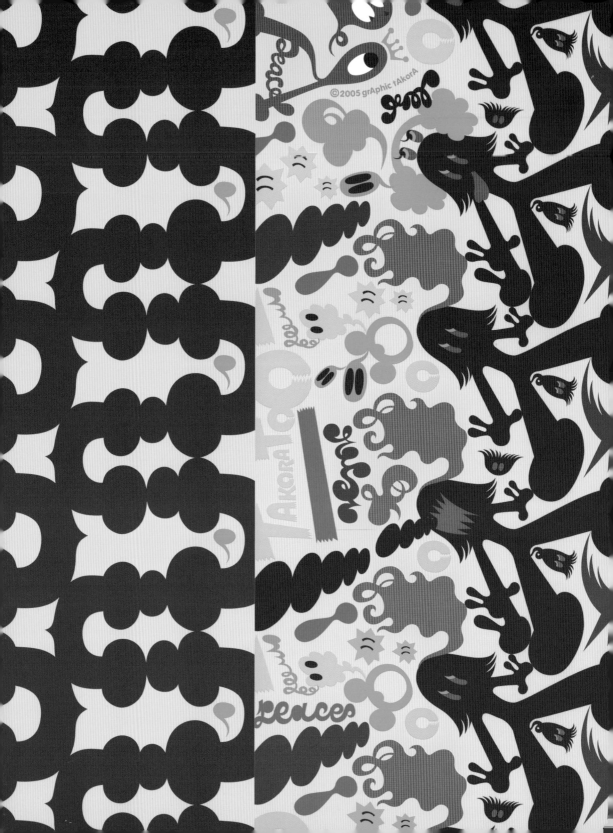

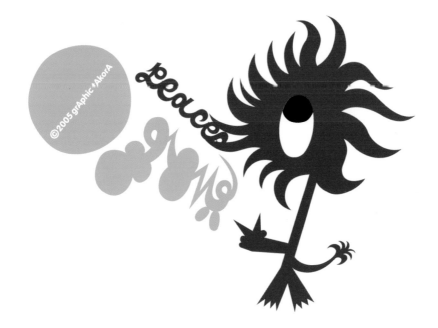

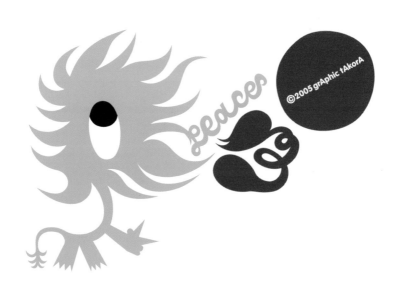

takora

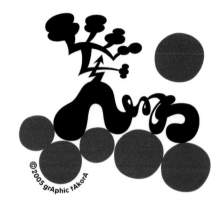

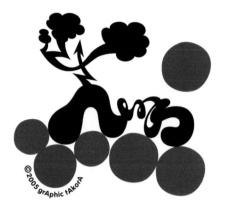

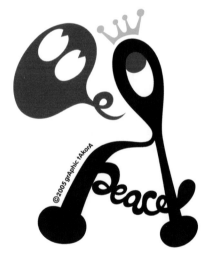

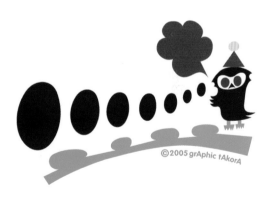

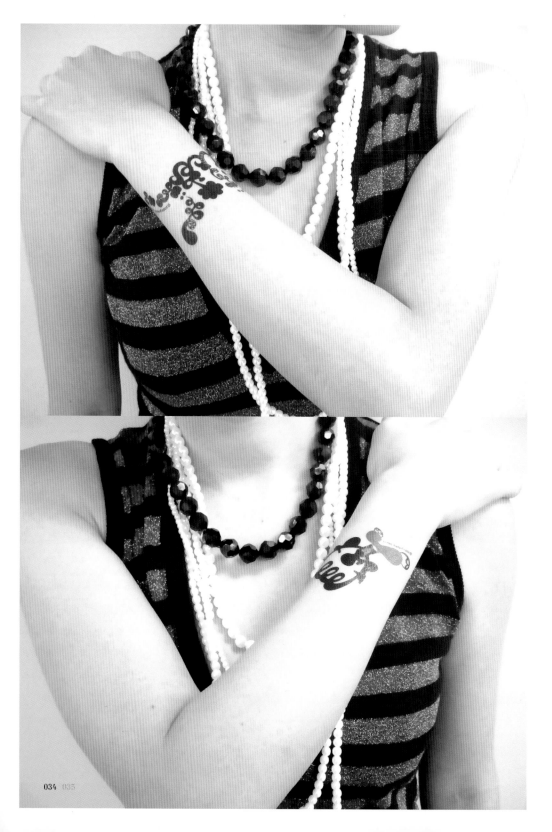

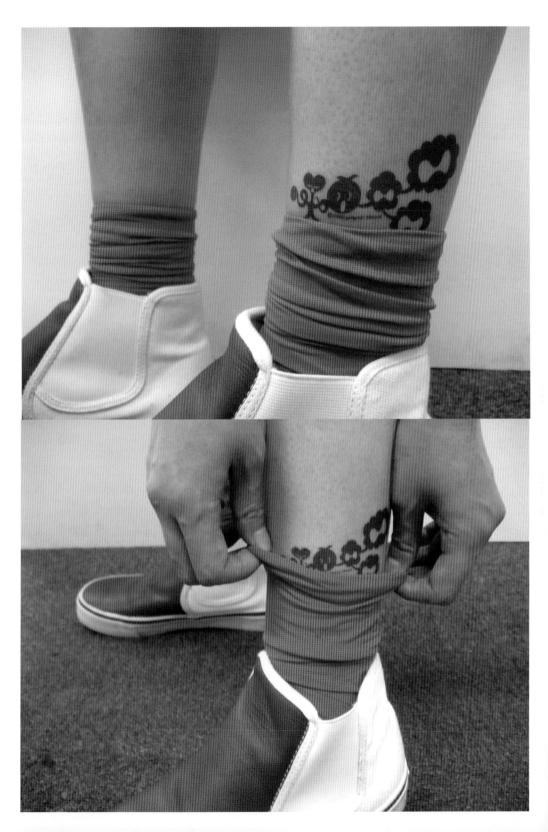

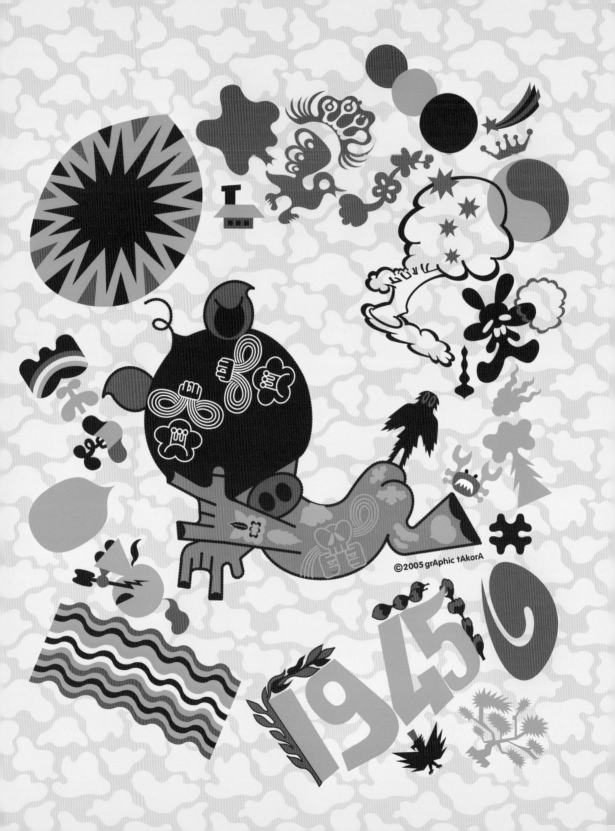

©2005 grAphic tAkorA

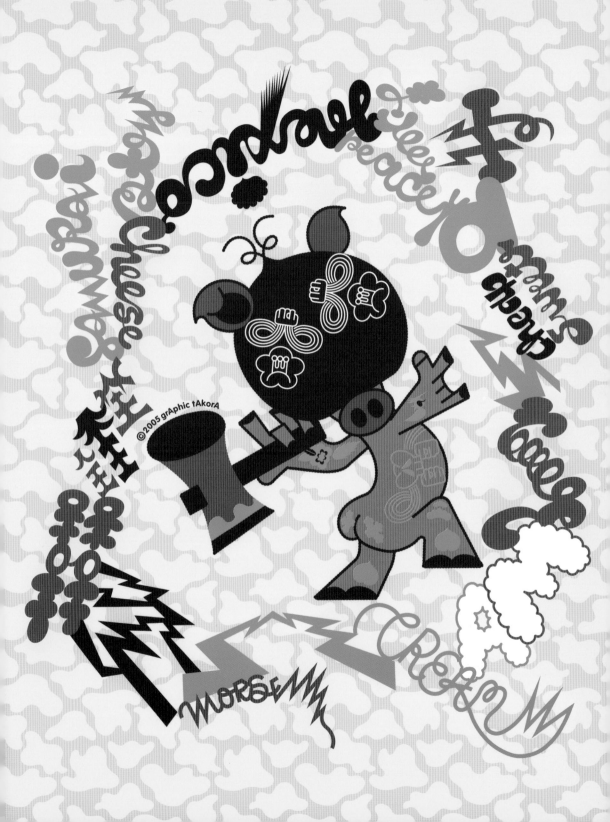

© 2005 grAphic tAkorA

rolitoland

La Madeleine, France

Do you have any tattoos? What does tattoo mean to you?
No. To be honest, I could not keep the same tattoo for the rest of my life. If one day I were to get a tattoo, I would really like something very traditional, of primitive origin, something like Polynesian tattoo.

What is the first thing that comes to mind when you think of tattoos?
I think about "primitive art." I think that tattoo expresses something, that they are not solely "decorative."

Where do you want to have your tattoo(s)? Why?
On the arms, like the drawings of geometric symbolic systems of tattoo of Eskimo of the East.

Would you like to get your "tattoo icon" as a real tattoo? Why or why not?
I don't really know. I believe that I would be afraid if one of my drawings were tattooed on someone's body for his whole life. Tattoo is a major commitment.

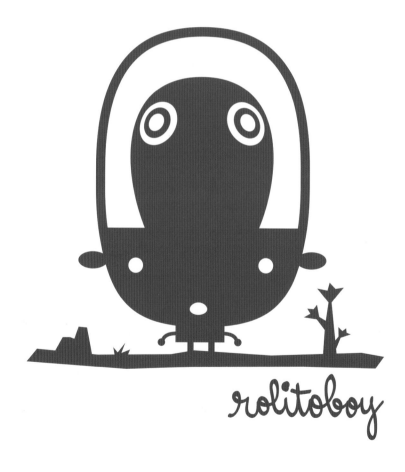

rolitoboy

rolitoboy

rolitoboy

rolitoboy

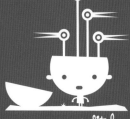

rolitoboy

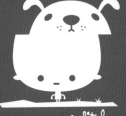

rolitoboy

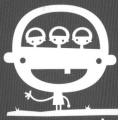

rolitoboy

rolitoboy

rolitoboy

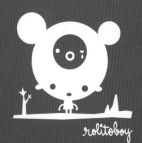

rolitoboy

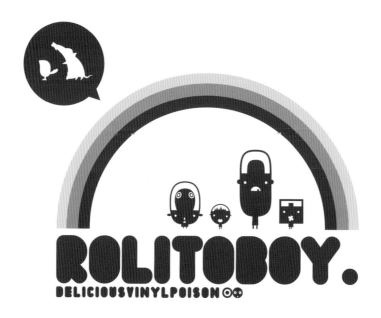

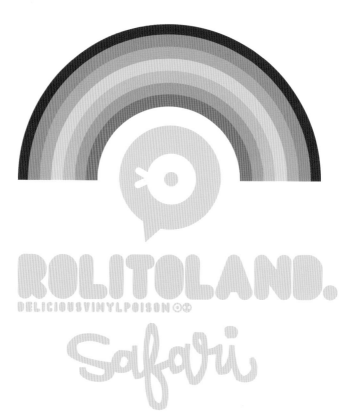

ROLITOLAND.Safari
DELICIOUSVINYLPOISON

NedZed

"le chasseur malin"

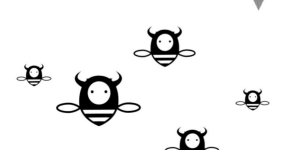

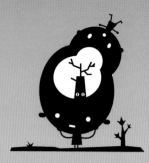
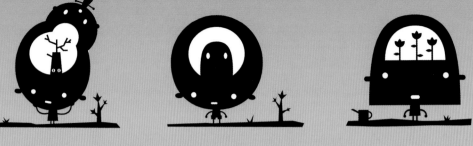

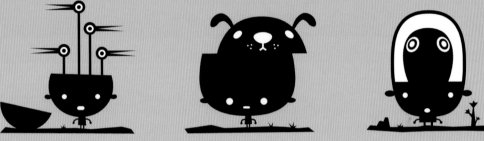

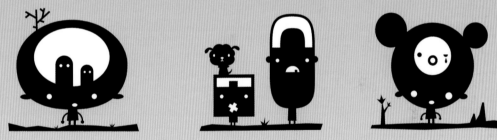
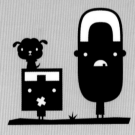
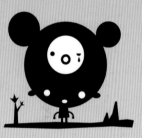
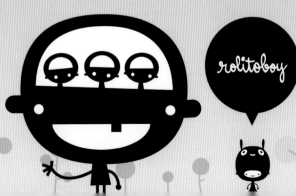

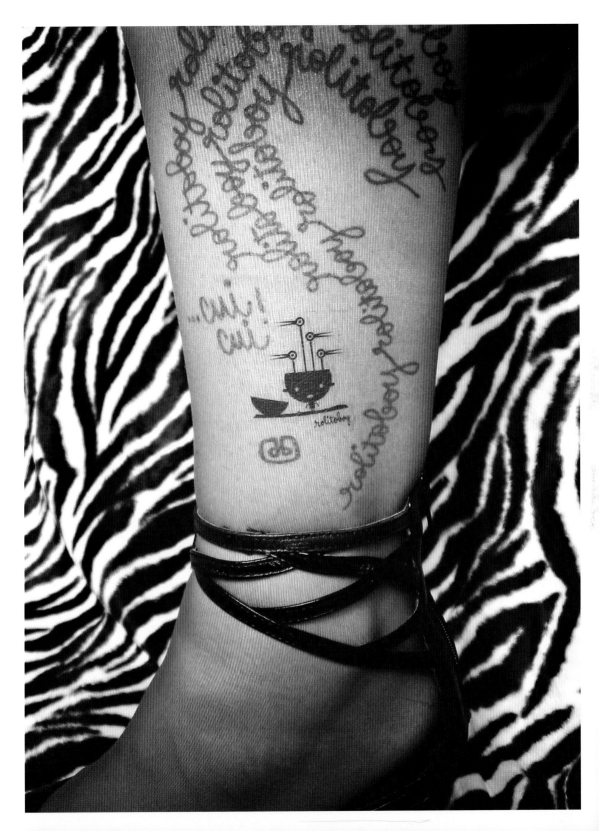

shellmoonsite

Hong Kong, China

Do you have any tattoos? What does tattoo mean to you?
No, it can't be now. Tattoo can be someone's identity.

What is the first thing that comes to mind when you think of tattoos?
To me, tattoo always reminds me of those gangsters from my childhood, who liked to show off their muscular body to others.

Where do you want to have your tattoo(s)? Why?
I can never make a decision about having a tattoo on any part of my body. I am a person who regrets any kind of imperfection.

Would you like to get your "tattoo icon" as a real tattoo? Why or why not?
It would be interesting to see my icon on anything or anyone else but myself.

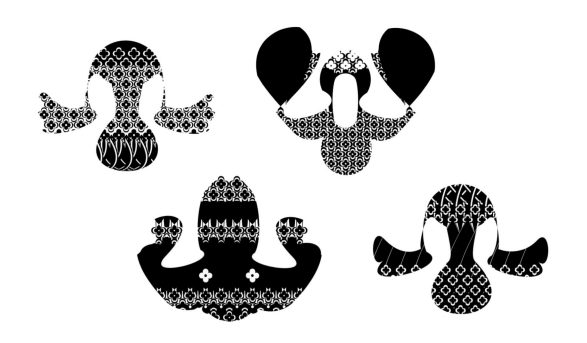

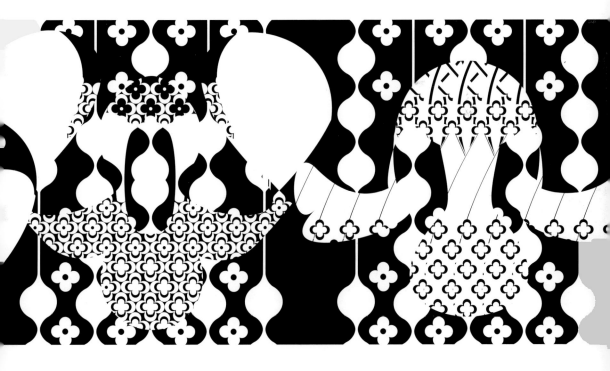

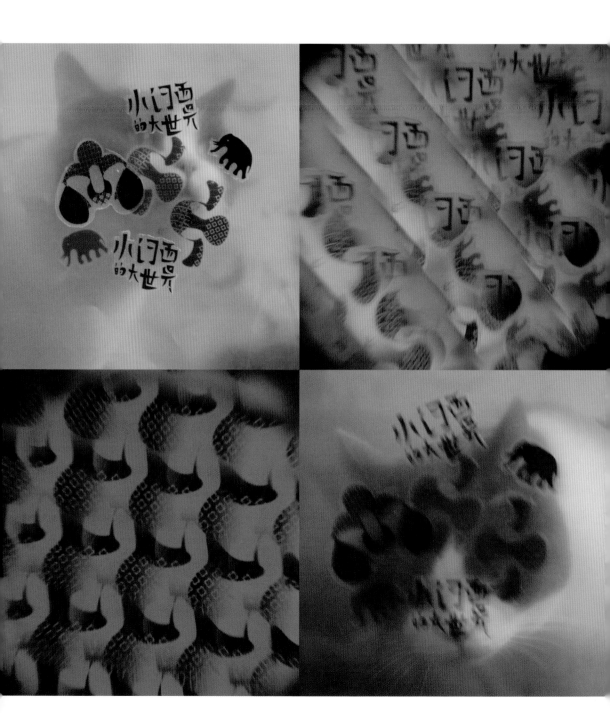

shellmoonsite

potipoti

Berlin, Germany

Do you have any tattoos? What does tattoo mean to you?
Not yet. We understand that tattoo is the human need to communicate something permanently. It's like a solid declaration of your taste and preferences. The problem is that it lasts forever and if you tattoo your girlfriend's name on your arm and she leaves you after one week — well, things change, but the tattoo does not.

What is the first thing that comes to mind when you think of tattoos?
Bearded men in motorcycles, black leather, bad boys with long hair and tongue piercings who kiss their girls rudely, rock n roll! Uuuh, scary!

Where do you want to have your tattoo(s)? Why?
We'd like to have a double tattoo, for example one on each hand or foot. Two characters that live with us, that look at each other and kiss when we wash our hands or clap.

Would you like to get your "tattoo icon" as a real tattoo? Why or why not?
Yes, of course, to show that a tattoo doesn't have to be taken too seriously, be boring, dark or traditional and to prove that it can also be fun and communicate positive feelings.

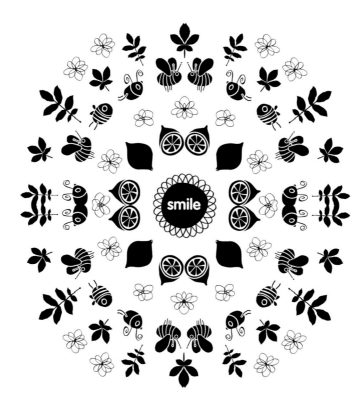

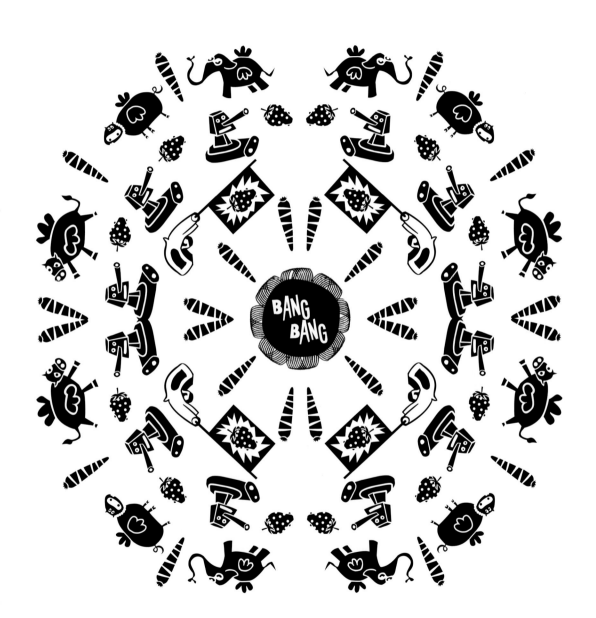

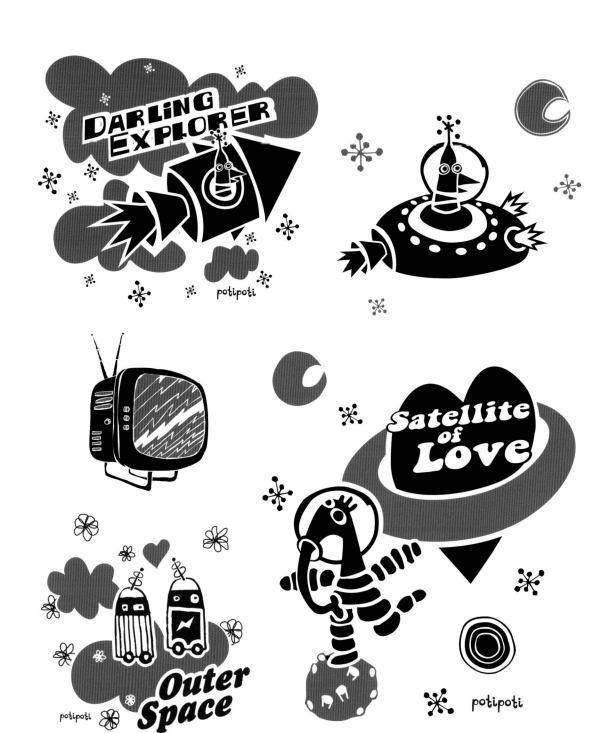

simon oxley

Fukuoka, Japan

Do you have any tattoos? What does tattoo mean to you?
No. A tattoo is a permanent statement to the world etched onto one's body, one's property. It is graffiti that cannot be erased by the State. It is using body as a billboard, communicating such primeval themes as love, hate and everything in between.

What is the first thing that comes to mind when you think of tattoos?
Bikers, punks, angry youth, people wearing clothing that purposely expose the full splendor of their body art, and prisoners in death camps with numbers etched onto their foreheads. I also think of the gangster culture here in Japan, and the artwork that traditionally covers the entire arm to the wrist and back, with symbols of strength and beauty such as dragons, flowers and fish.

Where do you want to have your tattoo(s)? Why?
Don't need one. I do have a certain amount admiration for people who commit to having a really good design placed on themselves, although I cannot help feeling that as time passes their opinions and taste must alter, making them regret the former decision.

Would you like to get your "tattoo icon" as a real tattoo? Why or why not?
Not at all, but when I was younger I did want one in an attempt to bolster some street cred points, of which I had none.

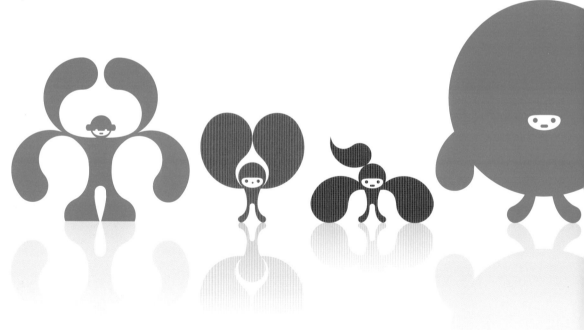

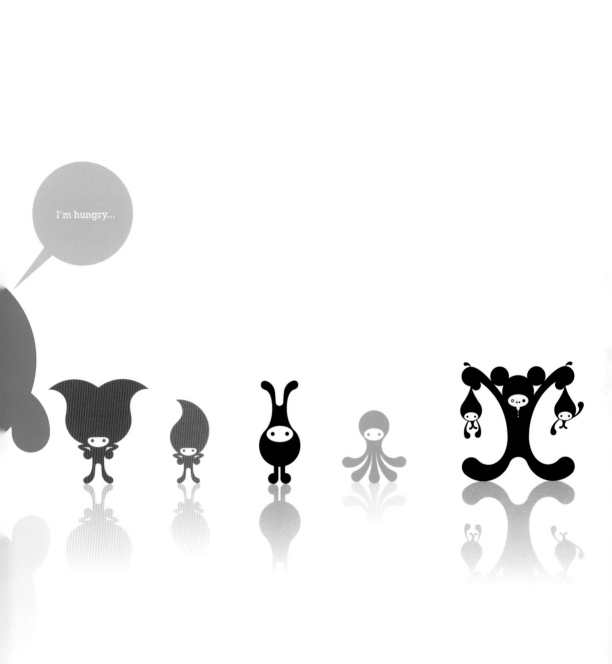

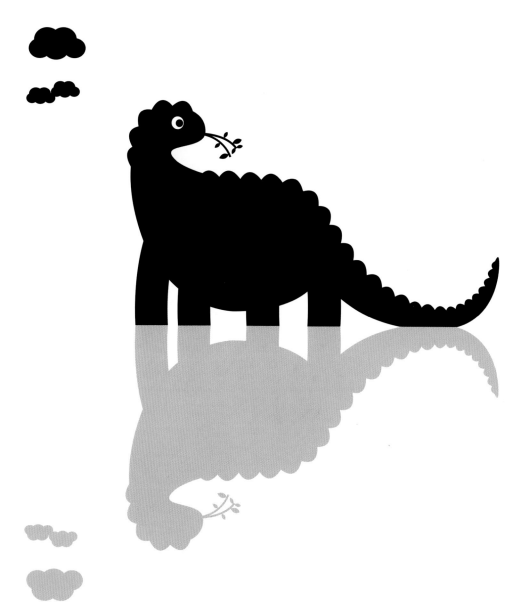

simon oxley

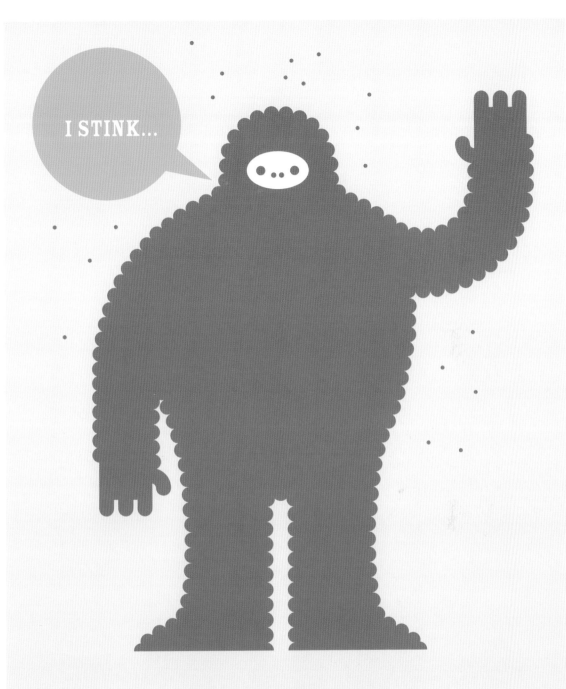

Feral Errol

'My favourite colour is tree, actually.'

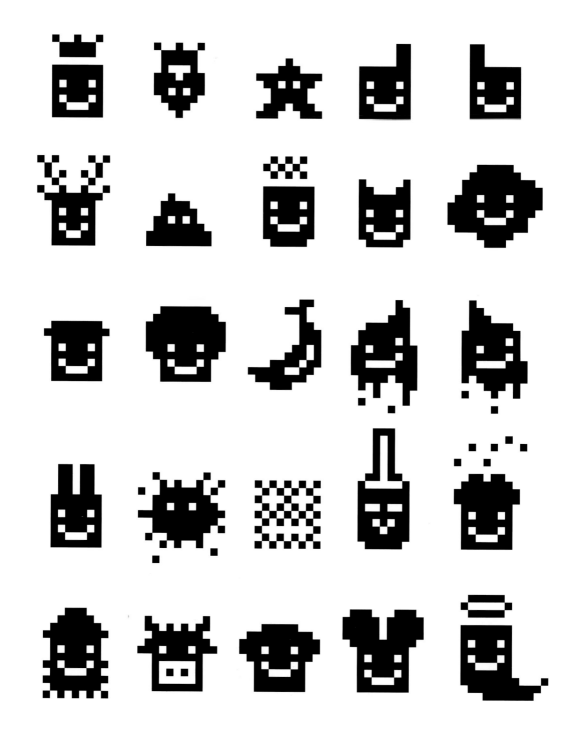

db-db

db-db

Hong Kong, China

Do you have any tattoos? What does tattoo mean to you?
No, I don't. Tattoo's irreversible nature makes it a very strong sign of your belief, taste and identity. It can shape how people see and interpret you. As a designer, I think tattoo can also be used to show my own designs. But of course, the premise is to come up with a piece that I would like to wear for a lifetime.

What is the first thing that comes to mind when you think of tattoos?
Probably it's an image of a typical Hong Kong gangster, who wears a huge dragon, tiger, snake or eagle tattoo.

Where do you want to have your tattoo(s)? Why?
Maybe on my buttocks! I think each of them can have a "db" tattoo, which comes together to form my website name.

Would you like to get your "tattoo icon" as a real tattoo? Why or why not?
Yes, very much indeed! Because they are cute, aren't they?

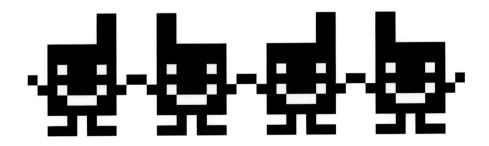

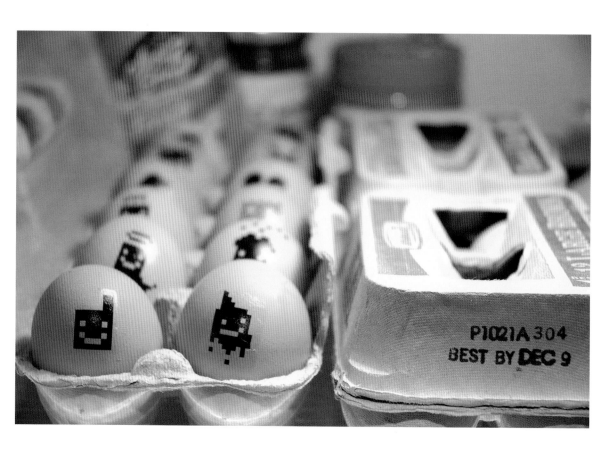

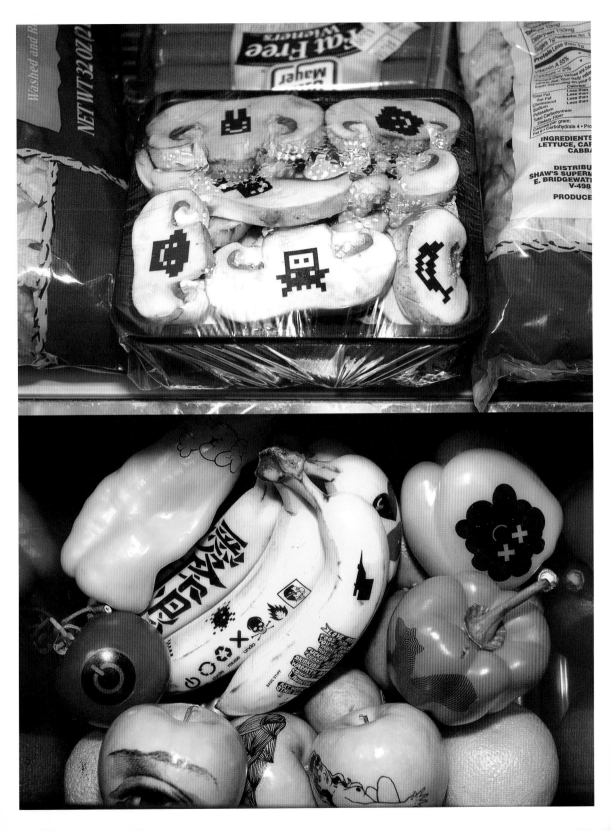

michael moser

Munich, Germany

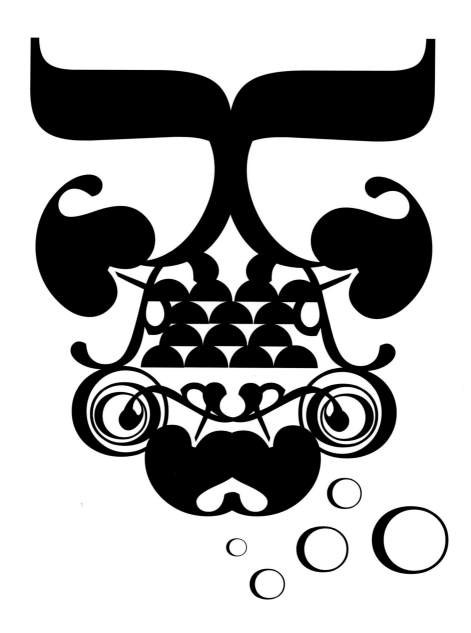

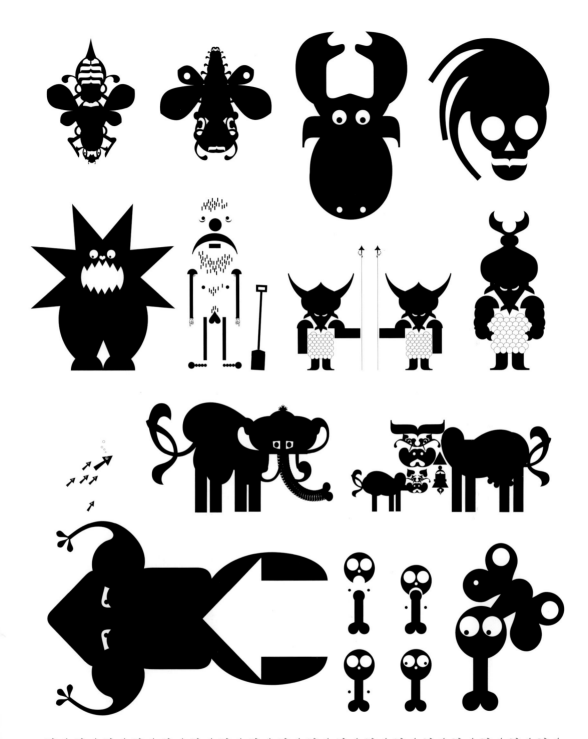

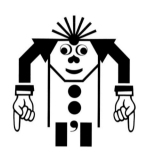

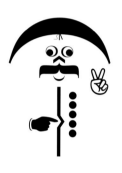

ME

YOU

KILL!

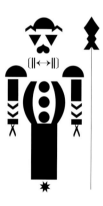

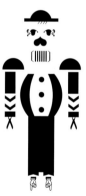

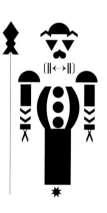

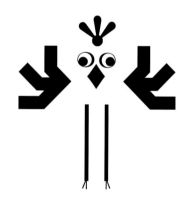

PIEP! PIEP! PIEP!

PIEP!

michael moser

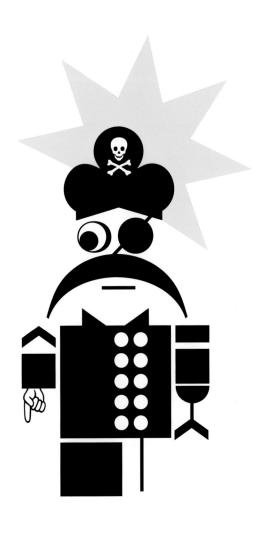

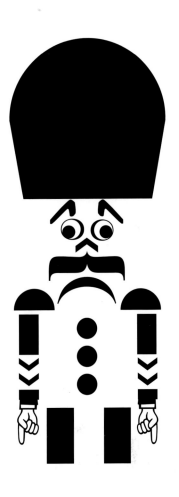

KILL! WHY?

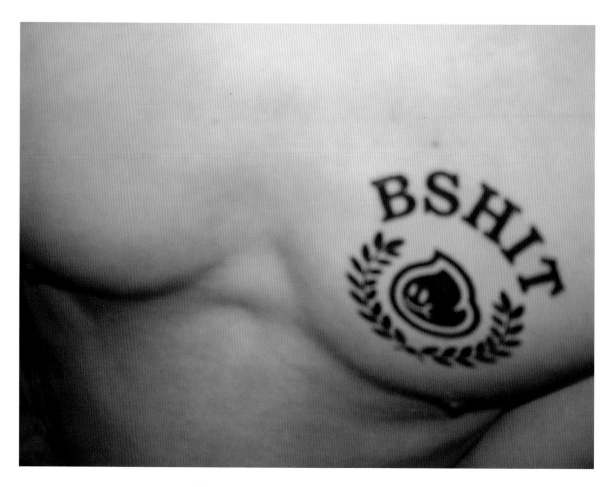

superdeux

Lille, France

Do you have any tattoos? What does tattoo mean to you?
I would like to have some, maybe one day. Tattoo means fun and art. But I know that for some people it's something really serious and has a real meaning.

What is the first thing that comes to mind when you think of tattoos?
My ex-girlfriend Ai-Lich. She has a beautiful Japanese tattoo all over her back — awesome.

Where do you want to have your tattoo(s)? Why?
I think usual places are cool — arms, chest, maybe on the neck. It's like clothing or accessories — we want it to be visible.

Would you like to get your "tattoo icon" as a real tattoo? Why or why not?
Hum no, I can't "wear" my own art. I would prefer asking somebody to design one for me. But I will be happy to see somebody with my designs as real tattoos.

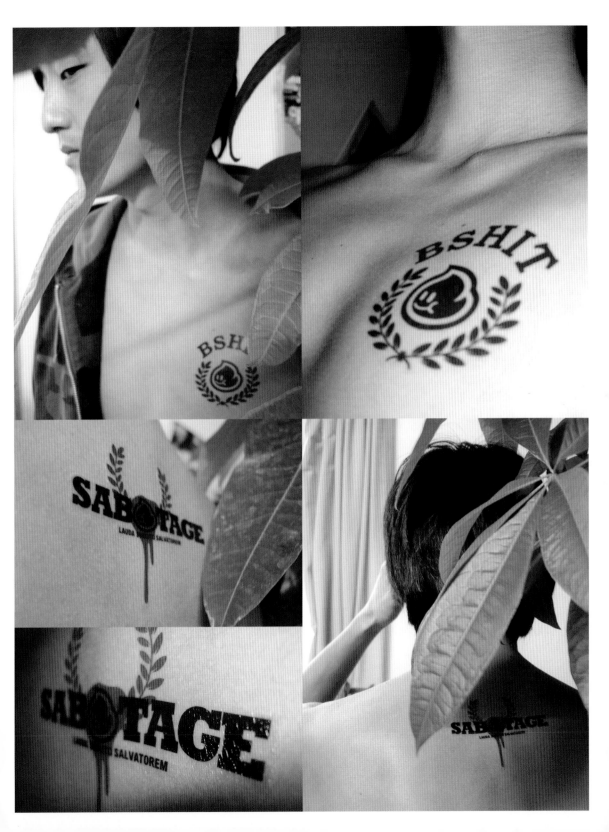

SABOTAGE

LAUDA SHIKITO SALVATOREM

BSHIT

DON'T FUCK WITH ME

I PLAY HARD

A FONKY

®

SHIT

upnorth

New York, New York

Do you have any tattoos? What does tattoo mean to you?
Yes, tattoo is my journey.

What is the first thing that comes to mind when you think of tattoos?
More, please.

Where do you have your tattoo(s)? Why?
Right arm top to bottom, chest, tailbone, left elbow, both wrists, right calf, left foot, left underarm. These are my favorite places.

Would you like to get your "tattoo icon" as a real tattoo? Why or why not?
Maybe. I'm not a real tattoo artist so I'm not sure I'd actually get my graphics tattooed on me.

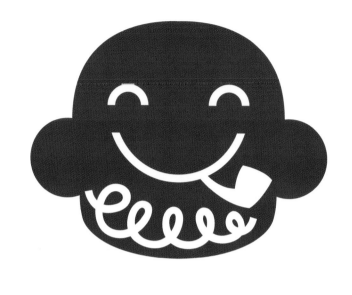

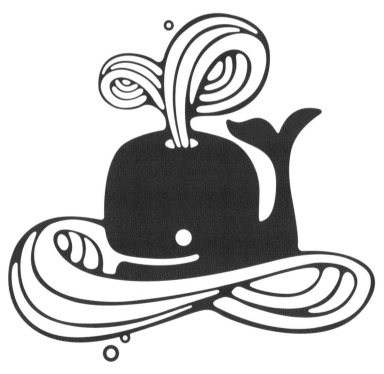

rinzen

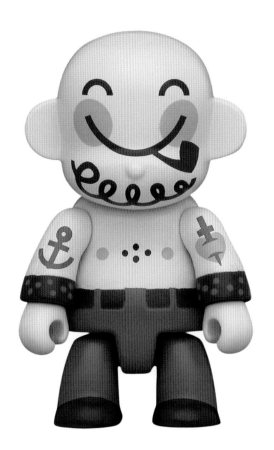
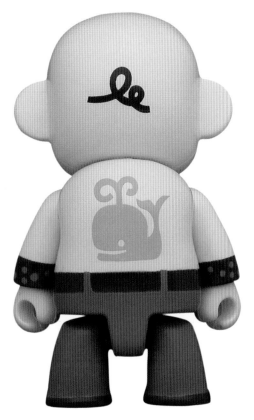

rinzen

Berlin, Germany / Queensland, Australia

Do you have any tattoos? What does tattoo mean to you?
No. Tattoos mean a permanent commitment and complete conviction.

What is the first thing that comes to mind when you think of tattoos?
Sailors. "A Sailor without a tattoo is like a ship without grog: not seaworthy." (Samuel O' Reilly, New York tattoo artist who invented the modern tattoo gun in 1891)

Where do you want to have your tattoo(s)? Why?
On Torbjorn the Boatman. He's seaworthy.

Would you like to get your "tattoo icon" as a real tattoo? Why or why not?
If it protected me from drowning and sharks, I'd give it some serious thought.

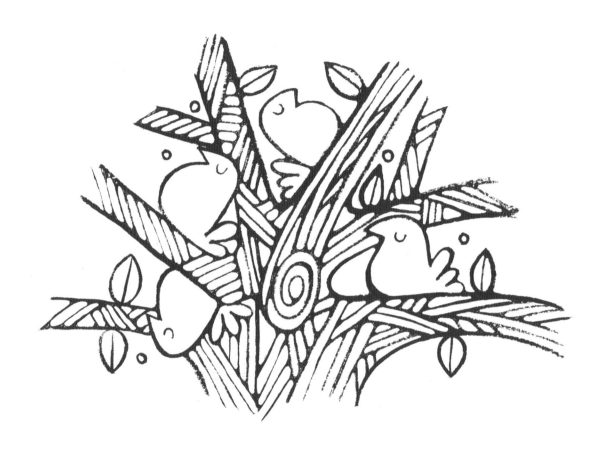

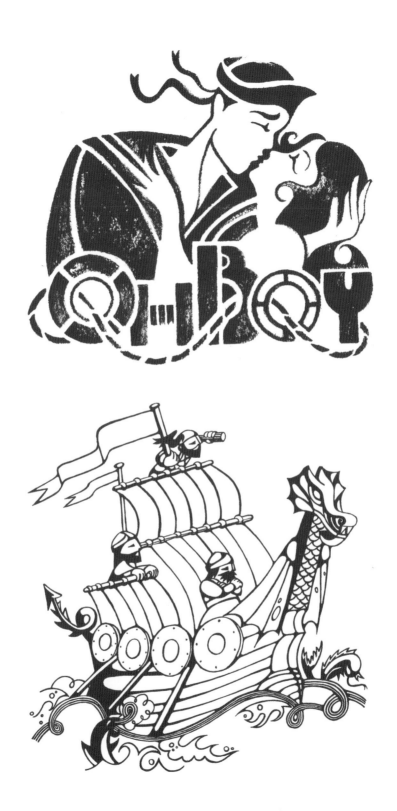

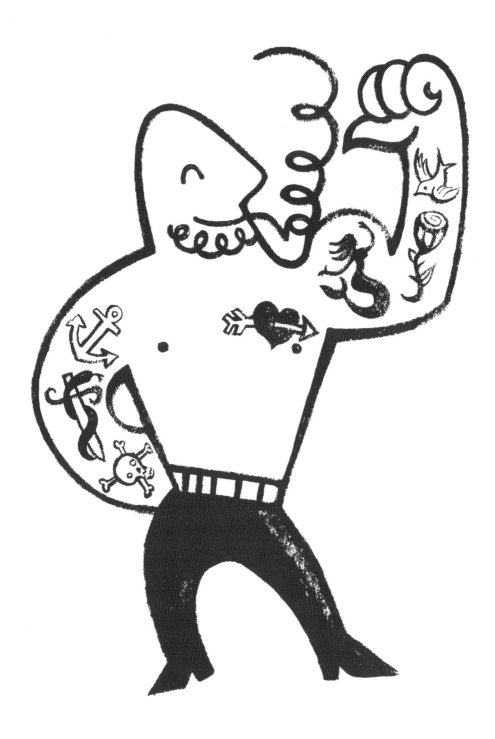

rinzen

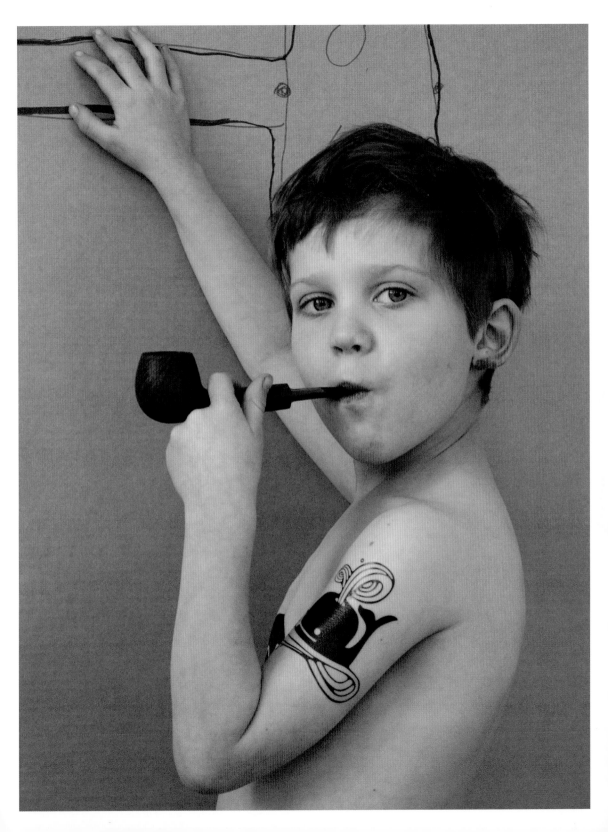

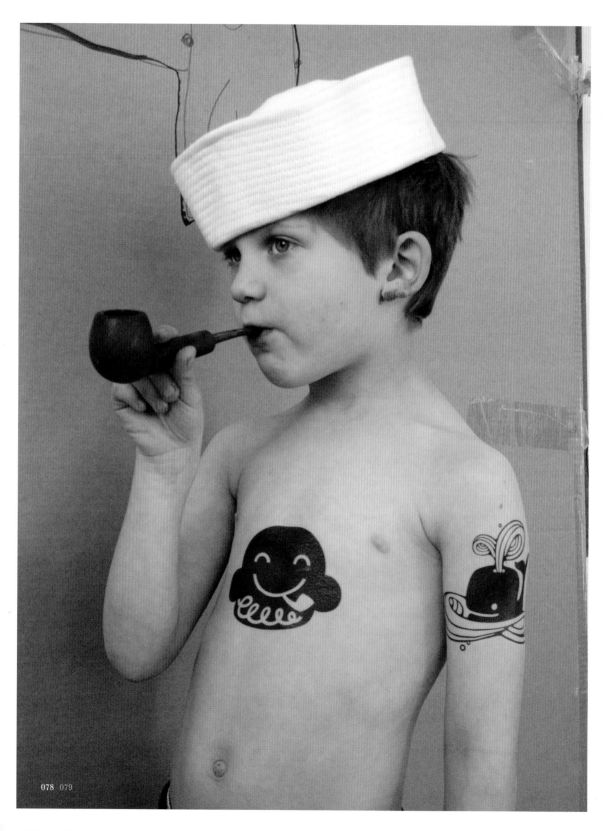

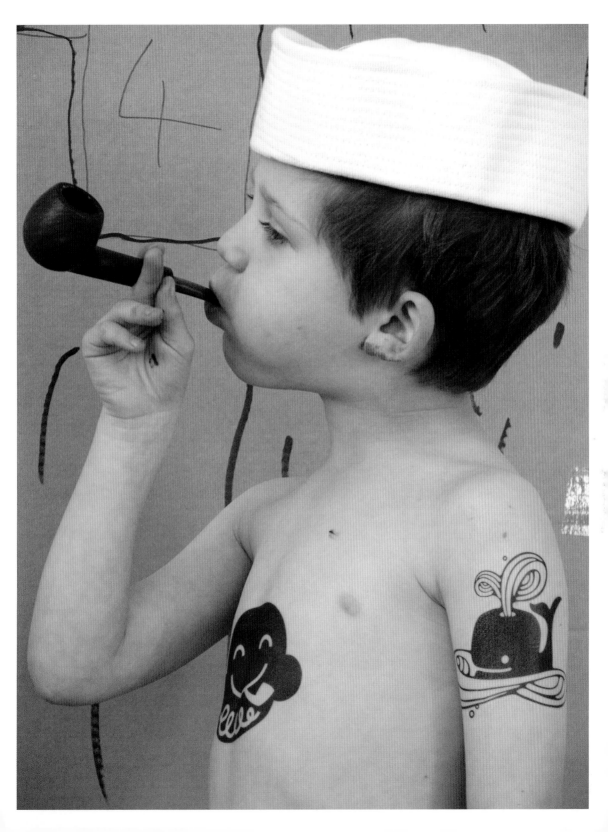

gaga inc

New York, New York

Do you have any tattoos? What does tattoo mean to you?
I don't have a tattoo. To me tattoo means something that you will get tired of eventually. That's why I prefer fake tattoos!

What is the first thing that comes to mind when you think of tattoos?
Popeye.

Where do you want to have your tattoo(s)? Why?
If I want a tattoo, I would have it in my elbow because the elbow is supposed to hurt less.

Would you like to get your "tattoo icon" as a real tattoo? Why or why not?
I would like someone else to have my tattoo made. Really big and on the back, like "yakuza." But this will be a different kind of "yakuza" — super-cute-happy "yakuza!"

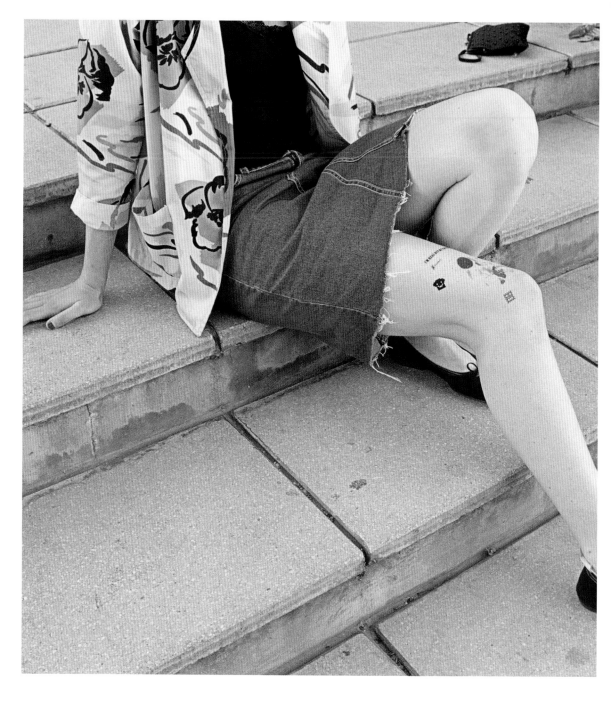

gaga inc

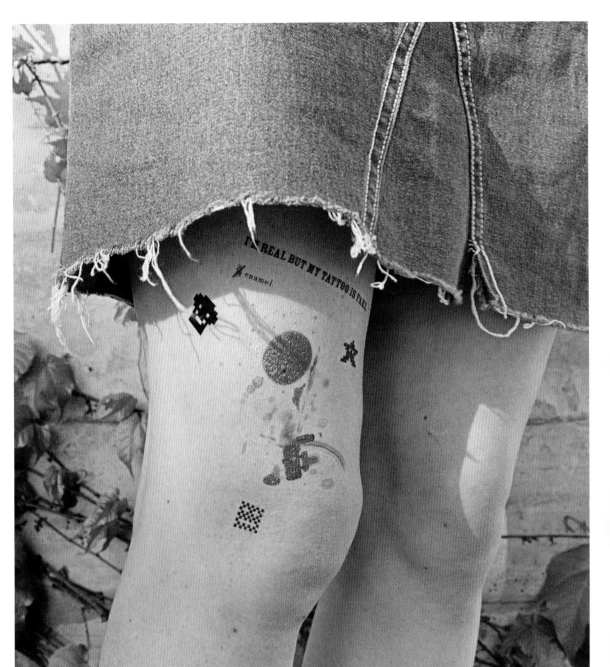

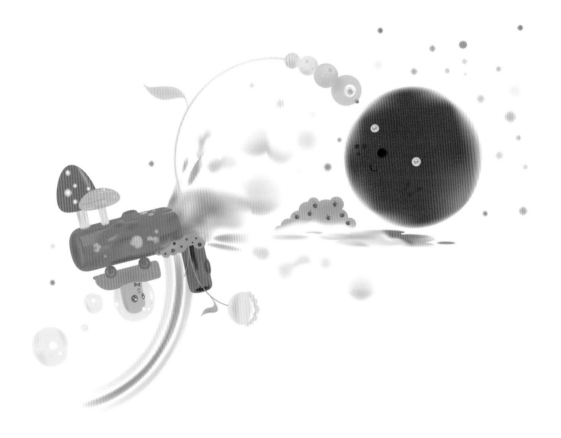

BRIAN
WILSON

Ice-Cream

Vintage Books

Chocolate

gaga inc

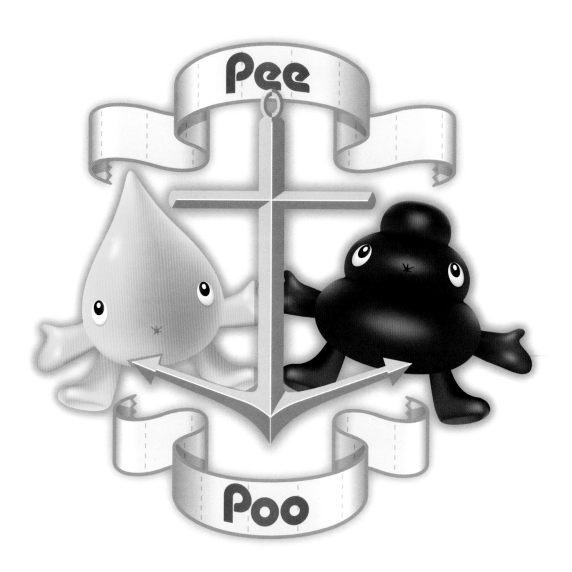

pee & poo

pee & poo

Stockholm, Sweden

Do you have any tattoos? What does tattoo mean to you?
No. It means fearlessness. Not worrying about how that rose is going to look on my butt, a decade from now.

What is the first thing that comes to mind when you think of tattoos?
Sailors and inmates.

Where do you want to have your tattoo(s)? Why?
I don't want to have one.

Would you like to get your "tattoo icon" as a real tattoo? Why or why not?
No. I'm a coward.

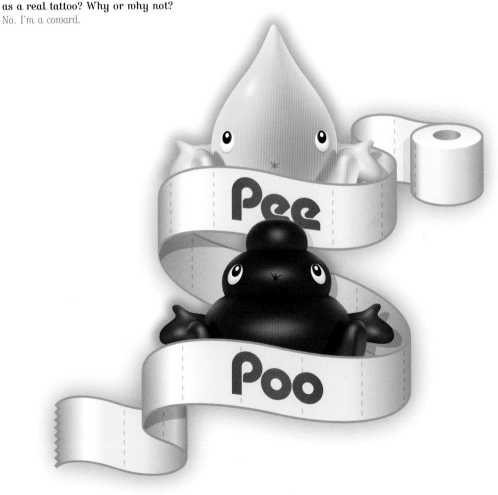

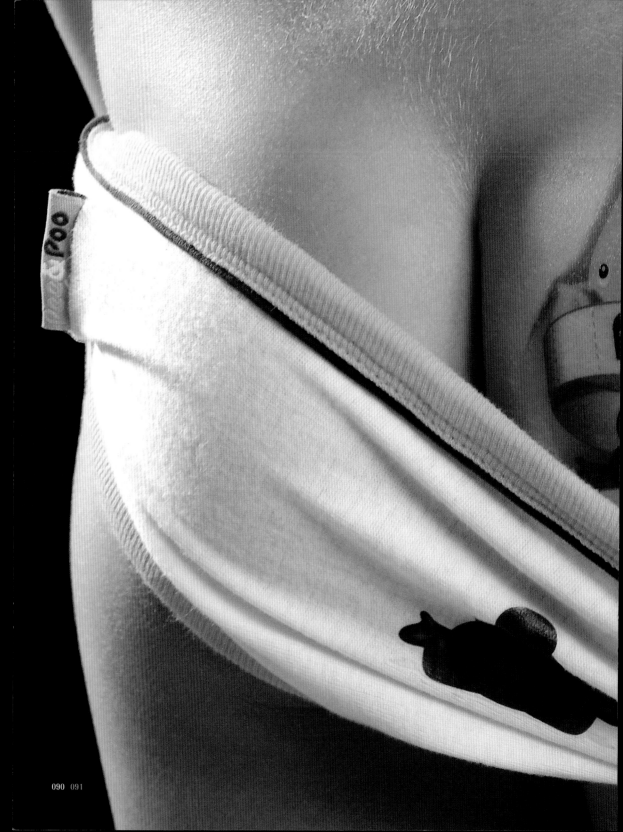

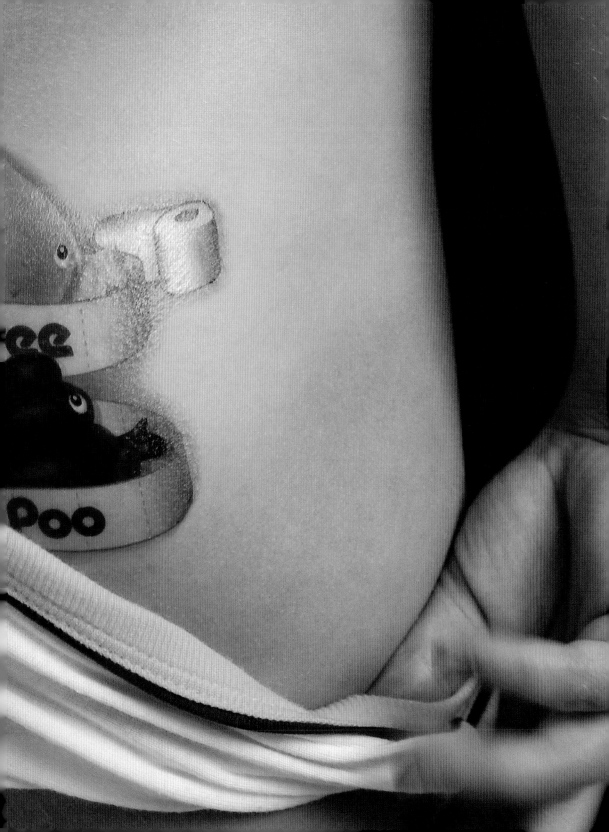

zip design

London, UK

Do you have any tattoos? What does tattoo mean to you?
I have one tattoo. It is my mother's name.

What is the first thing that comes to mind when you think of tattoos?
Permanence.

Where do you have your tattoo? Why?
On the inside of my right arm so I can see it.

Would you like to get your "tattoo icon" as a real tattoo? Why or why not?
Probably not, because I'm not sure I would want to end up being an old lady with monster tattoos. Plus I doubt they would stretch out too well.

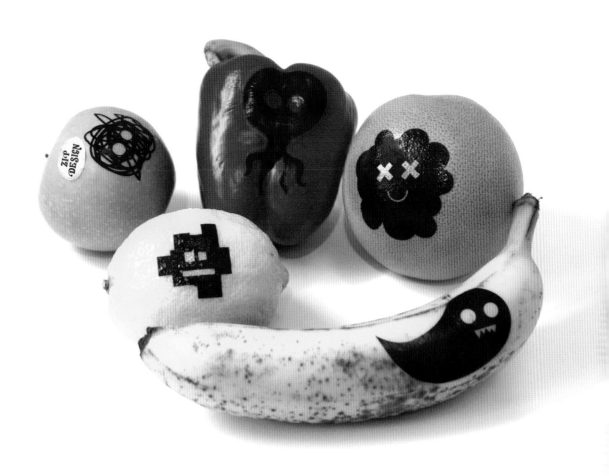

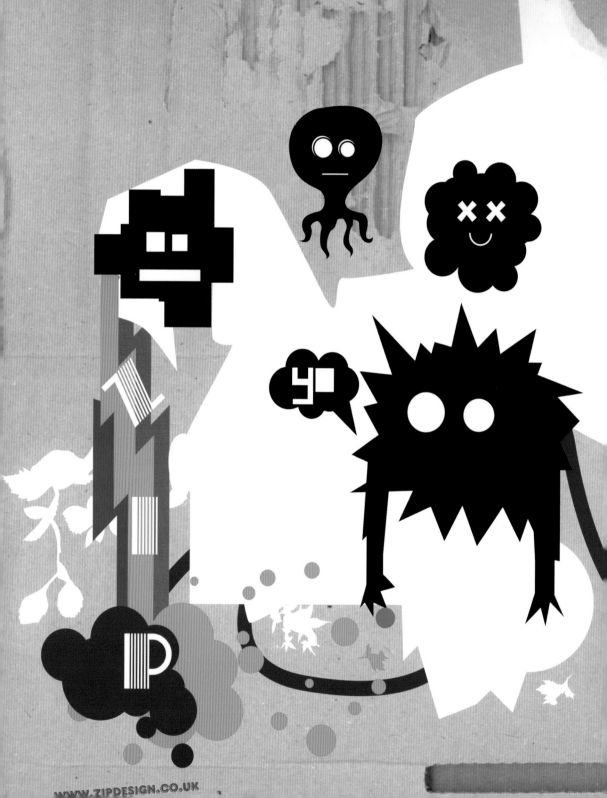

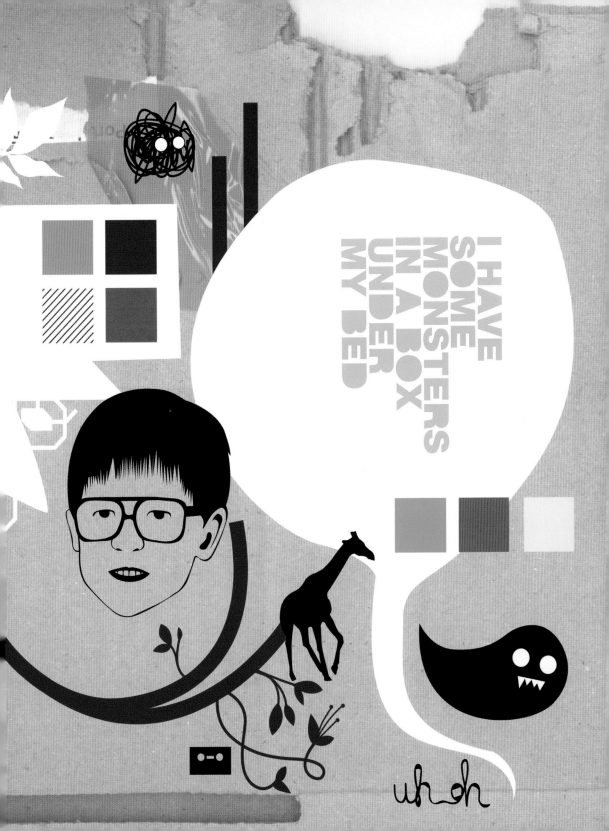

furi furi company

Tokyo, Japan

Do you have any tattoos? What does tattoo mean to you?
No tattoos!

What is the first thing that comes to mind when you think of tattoos?
Japanese tattoos! Because they are cool! The colors are so beautiful!

Where do you want to have your tattoo(s)? Why?
On my hip! Starting from there, filling the body with tattoos seems so much fun!

Would you like to get your "tattoo icon" as a real tattoo? Why or why not?
If I get a chance, yes! Because there are not many cute tattoos! Ours are so cute! They stand out in the crowd for sure!

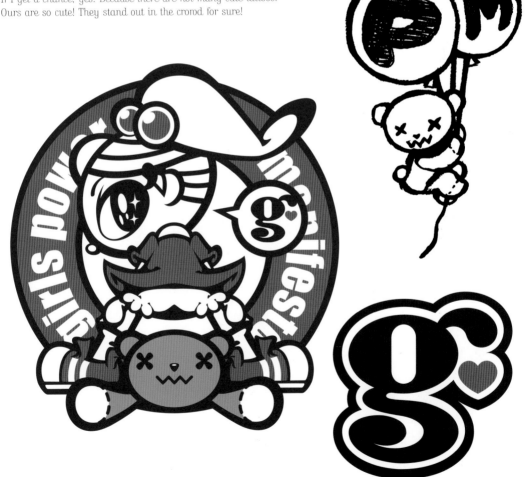

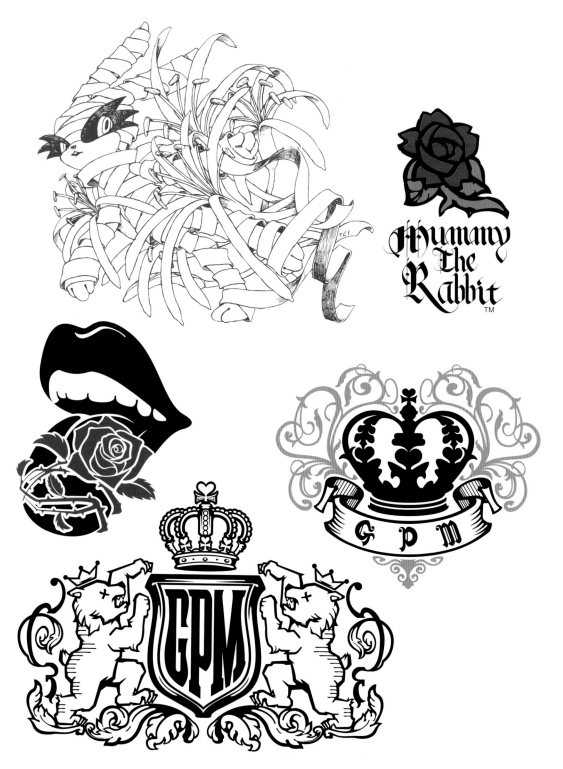

furi furi company

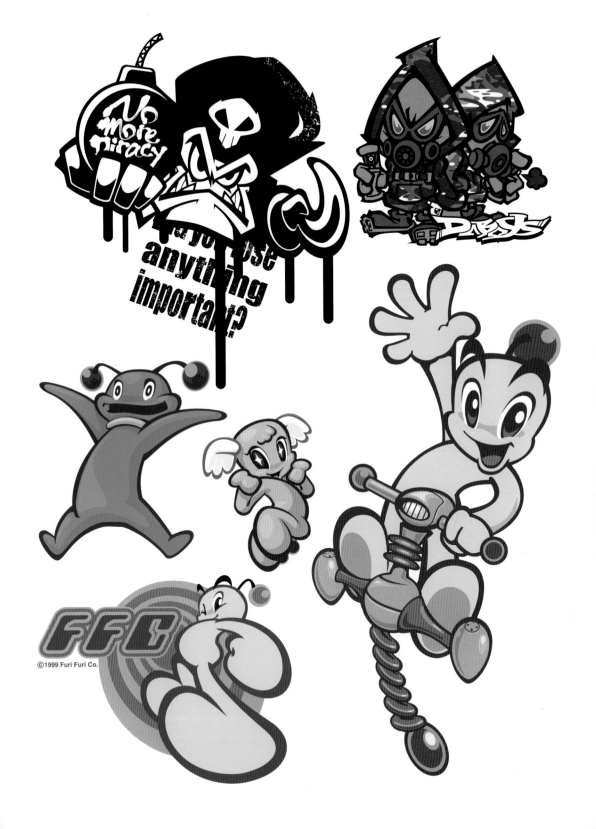

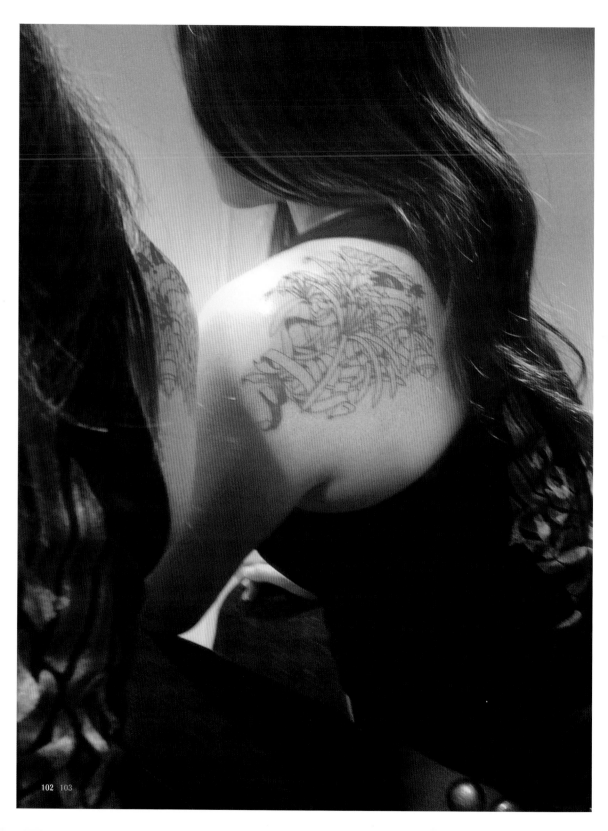

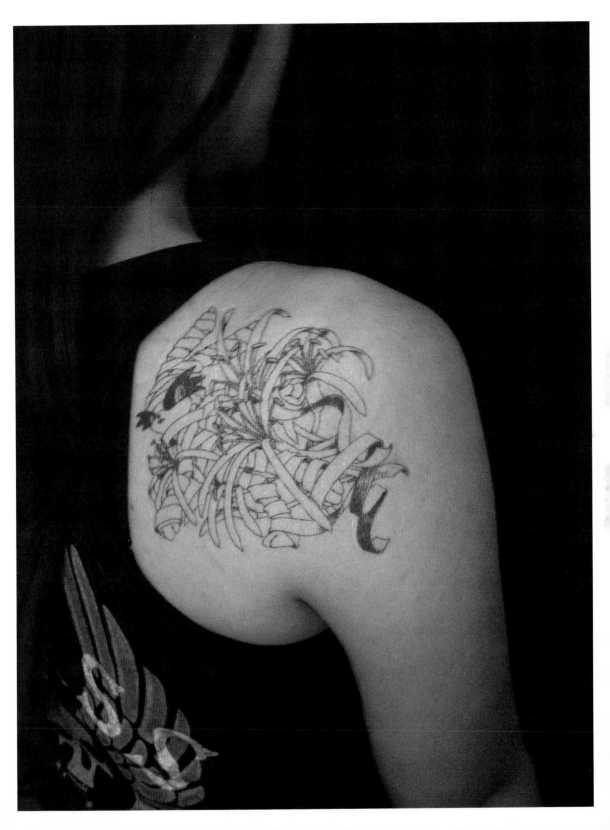

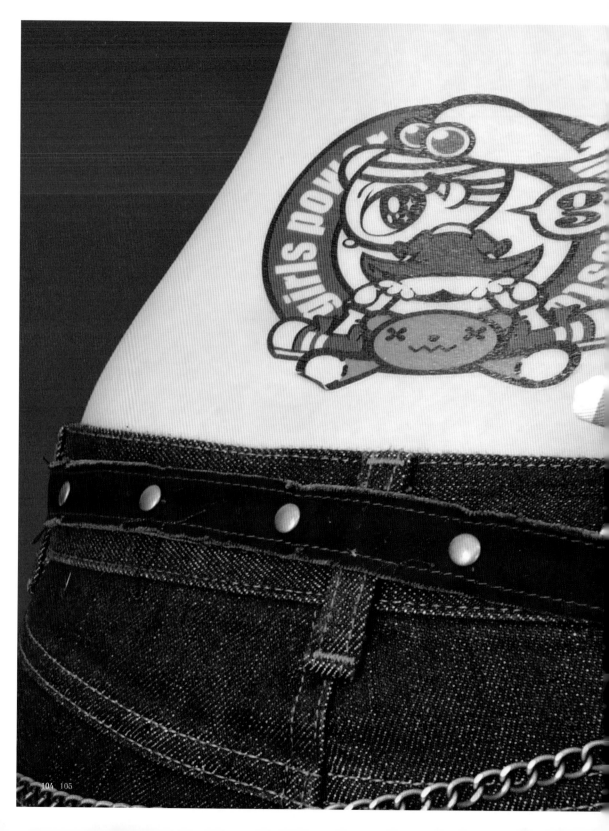

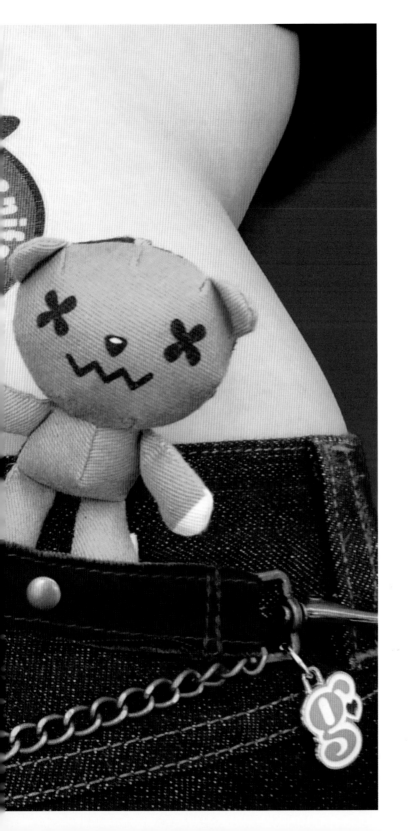

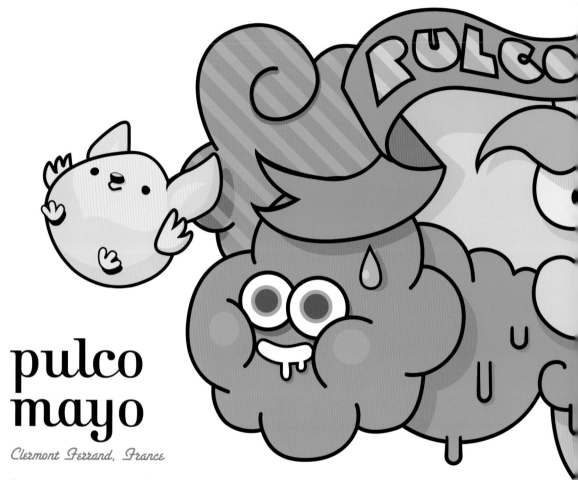

pulco mayo

Clermont Ferrand, France

Do you have any tattoos? What does tattoo mean to you?
No, only marker or Posca tattoo. For me, a tattoo is a way to be and to feel different from everyone, but it's also a way to feel integrated into a community, a tribe – it's a ritual.

What is the first thing that comes to mind when you think of tattoos?
Fat bearded bikers wearing leather boots and denim jacket.

Where do you want to have your tattoo(s)? Why?
I want it on my girl's thighs. Guess why.

Would you like to get your "tattoo icon" as a real tattoo? Why or why not?
Yes, of course. I don't think that skin is the best medium for graphic design, but to see people wearing your own work on their body is really terrific, especially if it's a fat bearded biker!

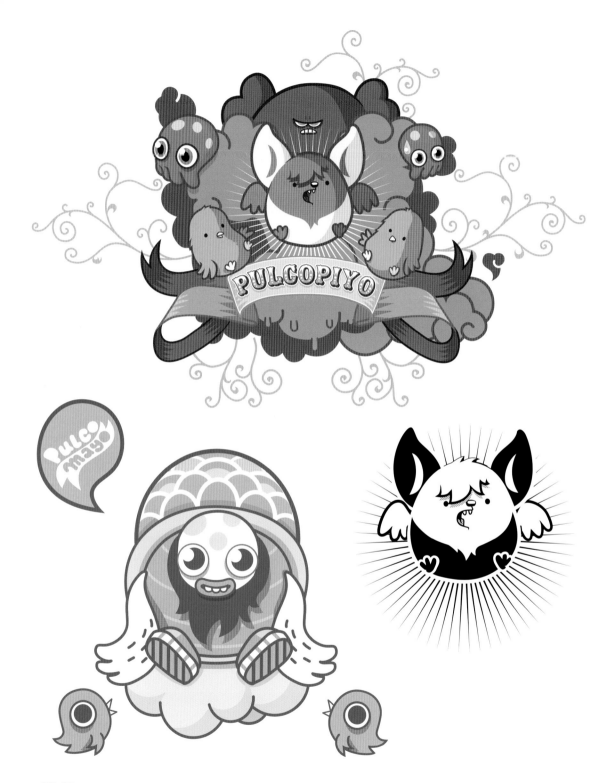

pulco mayo

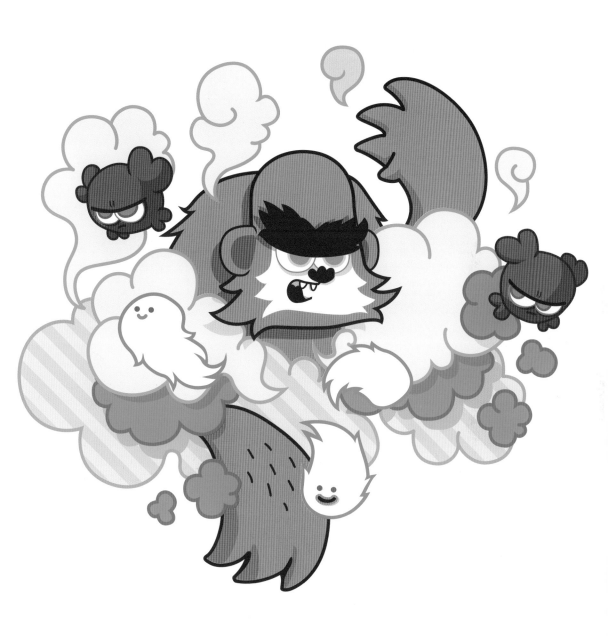

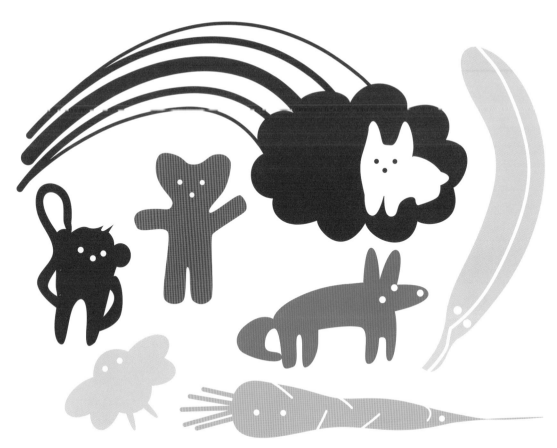

fl@33

London, UK

Do you have any tattoos? What does tattoo mean to you?
No. It's a state of mind. It's a bit like marriage – a decision that you make today while being convinced that you will think and feel the same way a few decades down the line and hopefully your entire life.

What is the first thing that comes to mind when you think of tattoos?
Popeye.

Where do you want to have your tattoo(s)? Why?
On somebody else. Why? See answer 1.

Would you like to get your "tattoo icon" as a real tattoo?
No.

wang wang cocorico

quack quack

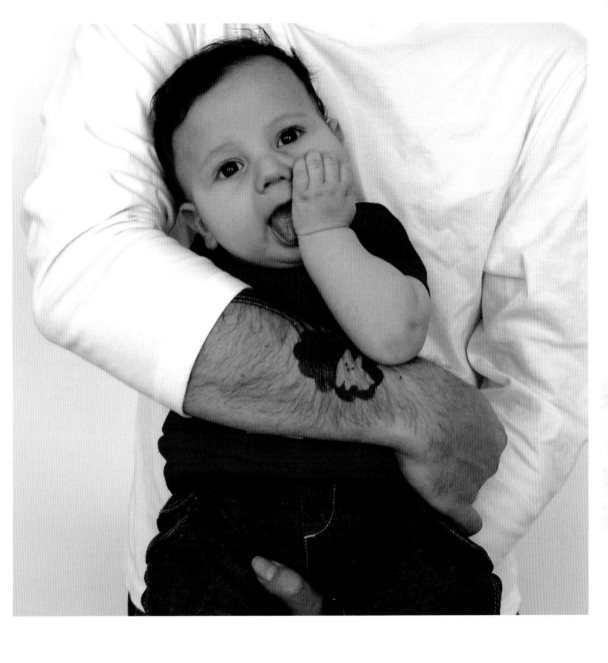

abiuro

abiuro

São Paulo, Brazil

Do you have any tattoos? What does tattoo mean to you?
Yes, it is part of my way of expression.

What is the first thing that comes to mind when you think of tattoos?
The concept.

Where do you have your tattoo(s)? Why?
On my arms, chest and belly. I don't have a particular reason.

Would you like to get your "tattoo icon" as a real tattoo? Why or why not?
Yes maybe, but I don't think about it in this moment, because I think it is necessary to finish the ones that I started first.

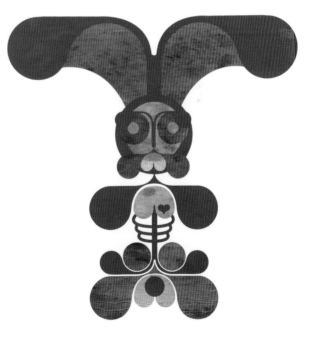

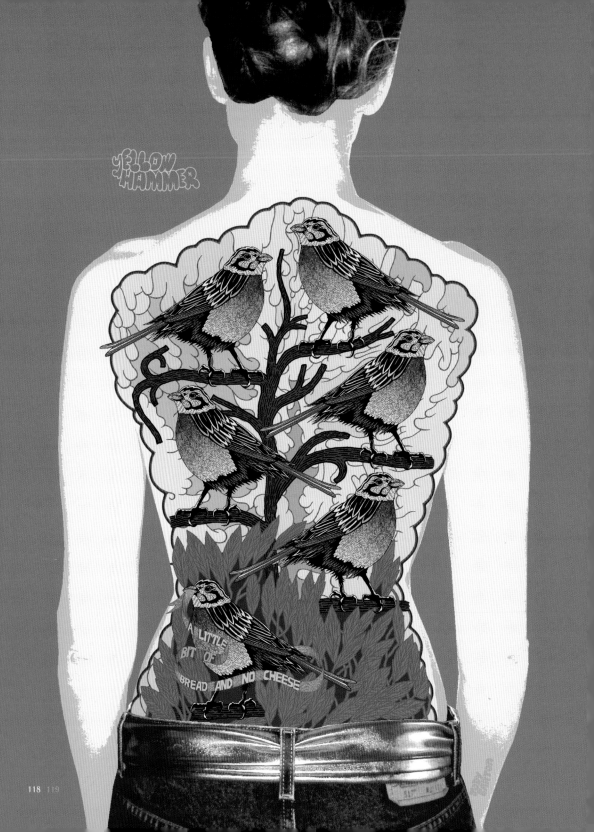

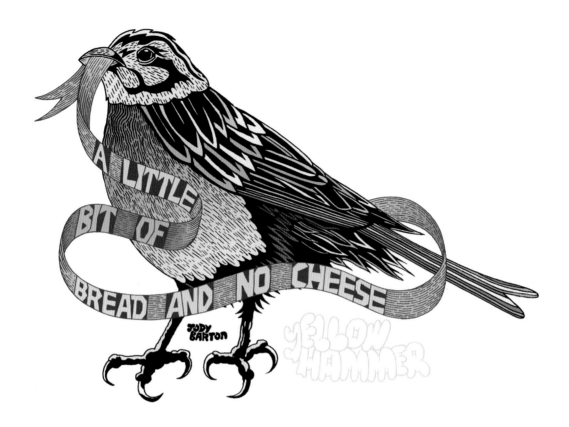

jody barton

Suffolk, UK

Do you have any tattoos? What does tattoo mean to you?

I don't have any tattoos as the ink doesn't stay in my skin. I went to a tattoo artist in Amsterdam and had a back piece done of SuperMario fighting Britney Spears with lightsabers. Within two weeks my $1200 tattoo had almost disappeared! My skin just eats ink. I went to a guy in London who said he'd put it deeper in with a heavier needle – I had a big leg piece done of Bob Marley and two "Greys" in a red, gold and green flying saucer powered by skunk smoke. Within a month it was as indistinct as a wine stain on a red carpet. So no tattoos for me. Henna ones would last longer. Tattoos mean sophistication to me.

What is the first thing that comes to mind when you think of tattoos?

I think nothing looks better than a fat, drunk woman wearing a football shirt, sporting a massive faded-out dolphin design covering a bicep as big as a ham. And have you noticed how tattoos make even the hardest motorcycle gang member look like an Oxford graduate – calm, literate, sophisticated and most of all approachable?

Where do you want to have your tattoo(s)? Why?

In my other job as a human resources manager for a preschool club, there is nothing so sure to secure the position in an interview than a face tattooed with cheeky spiderwebs, clever little swastikas and "cut here" instructions.

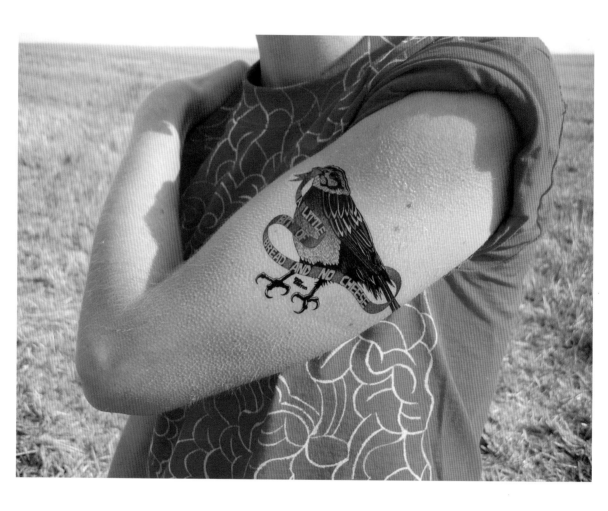

jody barton

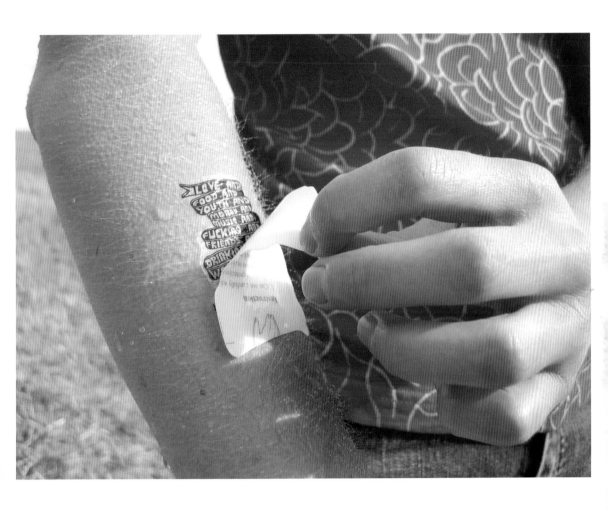

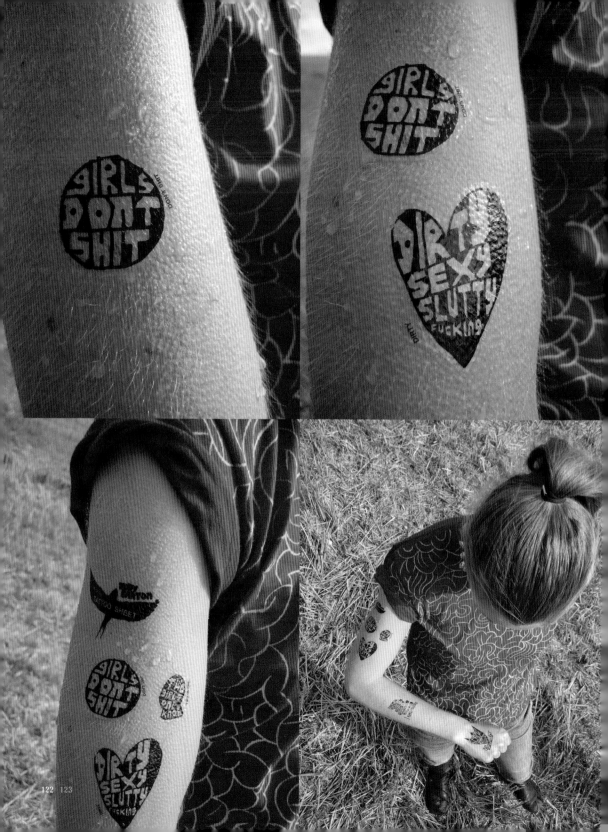

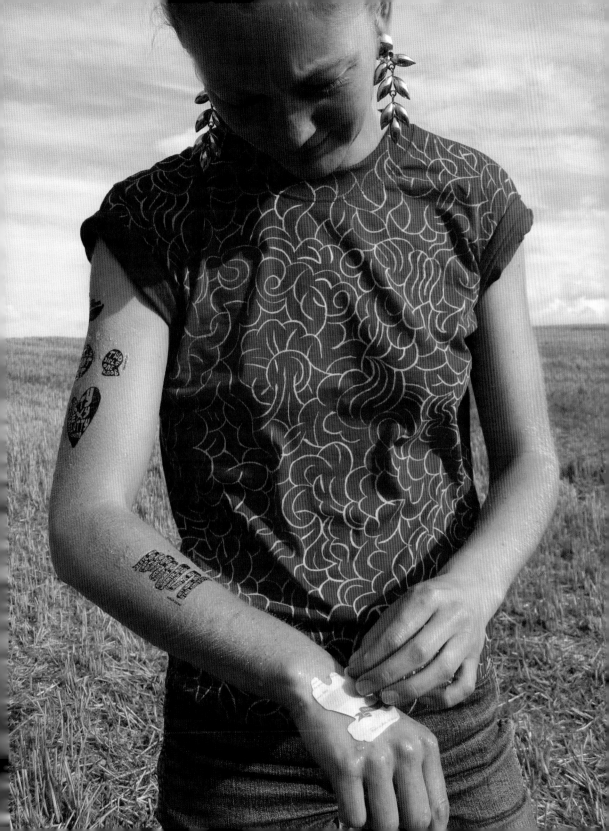

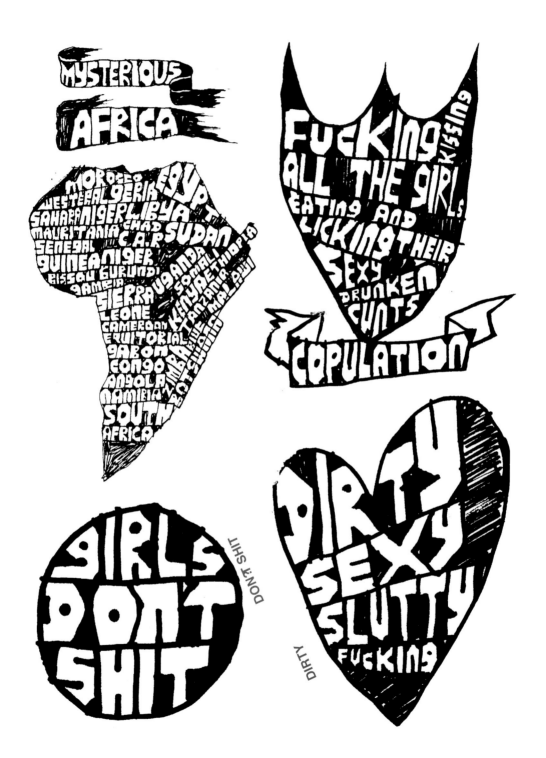

jody barton

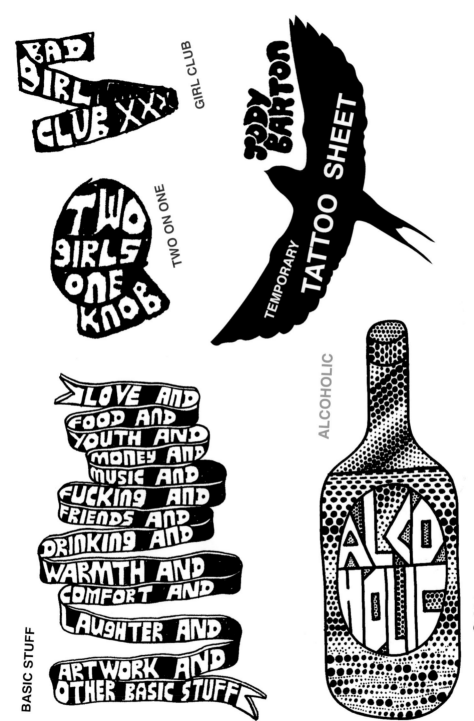

GIRL CLUB

TWO ON ONE

JODY BARTON

TEMPORARY TATTOO SHEET

ALCOHOLIC

BASIC STUFF

jody barton.

jody barton

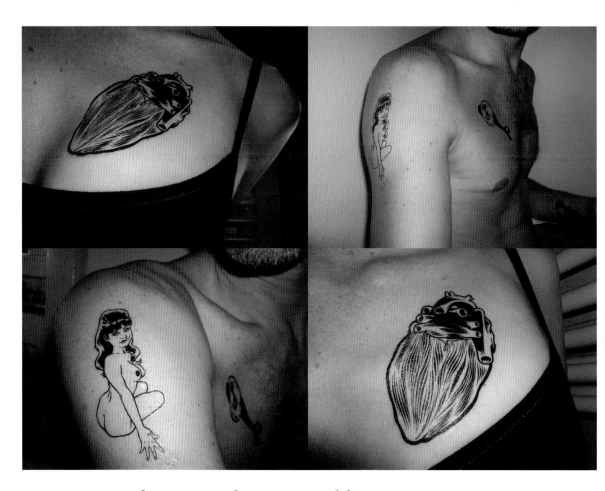

benjamin güedel

Zürich, Switzerland

Do you have any tattoos? What does tattoo mean to you?
No, I don't. You get yourself a tattoo when you are lovesick, or in prison.

What is the first thing that comes to mind when you think of tattoos?
Very hip. Most of the people have this one, which we call "arschbombe," which means something like "ass-bomb."

Where do you want to have your tattoo(s)? Why?
On the upper arm and the chest. That's where tattoos have to be, or on the face, but then you don't take tattoo stickers.

Would you like to get your "tattoo icon" as a real tattoo? Why or why not?
Some of them would be quite cool, but I will never get a tattoo. I think that's because I work the whole day with pictures so I don't like to "dirty" my body with drawings.

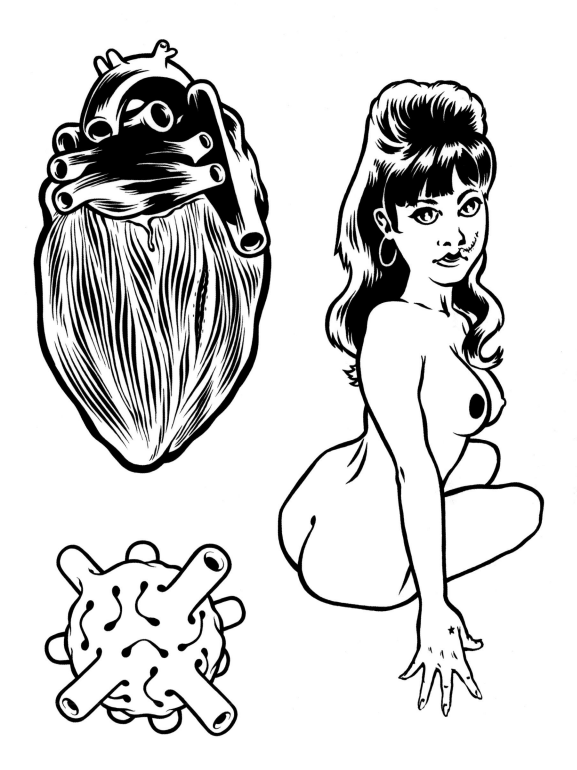

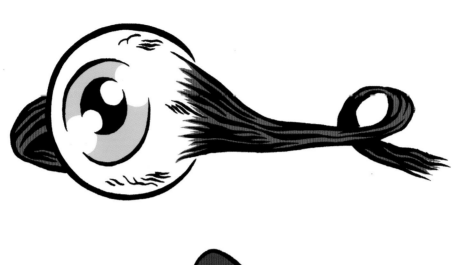

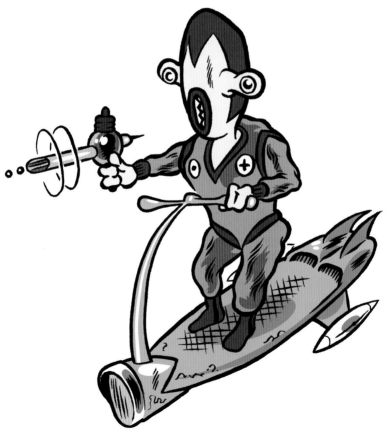

benjamin güedel

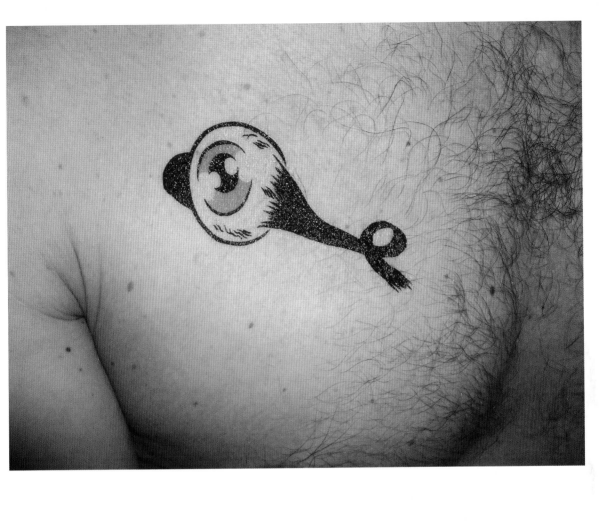

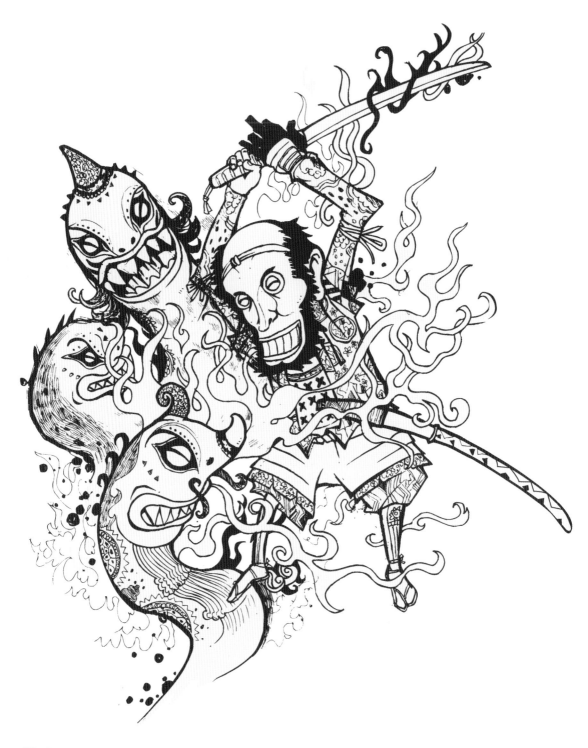

drip

drio

Selangor D. E., Malaysia

Do you have any tattoos? What does tattoo mean to you?
Not Yet. Tattoo is body art, a very personal art piece for every single individual according to their personality.

What is the first thing that comes to mind when you think of tattoos?
I should get at least one in my life.

Where do you want to have your tattoo(s)? Why?
Surrounding my legs, as I always wear shorts.

Would you like to get your "tattoo icon" as a real tattoo? Why or why not?
Certainly. Then I could have a solo exhibition with me no matter where I am.

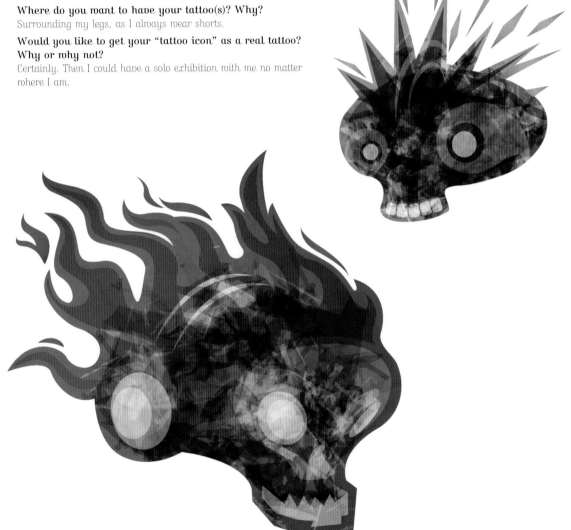

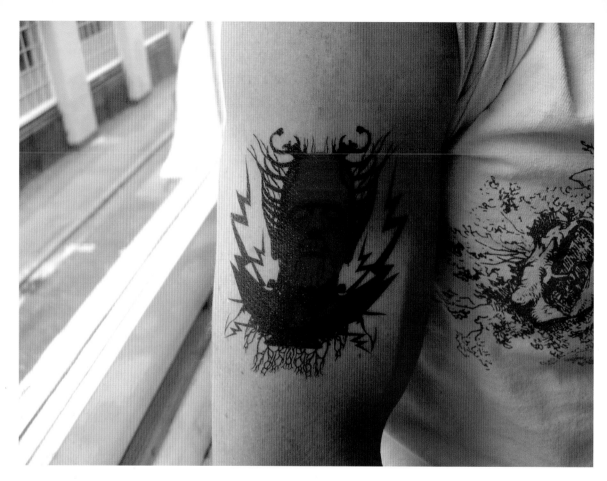

insect

London, UK

Do you have any tattoos? What does tattoo mean to you?
No. Tattoo means personal body expression.

What is the first thing that comes to mind when you think of tattoos?
It's for LIFE!

Where do you want to have your tattoo(s)? Why?
Nowhere. I've thought about getting some. But I know I would want to change them every six months. And Apple-Z-Command would not work!

Would you like to get your "tattoo icon" as a real tattoo? Why or why not?
Yes, and no. As I said above, I would always want to update or change any tattoos I had, so if I started I would never stop till I am totally covered! And that's not my style. I'm into that natural look. I feel that I don't need to express something by painting my skin – my mouth can do that.

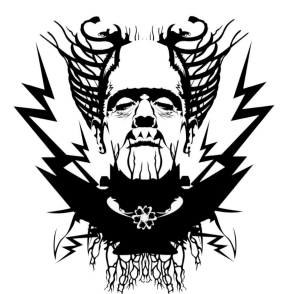
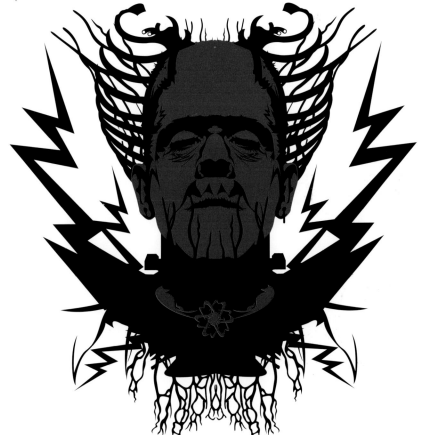

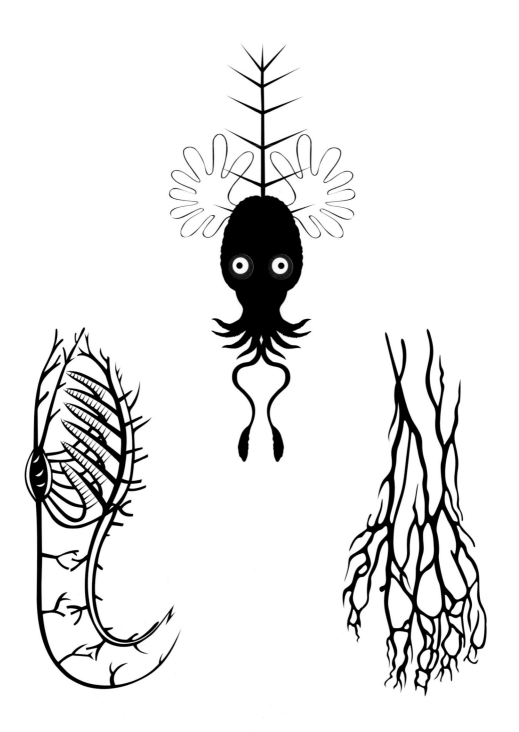

insect

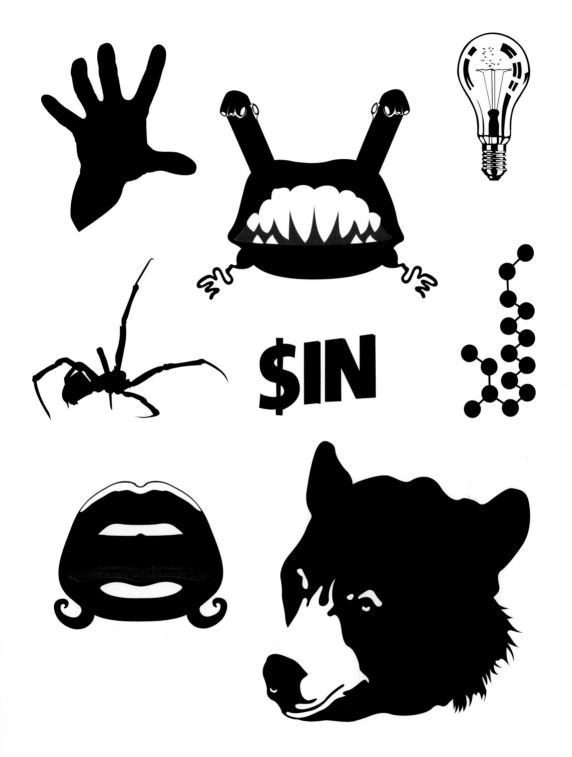

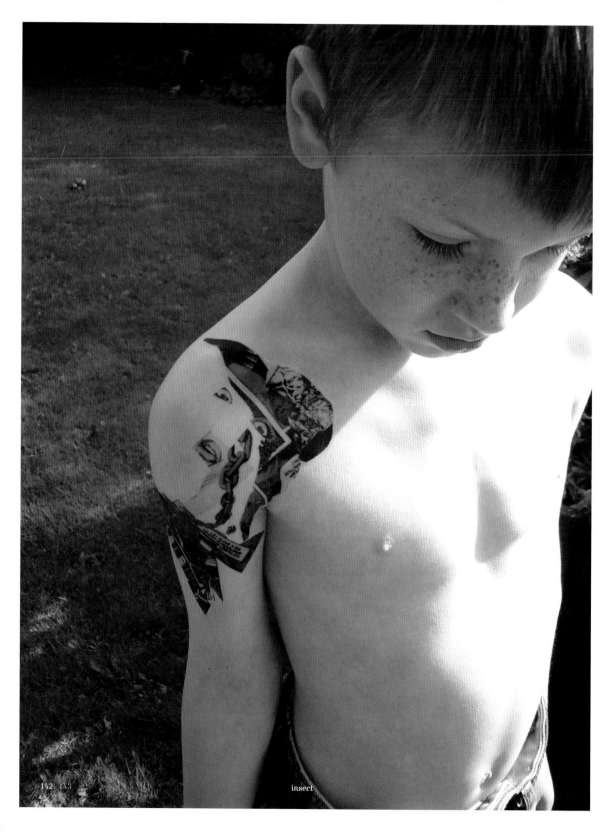

insect

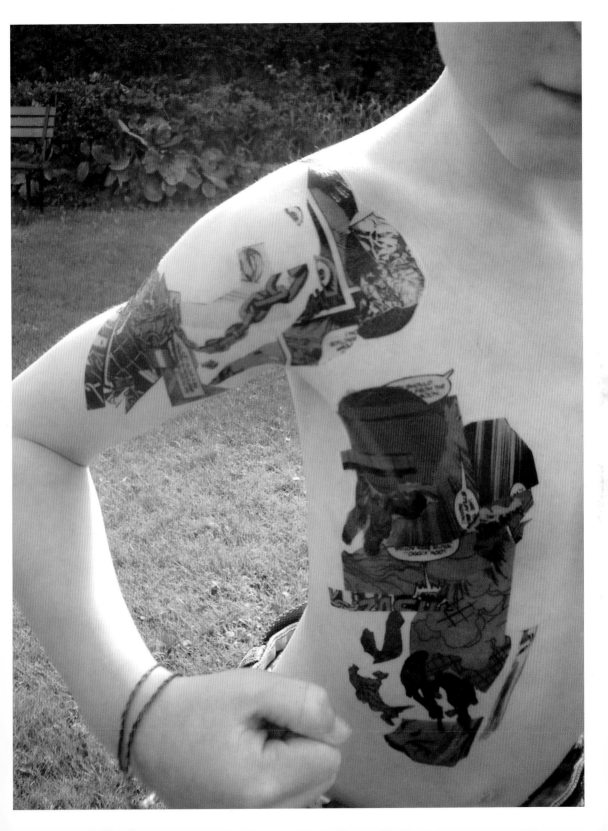

zion graphics

Stockholm, Sweden

Do you have any tattoos? What does tattoo mean to you?
No. It means fearlessness. Not worrying about how that Mickey Mouse is going to look when I'm 62 years old.

What is the first thing that comes to mind when you think of tattoos?
Ships.

Where do you want to have your tattoo(s)? Why?
I don't want to have one. I want to be different.

Would you like to get your "tattoo icon" as a real tattoo? Why or why not?
No, not for myself, but I would like to give it to someone else, maybe in order to be nice.

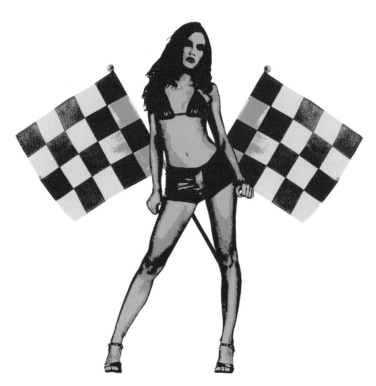

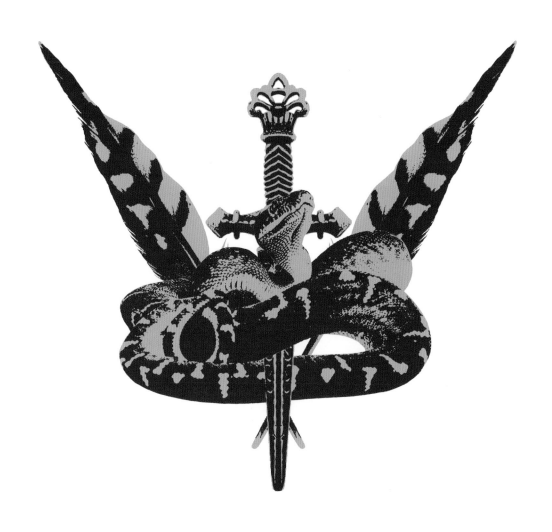

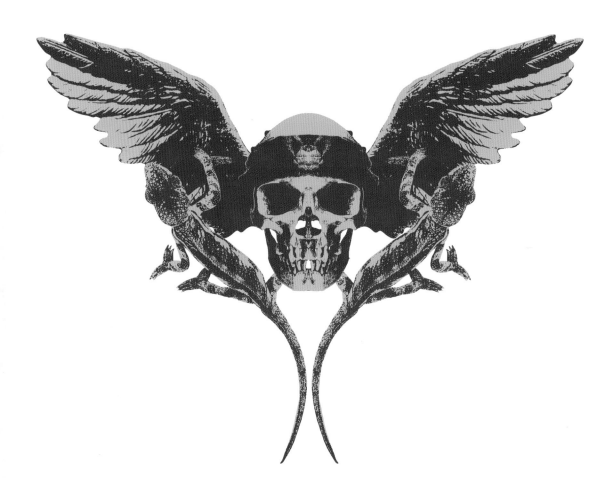

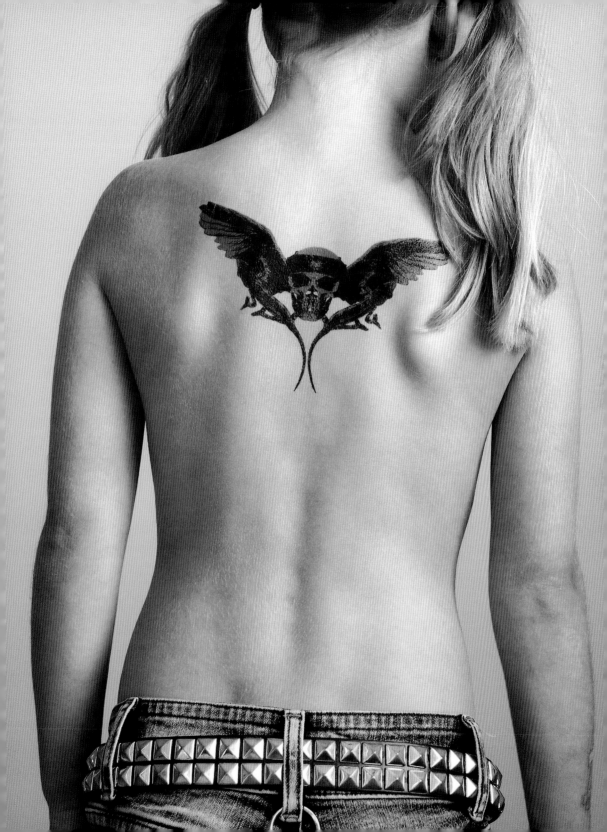

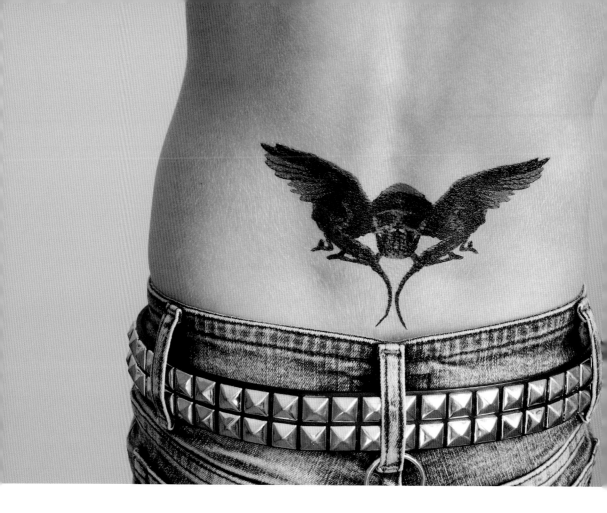

zion graphics

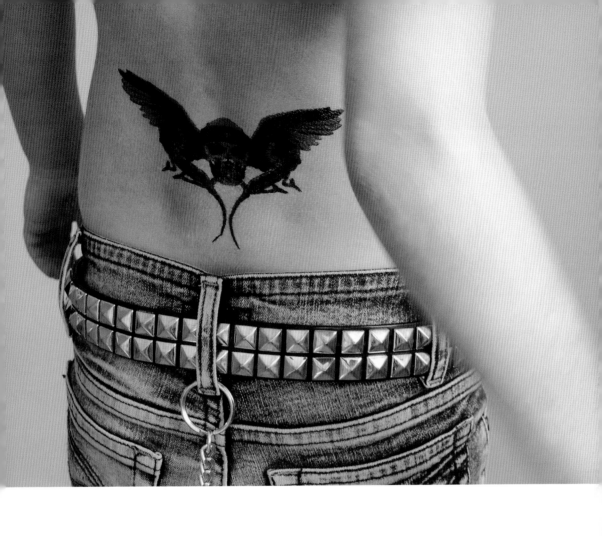

abcdef
ghijkl
mnopq
rstuvw
xyz,.+"
*ç%&/(
)=?!äö
üàéè_

Typechart
Bauer Bodoni Poster

acmilles greminger

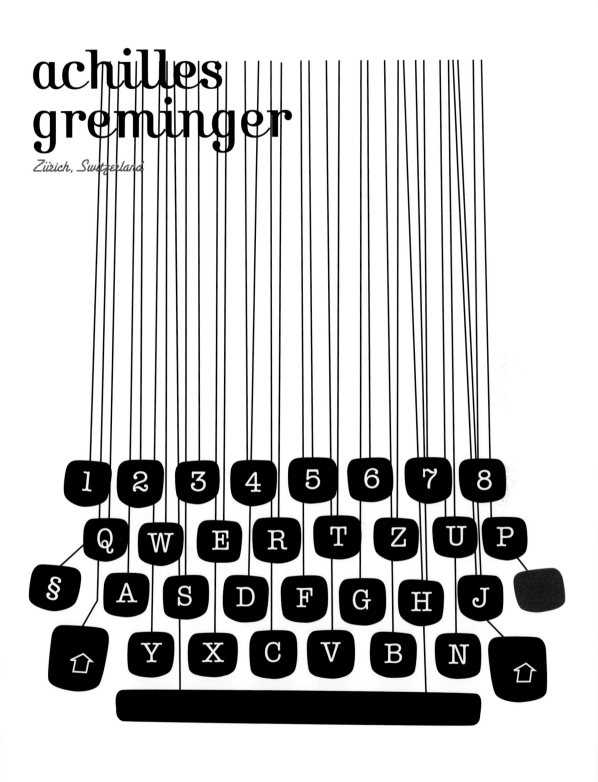

achilles greminger

Zürich, Switzerland

eighthourday

Minneapolis, Minnesota

Do you have any tattoos? What does tattoo mean to you?
Katie: I don't have any tattoos - I have issues with commitment.
Nathan: I've got a clean and minimal tattoo on my right bicep. It's five horizontal bars stacked vertically — sort of military-esque.

What is the first thing that comes to mind when you think of tattoos?
Katie: Personal style.
Nathan: Life experiences.

Where do you want to have your tattoo(s)? Why?
Katie: If I were to get one, it would be on the upper right arm.
Nathan: If I were to get another one, it would be on my lower back or right forearm.

Would you like to get your "tattoo icon" as a real tattoo? Why or why not?
Katie: Possibly "lionhead girl." This illustration holds personal meaning to me. It represents strength, humility, and the ability to overcome obstacles. Plus I think it could look pretty bad-ass.
Nathan: Since Katie designed the Tats and I photographed them, I guess I'll answer on behalf of Katie's illustrations. I too would consider "lionhead girl." I like the juxtaposition of the female figure in an overtly strong stance with crown and mane. If I were to get a tattoo I have designed, it would be my last name "Strandberg" set in Old English on my lower back.

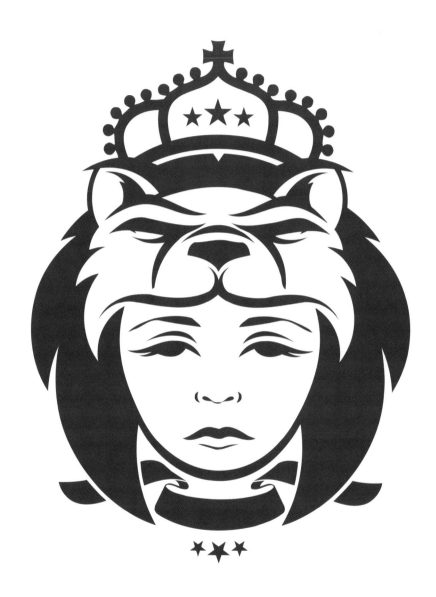

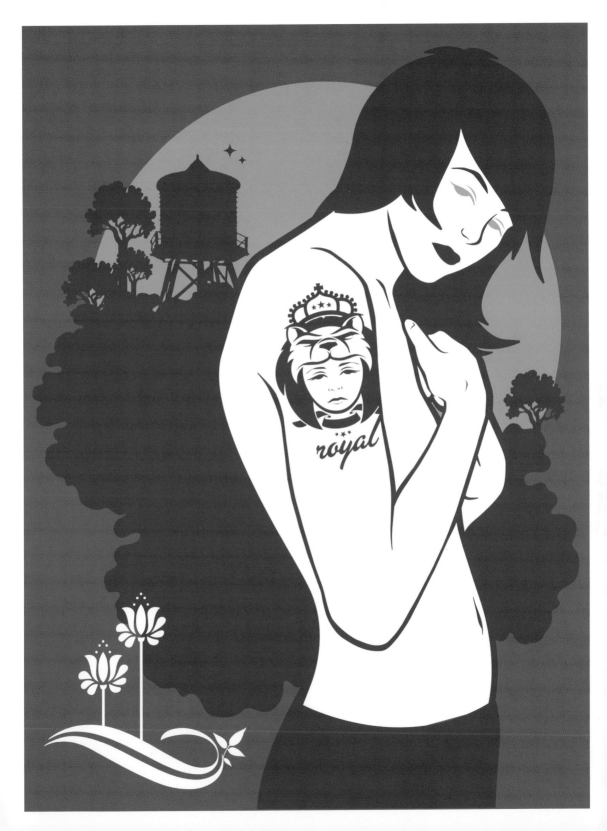

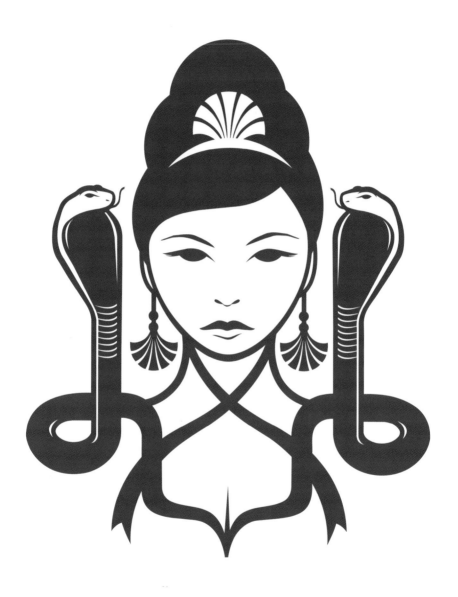

eighthourday

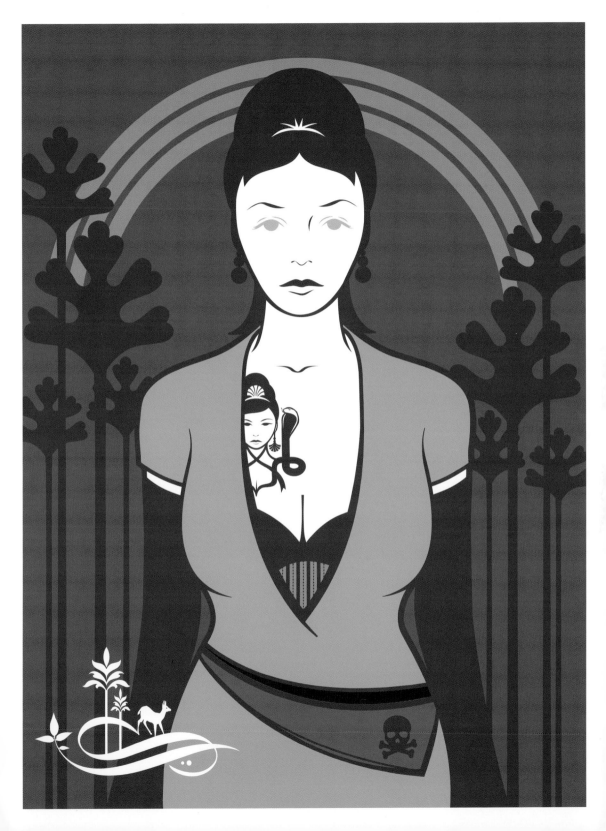

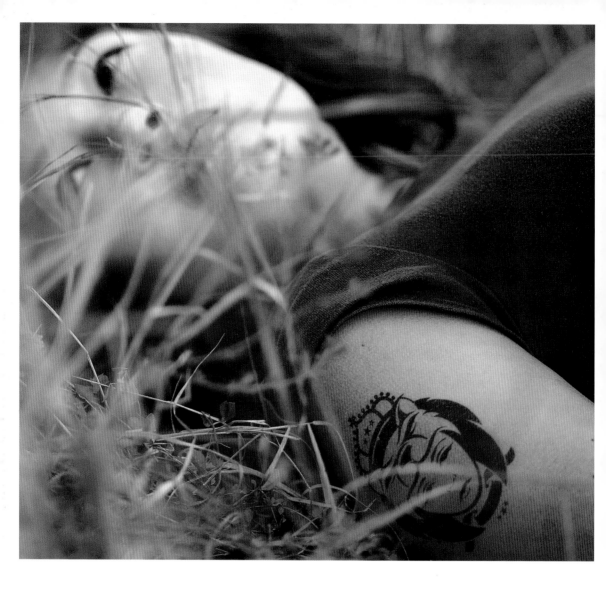

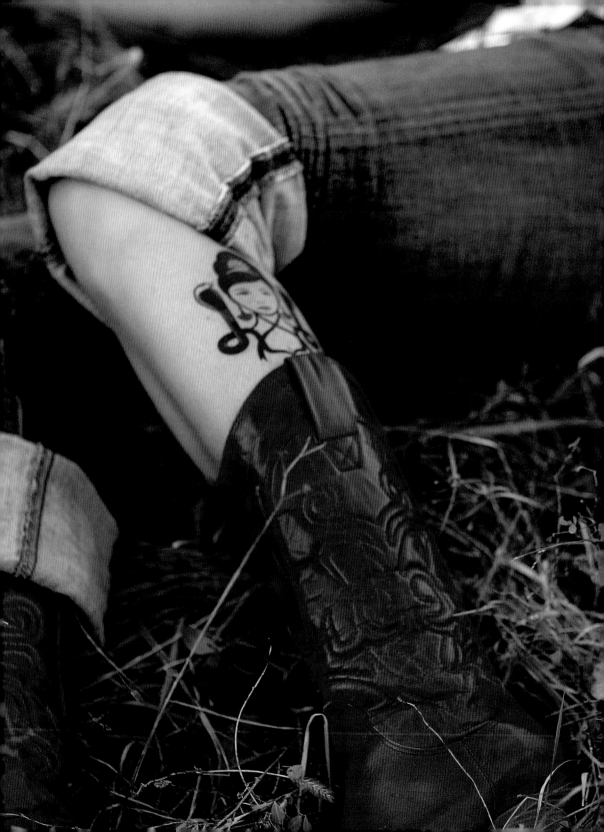

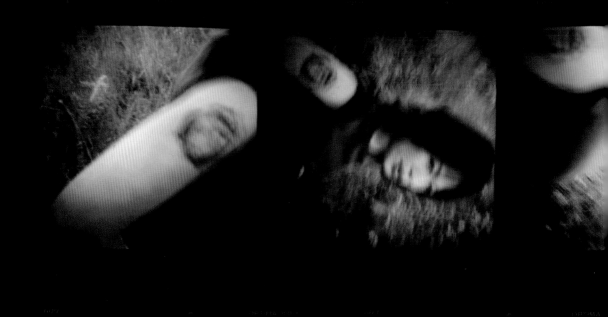

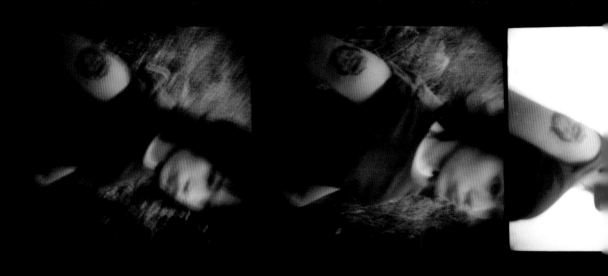

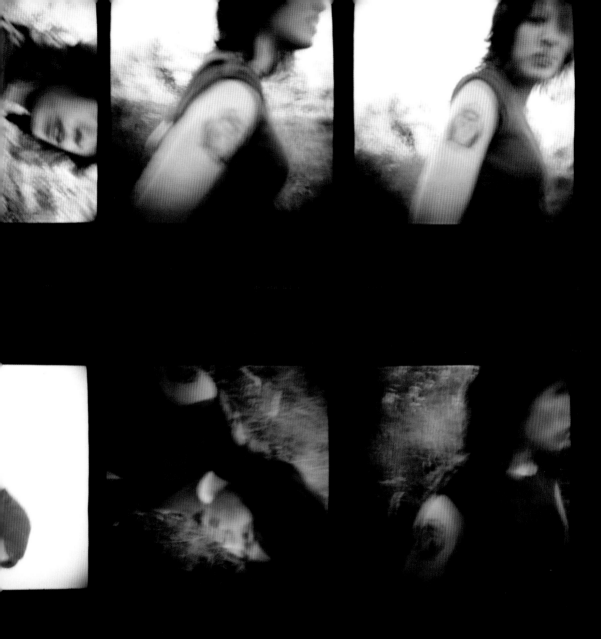

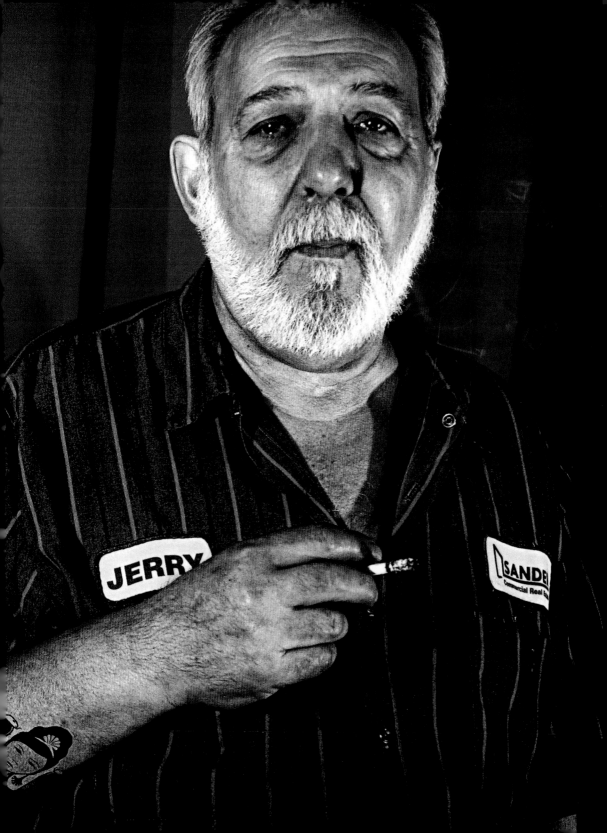

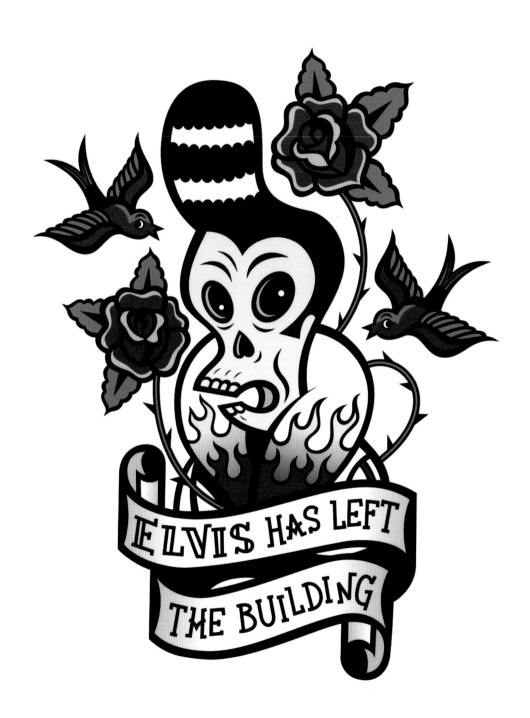

ELVIS HAS LEFT THE BUILDING

jorge alderete

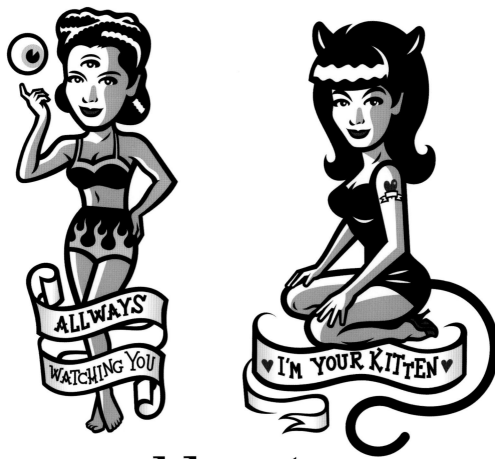

jorge alderete

Mexico City, Mexico

Do you have any tattoos? What does tattoo mean to you?
Yes, just one for the moment. For me, tattoo doesn't have bigger mystic meaning, neither does it represent something that has marked my life in a profound way. It has more to do with things that I like, and in a way it is just a decoration. Maybe more like an art form that I can always take with me.

What is the first thing that comes to mind when you think of tattoos?
Rock'n'roll!!

Where do you have your tattoo? Why?
I have my tattoo on my left arm. I don't know why.

Would you like to get your "tattoo icon" as a real tattoo? Why or why not?
Actually I have one of these old school tattoos on my arm, and I hope this is the first one of many more to come.

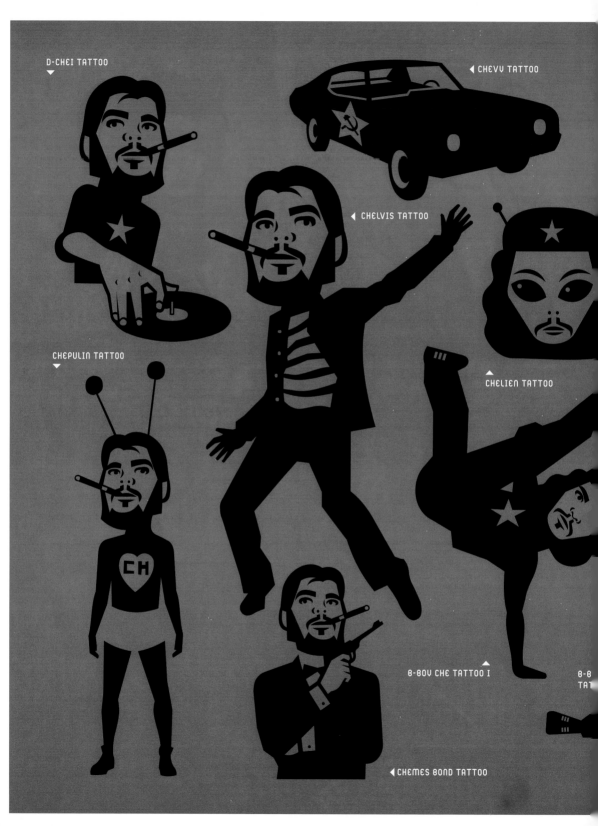

D-CHEI TATTOO

◀ CHEVU TATTOO

◀ CHELVIS TATTOO

CHEPULIN TATTOO

CHELIEN TATTOO

B-BOY CHE TATTOO I

B-B
TAT

◀ CHEMES BOND TATTOO

◄ MARIACHE TATTOO

CHESUS TATTOO ▼

◄ CHE FEVER TATTOO

CANABIS CHE TATTOO ▼

CHE TATTOO
COLLECTION
BY DR. ALDERETE

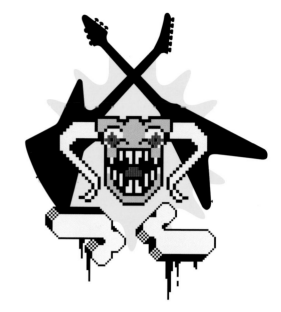

happypets

Lausanne, Switzerland

Do you have any tattoos? What does tattoo mean to you?

Yes, two of us have quite big tattoos. Patch has a whole arm tattooed in traditional Tibetan style, and Violene has a big Japanese koi fish on her back. We love tattoos — at least two of us do. We have a very famous tattoo shop here in Lausanne — it's the Leu family's iron, and we have been tattooed by the well-known tattoo artist Rinzing.

Cédric doesn't like the idea of having something permanent on his skin. He is worried he would get tired of it after a while. Tattoos have a strong personal meaning. It's a very personal approach. They each have a meaning that is different and corresponds to the personality. It is part of the process of choosing what you are going to tattoo on yourself. I couldn't tattoo something on myself that has no meaning to me.

What is the first thing that comes to mind when you think of tattoos?

What am I going to tattoo next?

Where do you have your tattoos? Why?

For Patch, on the whole body. Body suits are beautiful. For me, I would like to continue to have the whole back covered. I like the fact that it remains very private — hidden under clothes. And for a woman I think the whole body would be too much — a little flesh is nice.

Would you like to get your "tattoo icon" as a real tattoo? Why or why not?

No. We are really into traditional Japanese or Tibetan tattoos. We think that if it was a personal creation, we would be very critical of it and most of all in a couple of years we would think, "I shouldn't have done that like this." We would get tired of it. Traditional tattoos never age. They have something more — a symbolism that remains.

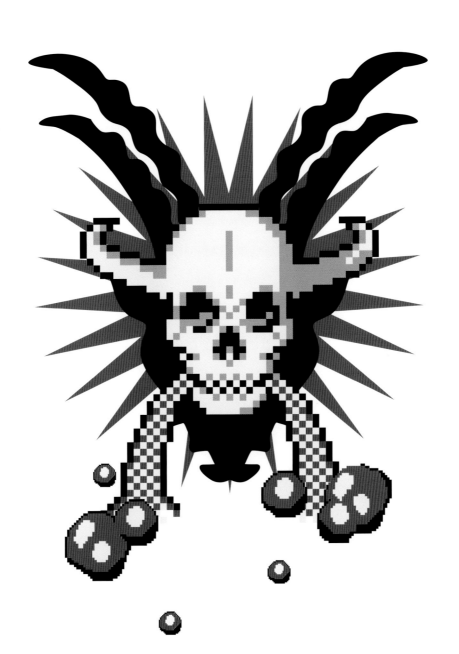

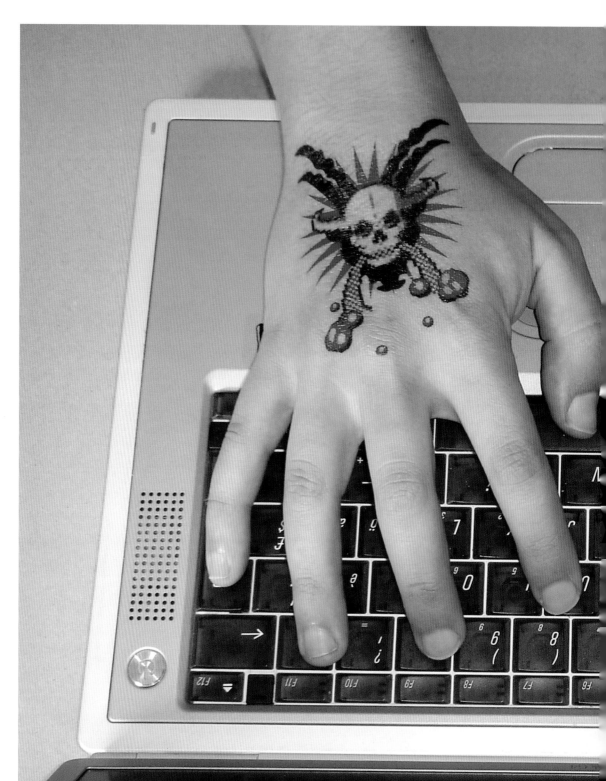

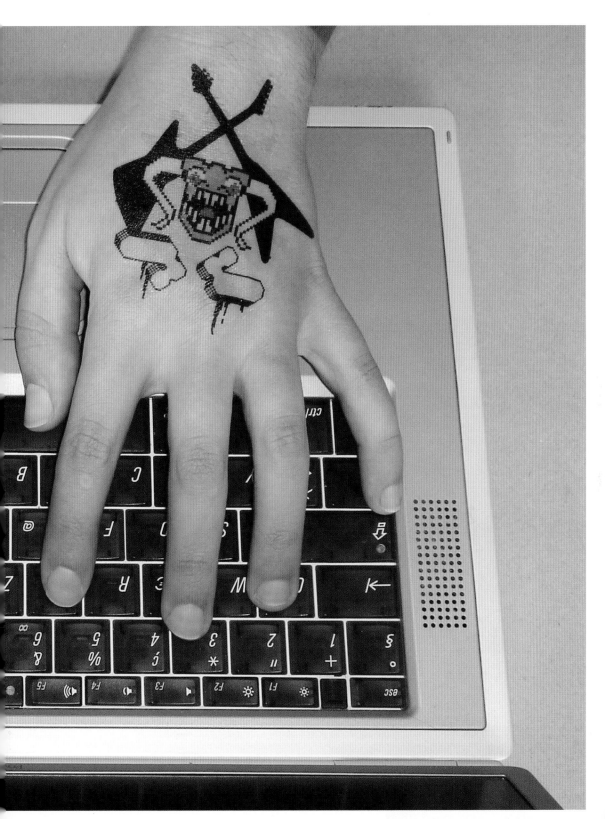

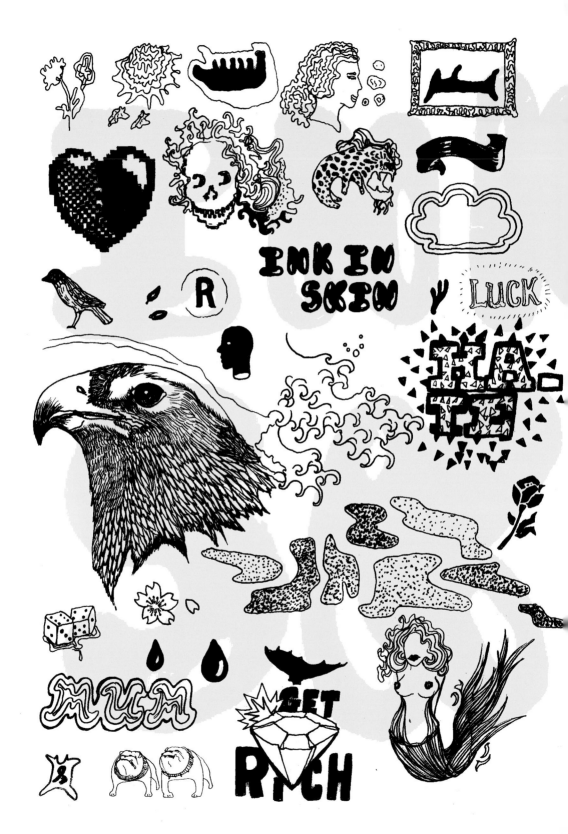

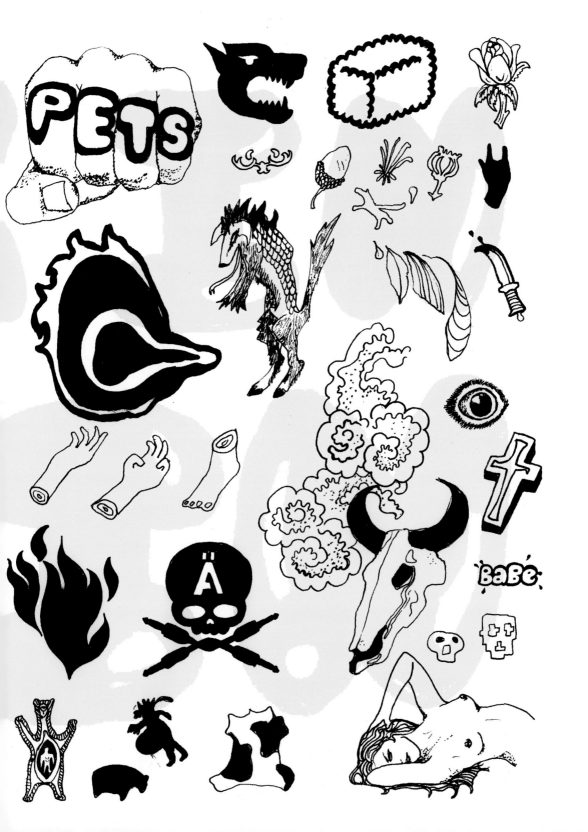

///colconex/valley///

KUNSTSPERBER KIRCHE

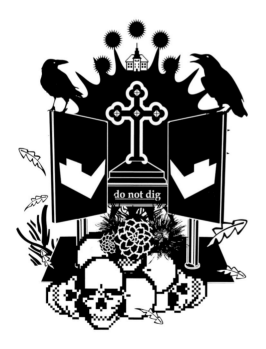

do not dig

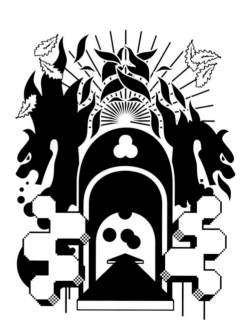

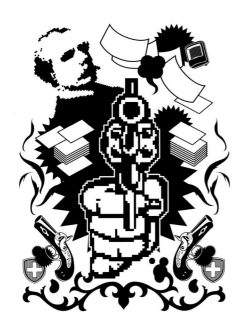
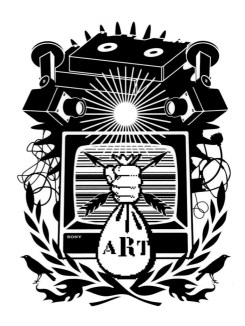
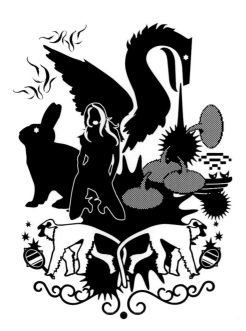
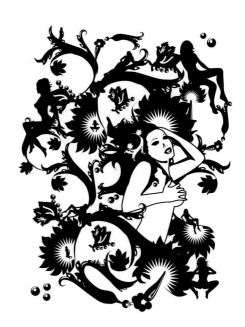

电解质的滴加

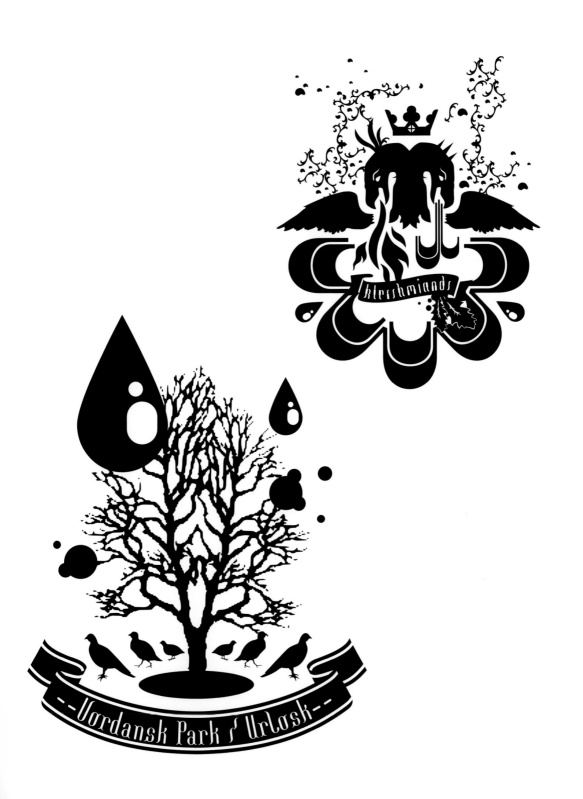

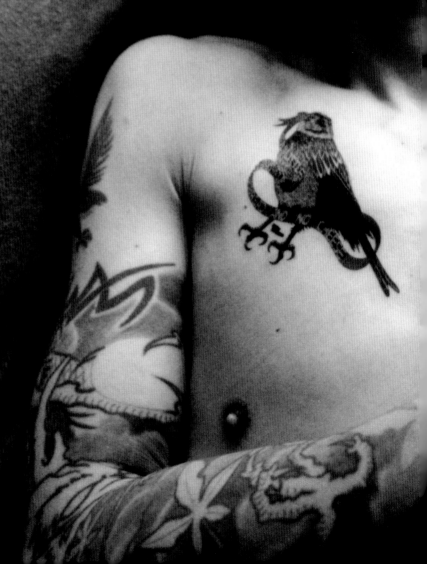

kabo

Tokyo, Japan

Do you have any tattoos? What does tattoo mean to you?
I have a birthmark shaped like a bird.

What is the first thing that comes to mind when you think of tattoos?
Time or memory.

Where do you have your tattoo? Why?
I hope someone gets my name tattooed on their body.

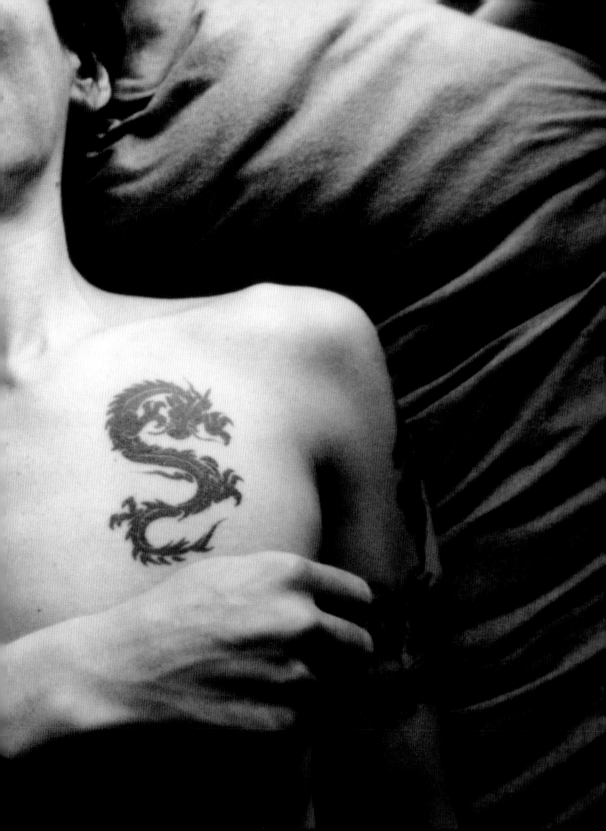

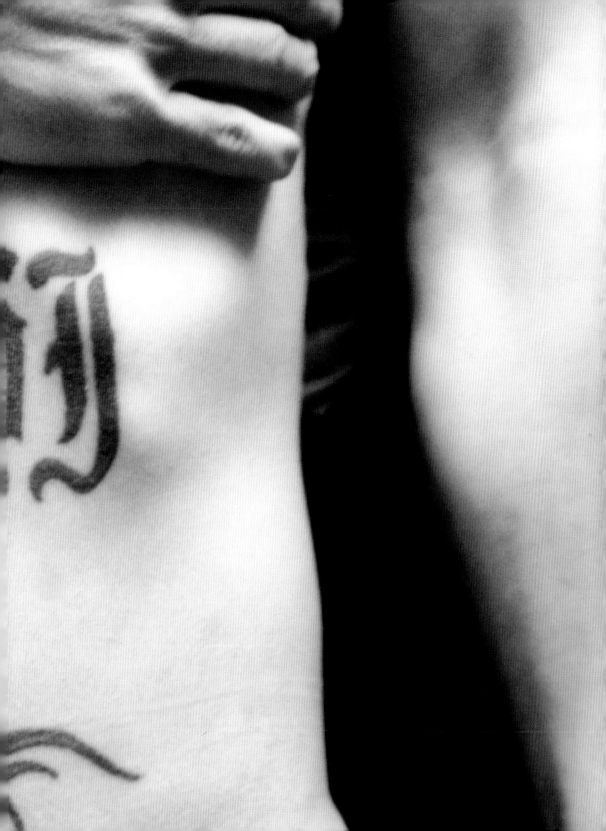

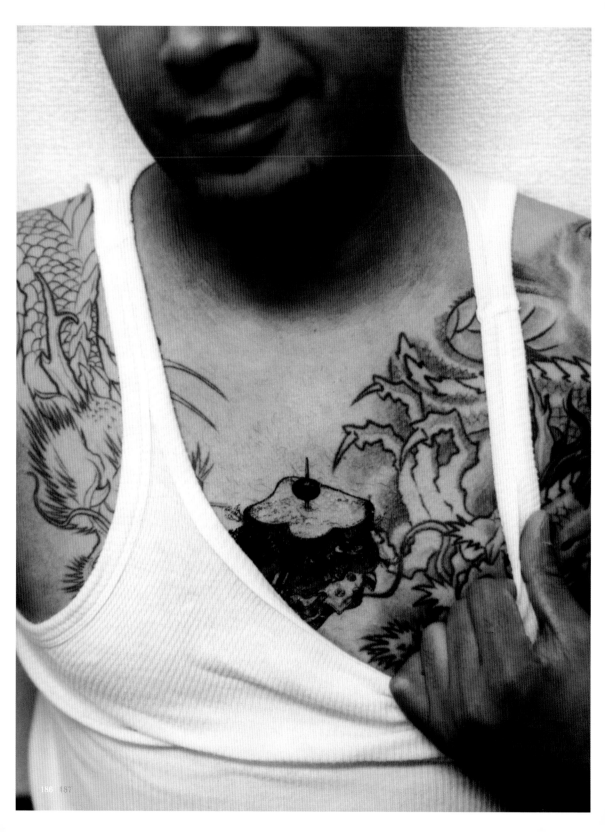

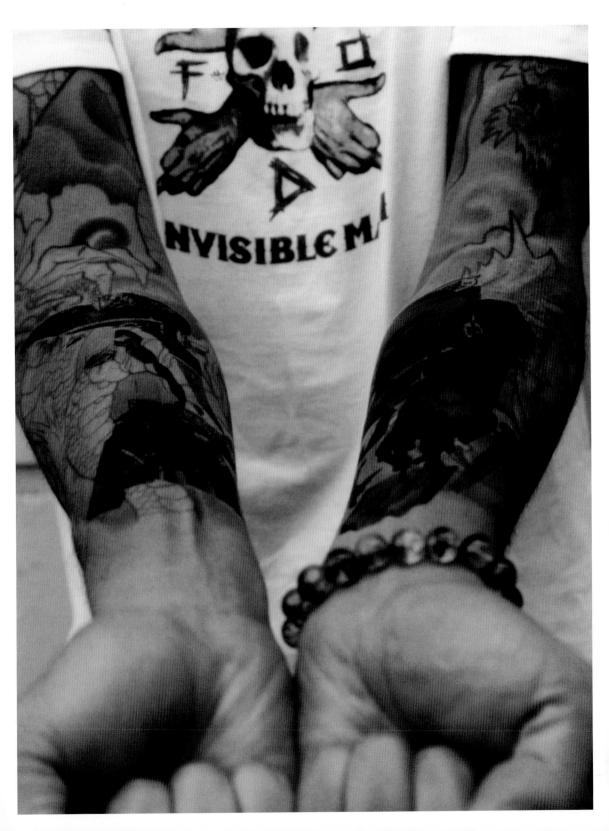

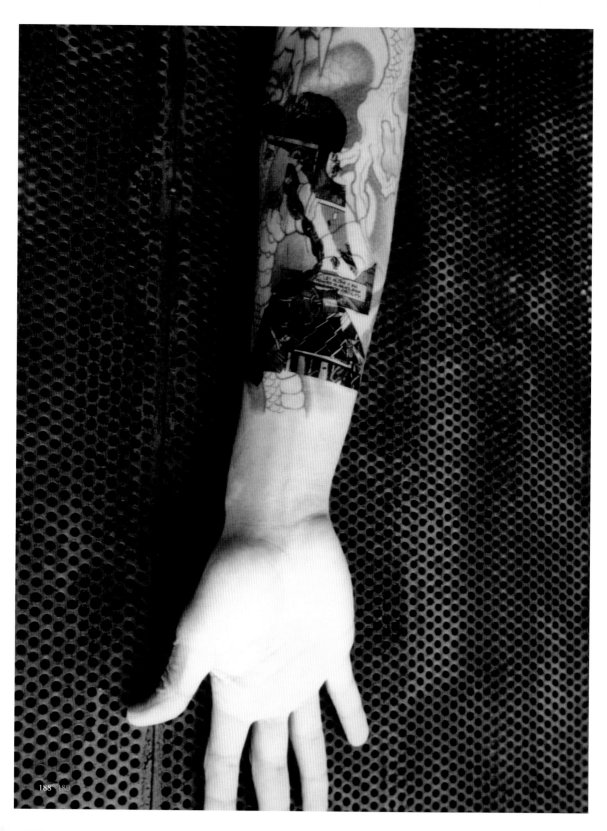

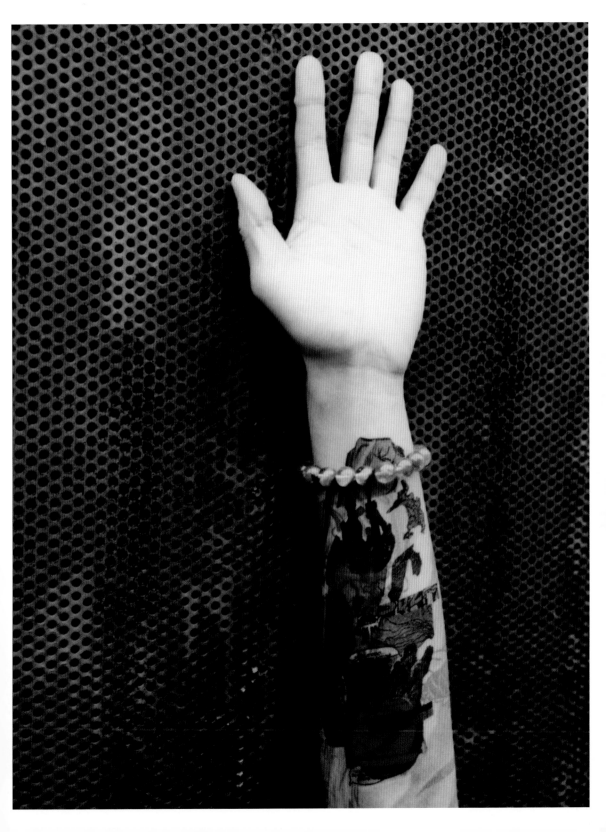

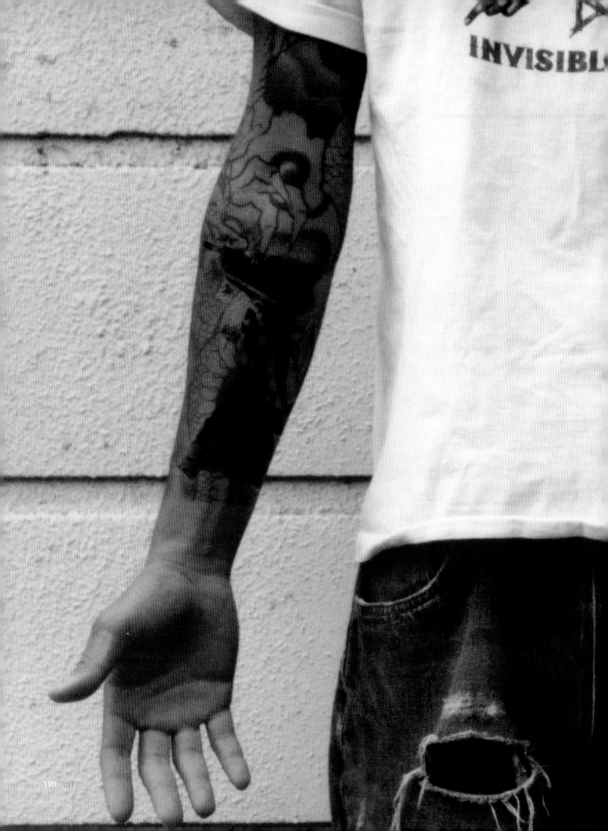

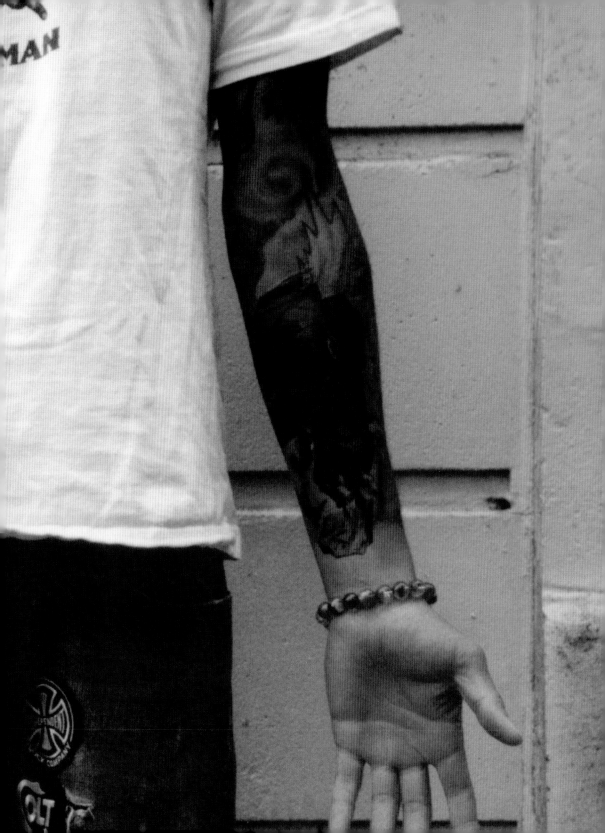

eddy so

Hong Kong, China

Do you have any tattoos? What does tattoo mean to you?
I have no tattoo on my body, but I think tattoo means experience.

What is the first thing that comes to mind when you think of tattoos?
Decoration on body.

Where do you want to have your tattoo(s)? Why?
If I have a tattoo on my shoulder, it must be fun for me.

Would you like to get your "tattoo icon" as a real tattoo? Why or why not?
I think my "tattoo icon" can't be a real tattoo on my body, because it's too complicated.
It must be painful.

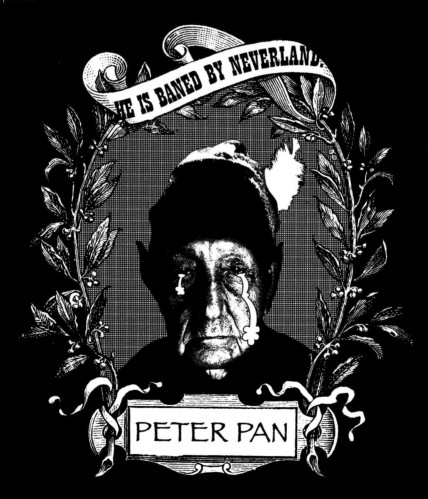

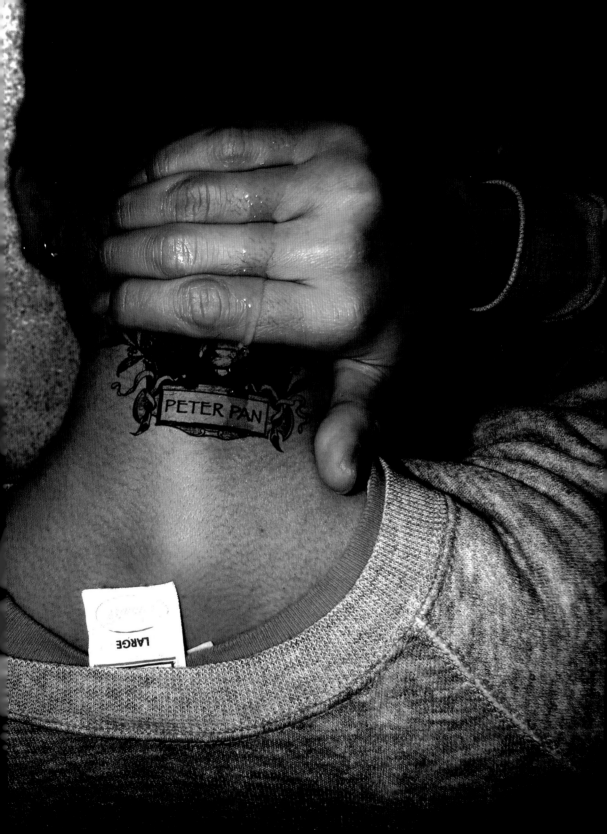

swigg

New York, New York

Do you have any tattoos? What does tattoo mean to you?
No, I do not have any tattoos.

What is the first thing that comes to mind when you think of tattoos?
I think rebellion, youth, adventure and its documentation. Tattoos for many tell the story of their lives — reminders of good times and bad.

Where do you want to have your tattoo(s)? Why?
I do not think I will ever get a tattoo. If I do, it will be towards the end of my life. The things that I think are the best keep on getting topped by even greater things. I would end up becoming "tattoo happy" and then run out of room.

Would you like to get your "tattoo icon" as a real tattoo? Why or why not?
If I had been insightful enough when I was in first grade to get a tattoo, this would have been it. I was the only girl able to land the kickball in the upper playground, and having this tattoo on my leg would have made me even more badass.

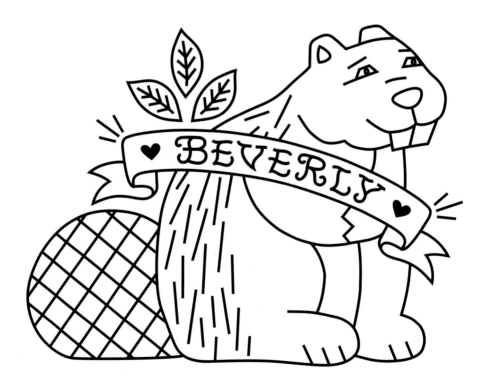

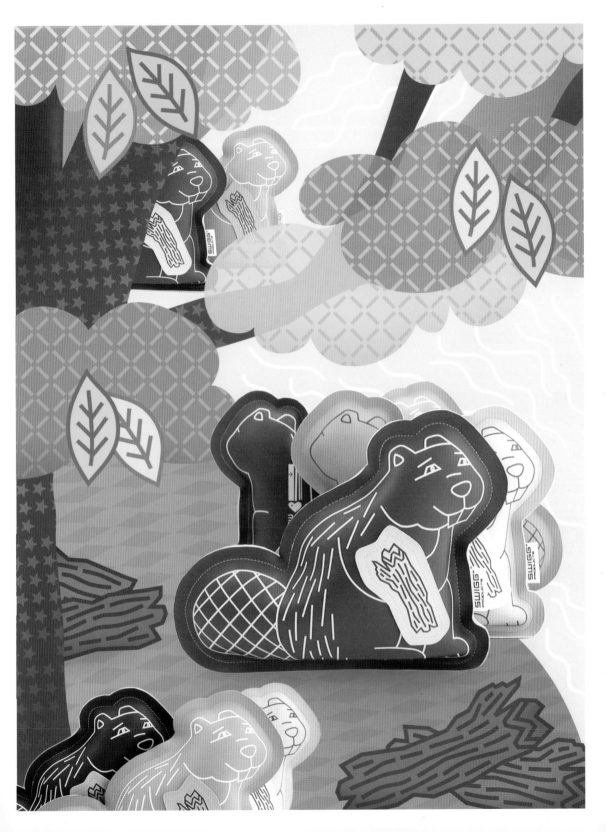

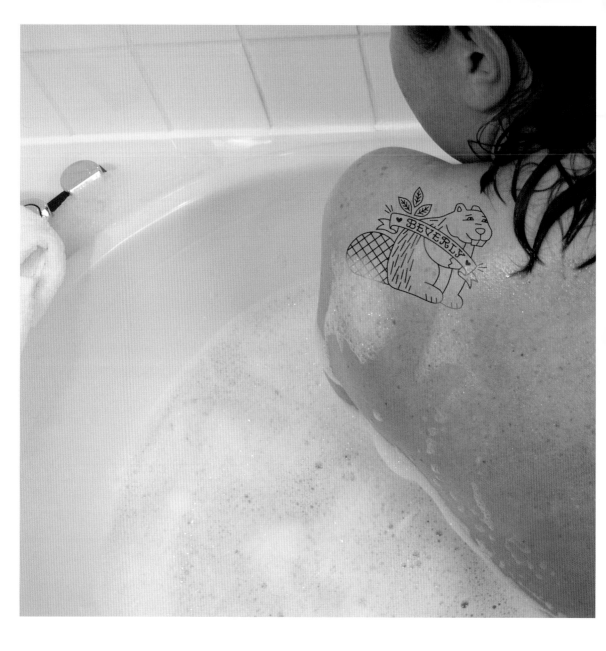

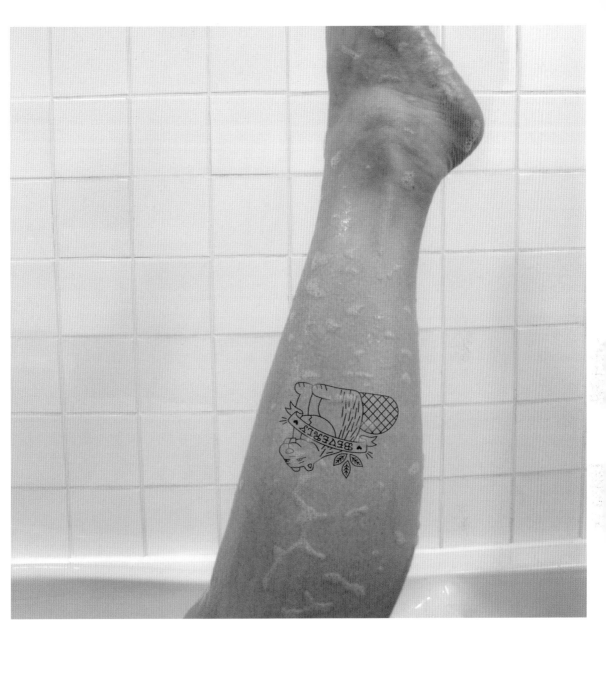

pill and pillow

Hong Kong, China

Do you have any tattoos? What does tattoo mean to you?
I don't have any tattoos. I think tattoo is a strong statement you make for yourself.

What is the first thing that comes to mind when you think of tattoos?
... (Honestly).

Where do you want to have your tattoo(s)? Why?
I would like to have it somewhere not noticeable, maybe on my back.

Would you like to get your "tattoo icon" as a real tattoo? Why or why not?
No. Although it is my work, it doesn't actually speak for my personality and belief. I have a fast-changing mind, so I will get tired of my tattoo very soon.

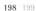

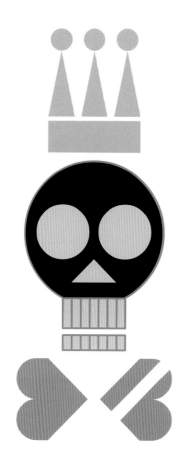

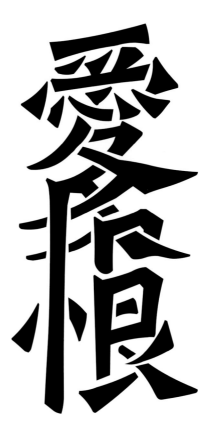

pill and pillow

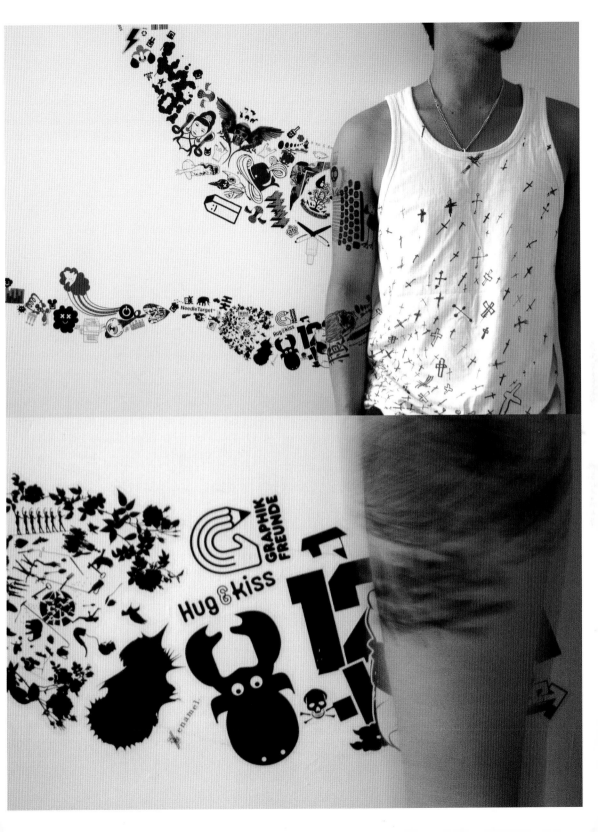

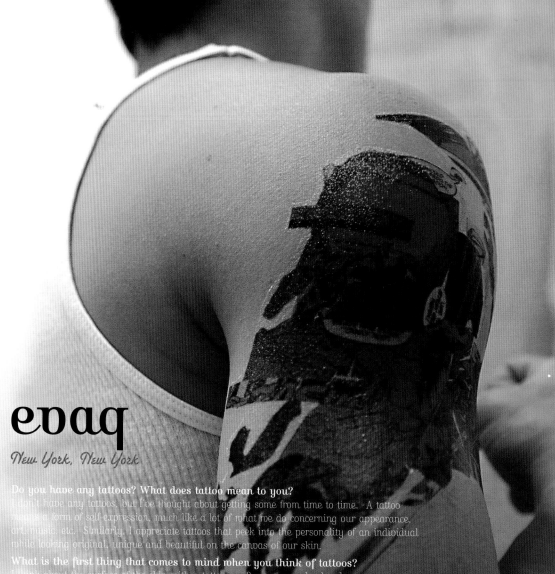

evaq

New York, New York

Do you have any tattoos? What does tattoo mean to you?
I don't have any tattoos, but I've thought about getting some from time to time. A tattoo means a form of self-expression, much like a lot of what we do concerning our appearance, art, music, etc. Similarly, I appreciate tattoos that peek into the personality of an individual while looking original, unique and beautiful on the canvas of our skin.

What is the first thing that comes to mind when you think of tattoos?
I think about the surface of the skin with a tattoo - soft, porous and colored.

Where do you want to have your tattoo(s)? Why?
I've always really liked "sleeves" - the tattoos that cover a person's arm in a collage of color and line. The ones I really like have a sense of flow and a "blanketing" of the arm where different images weave in and out to cover the arm from shoulder to forearm.

Would you like to get your "tattoo icon" as a real tattoo? Why or why not?
Actually, I designed a sleeve tattoo using comic book graphic shapes and imagery. I like how it came out very much. It paints a story. But to keep it as a tattoo for life, it would be a heavy decision!

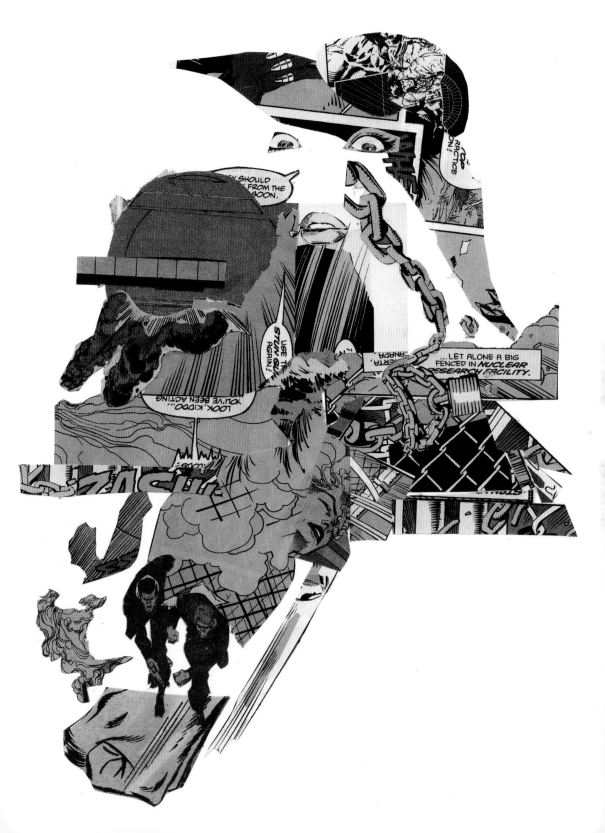

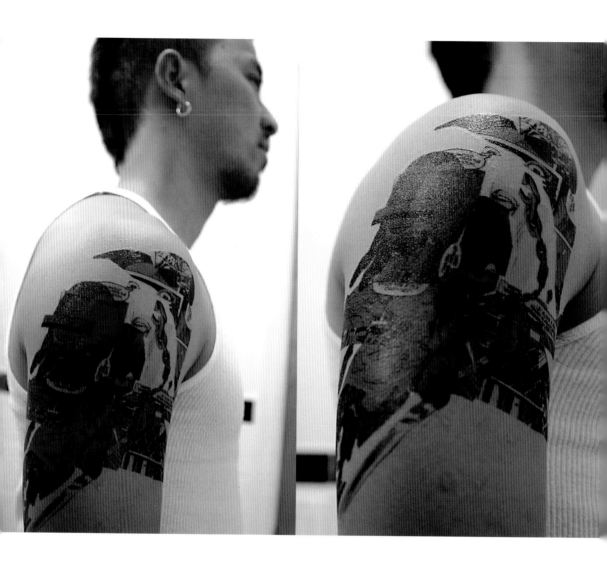

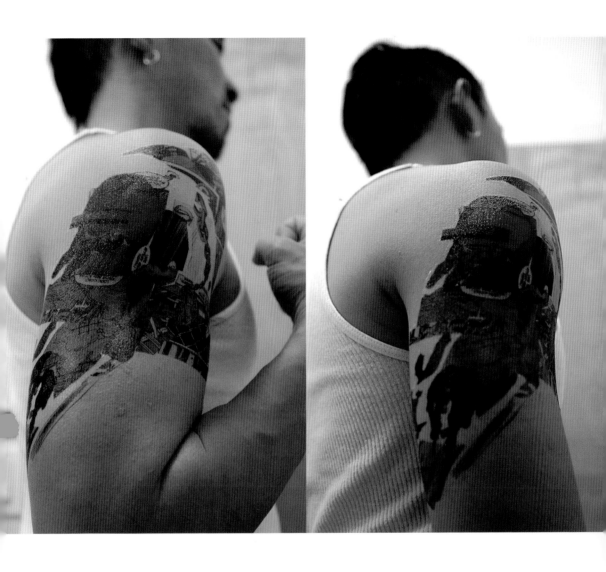

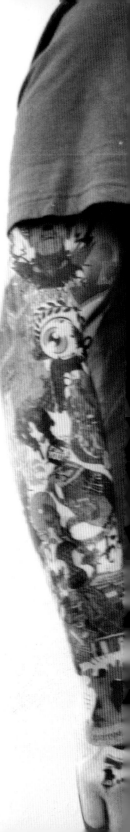

viction:design workshop

Hong Kong, China

Do you have any tattoos? What does tattoo mean to you?
Em, I do have fake ones sometimes, just for fun. But hard to tell if I might have the real
one someday. To me, tattoo means power, commitment and memory.

What is the first thing that comes to mind when you think of tattoos?
Tattoo Icons.

Where do you want to have your tattoo(s)? Why?
On my left butt (just kidding). I don't know yet.

Would you like to get your "tattoo icon" as a real tattoo? Why or why not?
No, fake is fun.

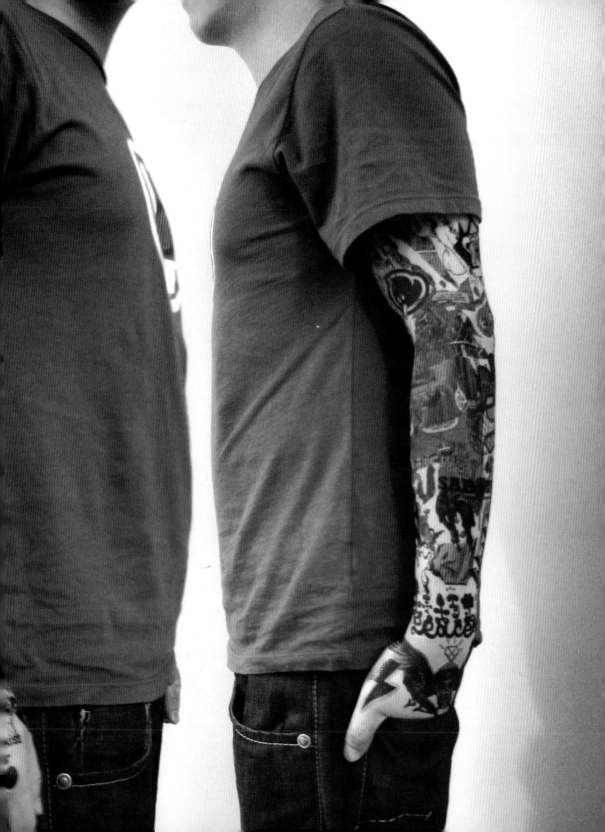

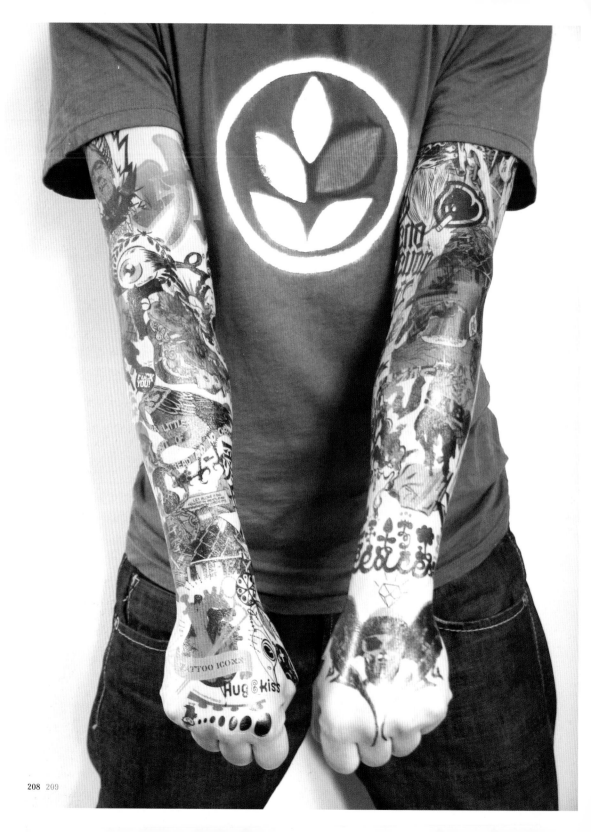

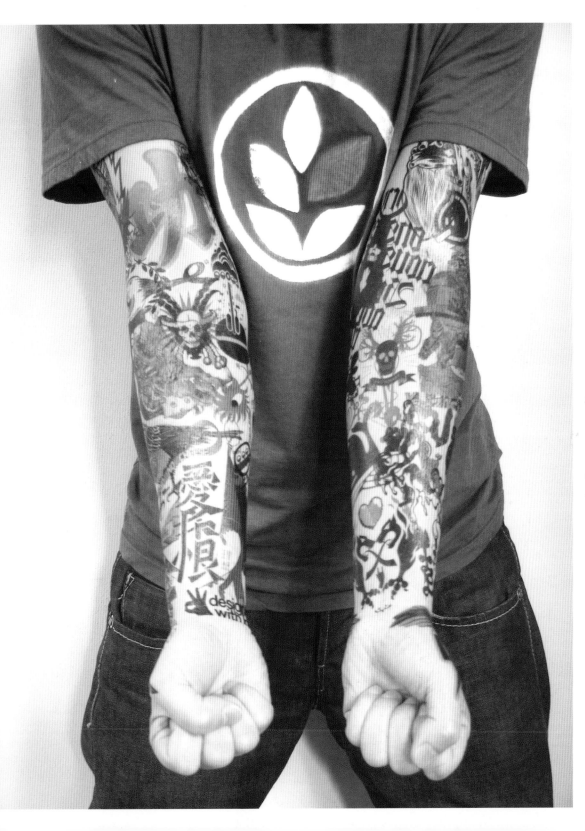

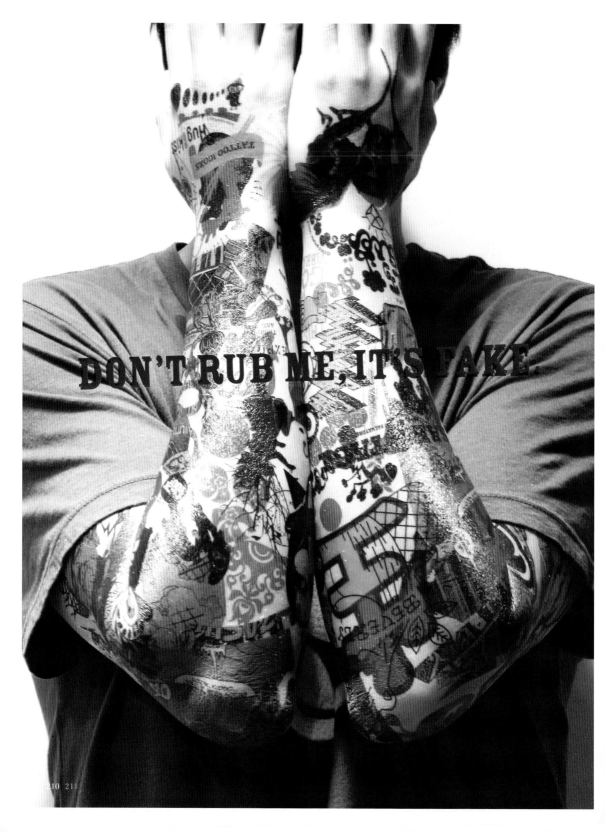

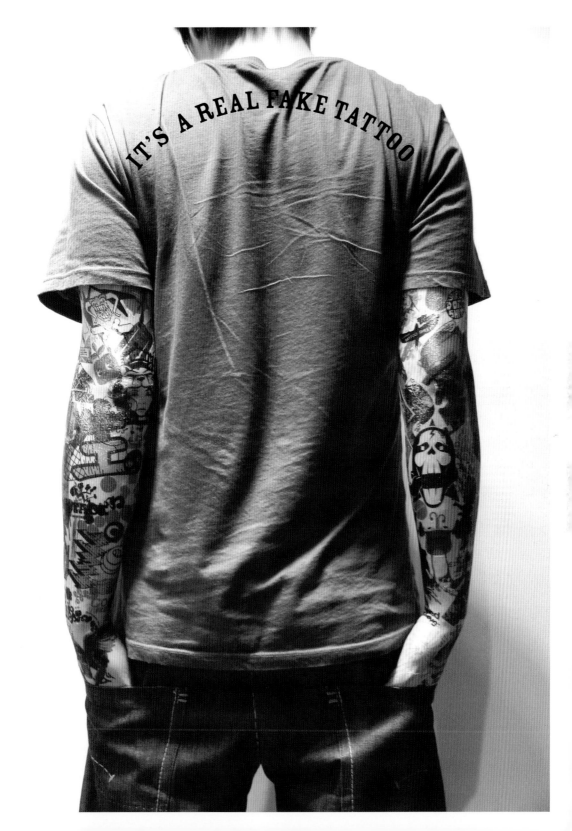

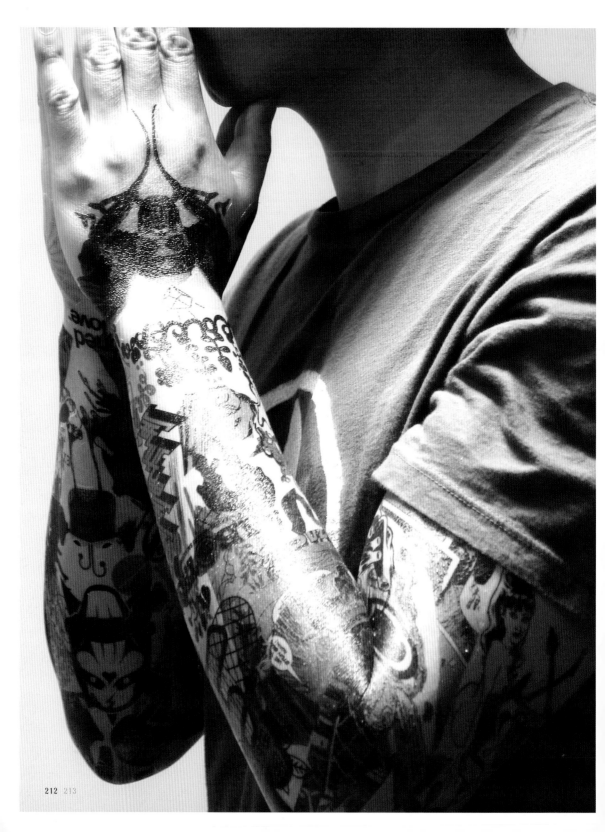

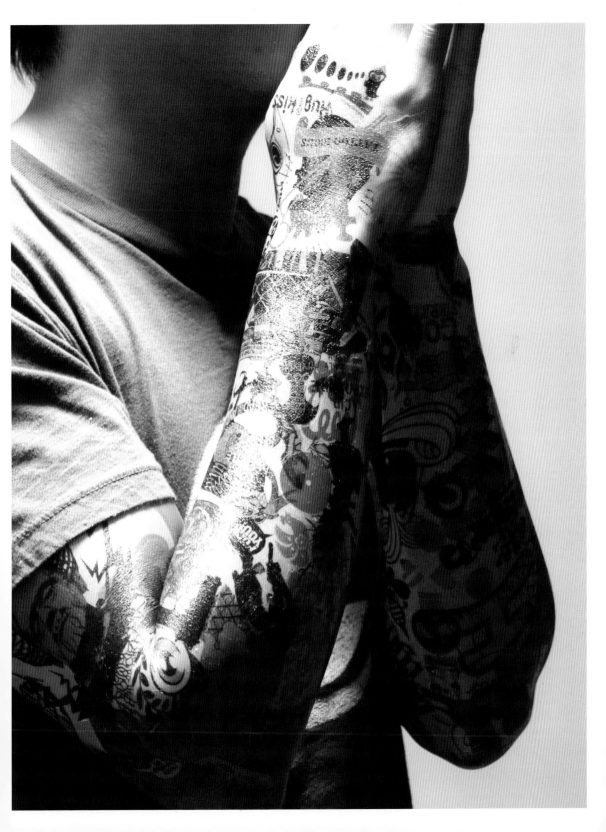

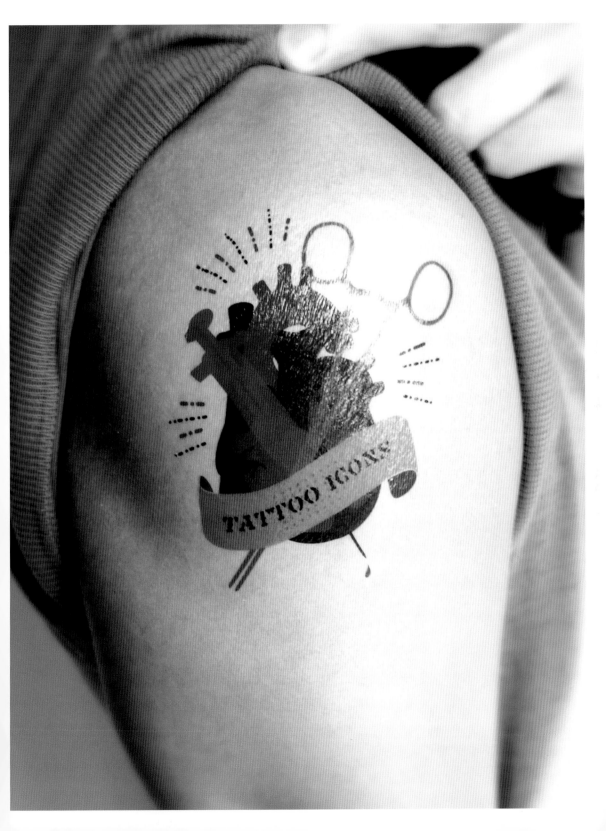

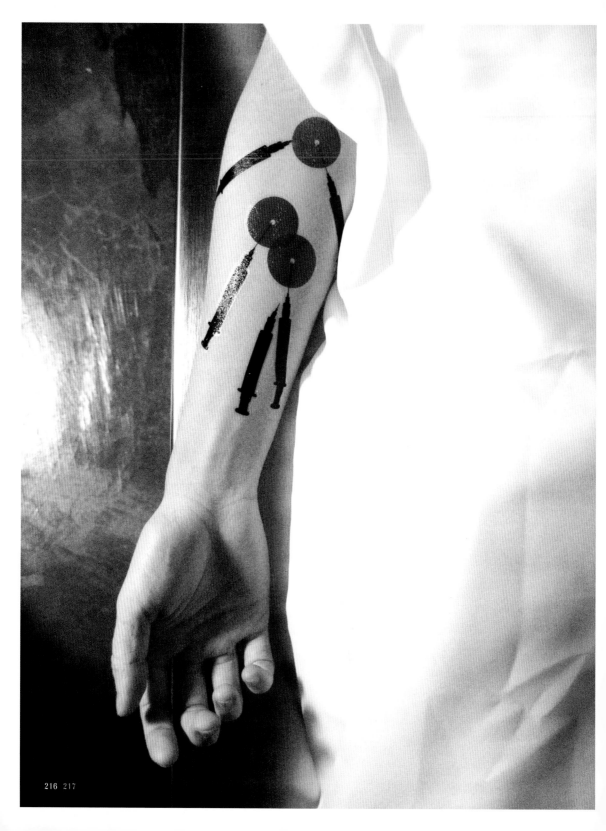

TATTOO ICONS

VICTIONARY

TATTOO ICONS 2006

martí guixé

Barcelona, Spain

Do you have any tattoos? What does tattoo mean to you?
No. It means decoration, fashion but not anymore.

What is the first thing that comes to mind when you think of tattoos?
They had a function, a practical purpose, but it is not present anymore. Through fashion, it has become a banal element.

Where do you want to have your tattoo(s)? Why?
At a place that works for function, but not for showing off.

Would you like to get your "tattoo icon" as a real tattoo? Why or why not?
No, only as a temporary one.

8 7 6 5 4 3 2 1 0

NOTES

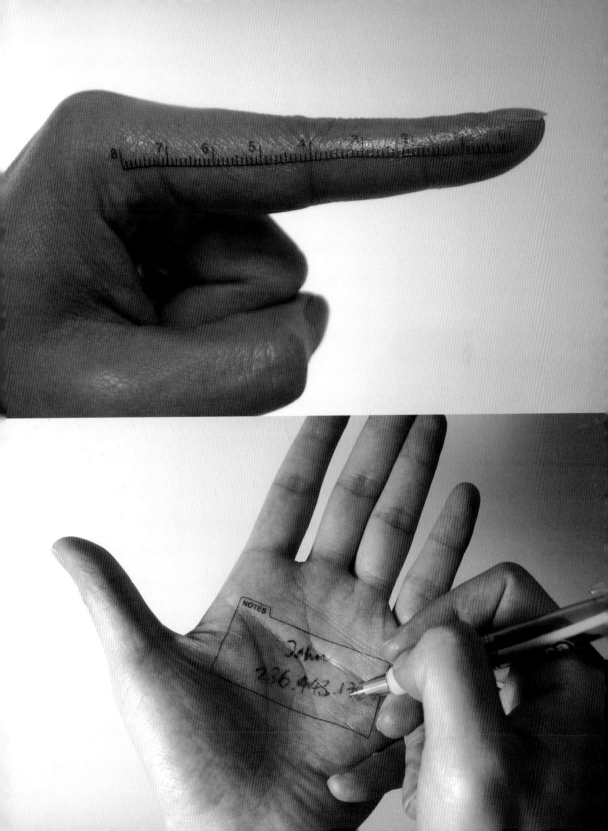

made

Oslo, Norway

Do you have any tattoos? What does tattoo mean to you?
We have one tattoo in the studio. The tattoo is fortunately well hidden.
It was a teenage "mistake." Somehow tattoo means history to us.

What is the first thing that comes to mind when you think of tattoos?
The first thing that comes to mind is sailors and ink.

Where do you have your tattoo? Why?
The tattoo is well hidden under clothes and only come out when the sun really shines.
is on the right side of the body.

Would you like to get your "tattoo icon" as a real tattoo? Why or why not?
We would not like to get our tattoo icons. Our tattoo icons are made for office workers
that love their job.

Coffee Before Dishonour

9 to 5 for life

Death Before Paperjam

made

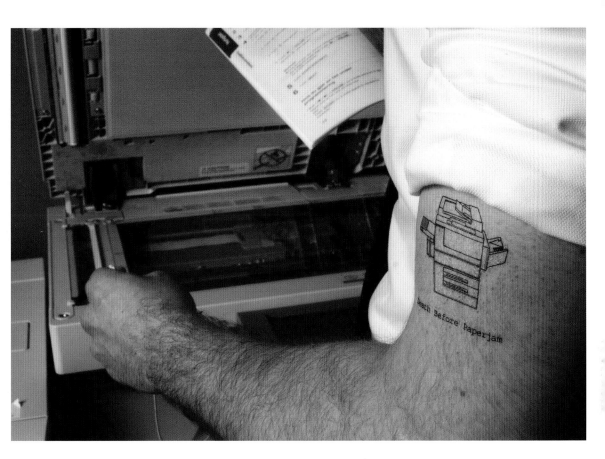

No Body
On Copy

made

Machine
Please

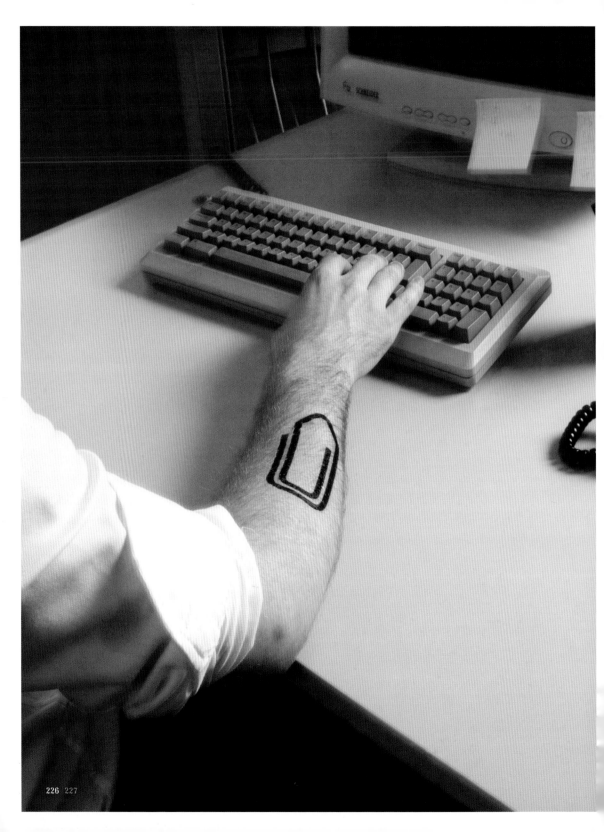

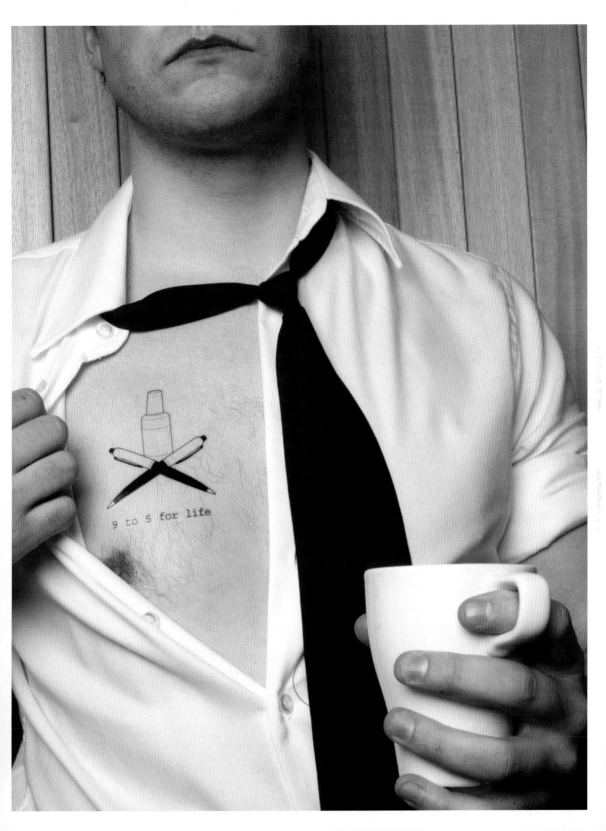

sweden graphic

Stockholm, Sweden

Do you have any tattoos? What does tattoo mean to you?
No, I don't have any tattoos. I think tattoos are a bit embarrassing.

What is the first thing that comes to mind when you think of tattoos?
People who star in reality shows.

Where do you want to have your tattoo(s)? Why?
I don't really think I want any tattoos.

Would you like to get your "tattoo icon" as a real tattoo? Why or why not?
The idea of our tattoo system is that you can build your own tattoo pattern out of the modules. Therefore it wouldn't really work as a real tattoo.

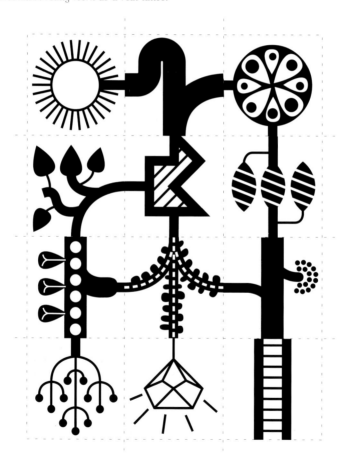

CUT ALONG LINES
COMPOSE YOUR UNIQUE
∷ SWEDEN GRAPHICS TATOO

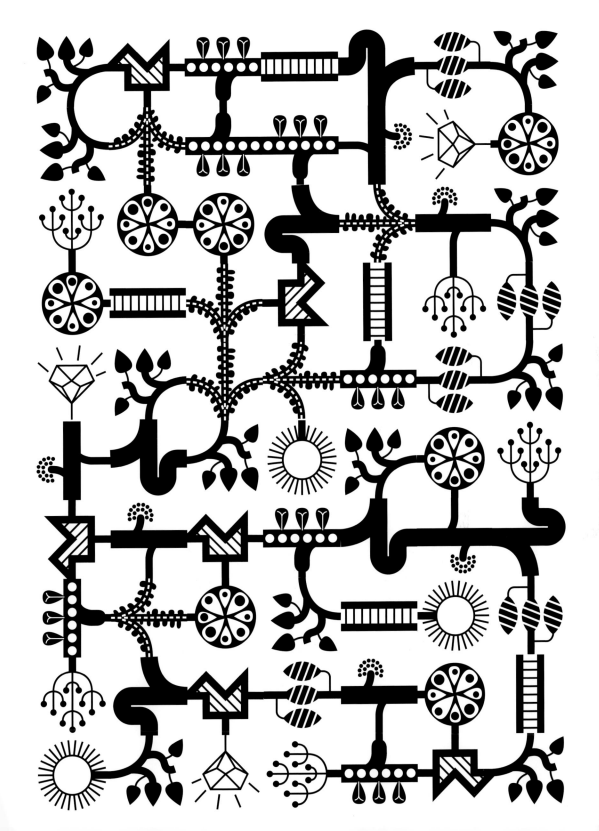

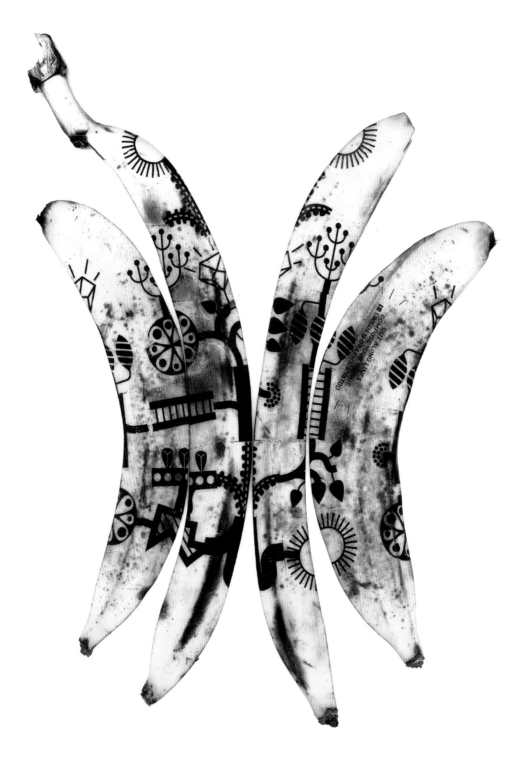

sweden graphic

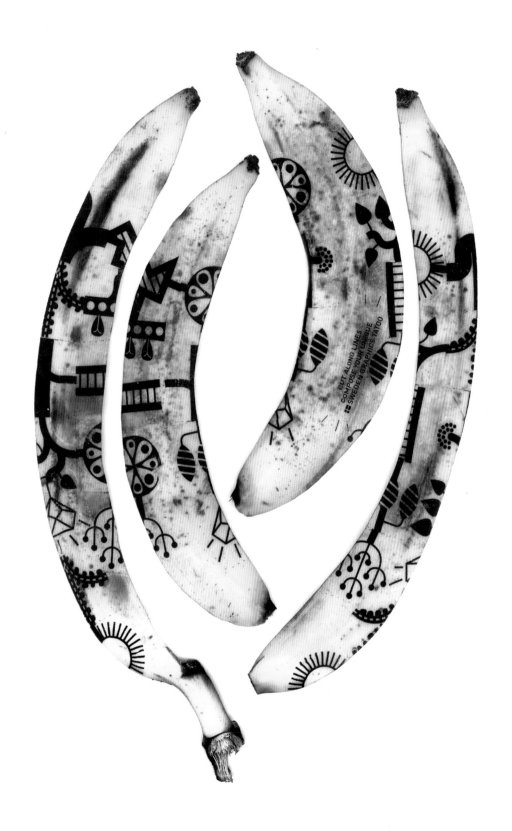

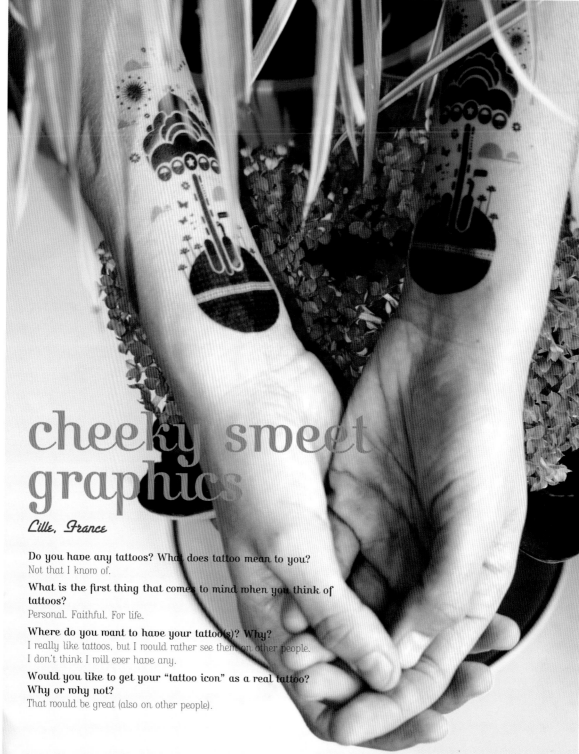

cheeky sweet graphics

Lille, France

Do you have any tattoos? What does tattoo mean to you?
Not that I know of.

What is the first thing that comes to mind when you think of tattoos?
Personal. Faithful. For life.

Where do you want to have your tattoo(s)? Why?
I really like tattoos, but I would rather see them on other people. I don't think I will ever have any.

Would you like to get your "tattoo icon" as a real tattoo? Why or why not?
That would be great (also on other people).

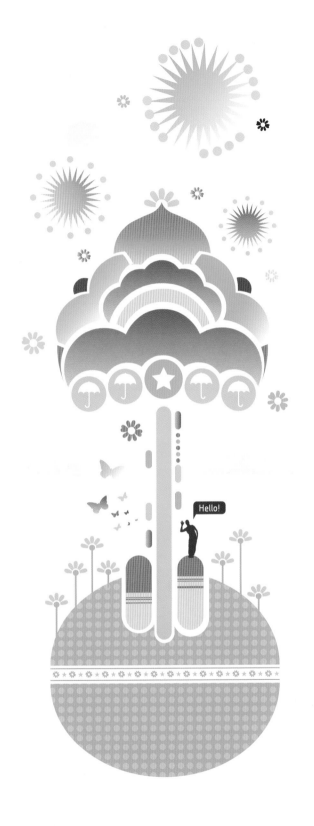

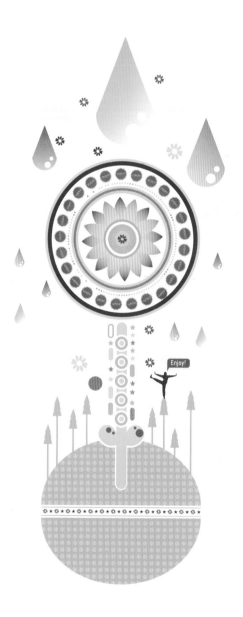
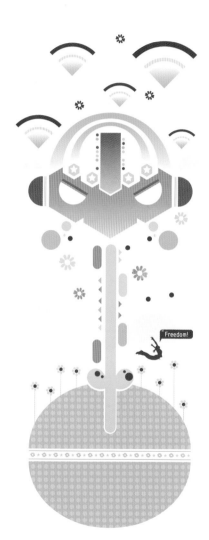

Enjoy!

Freedom!

cheeky sweet graphics

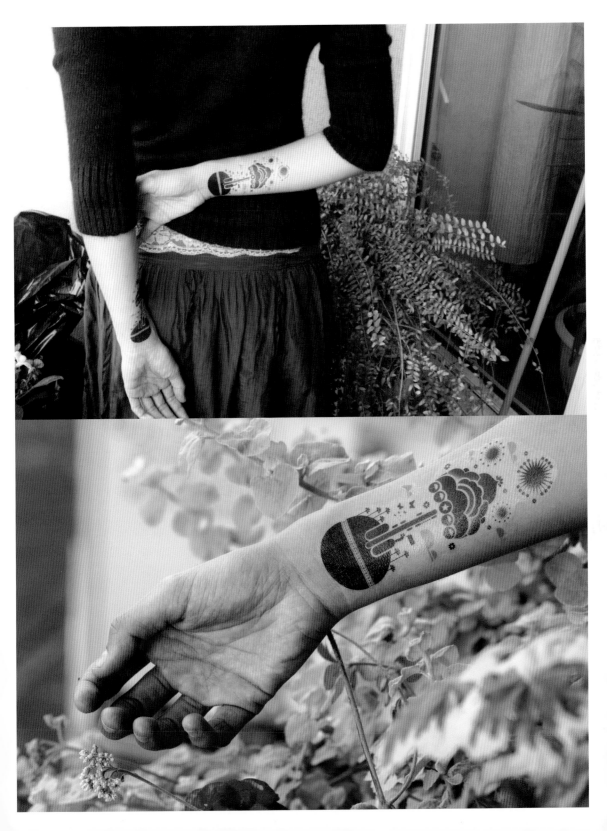

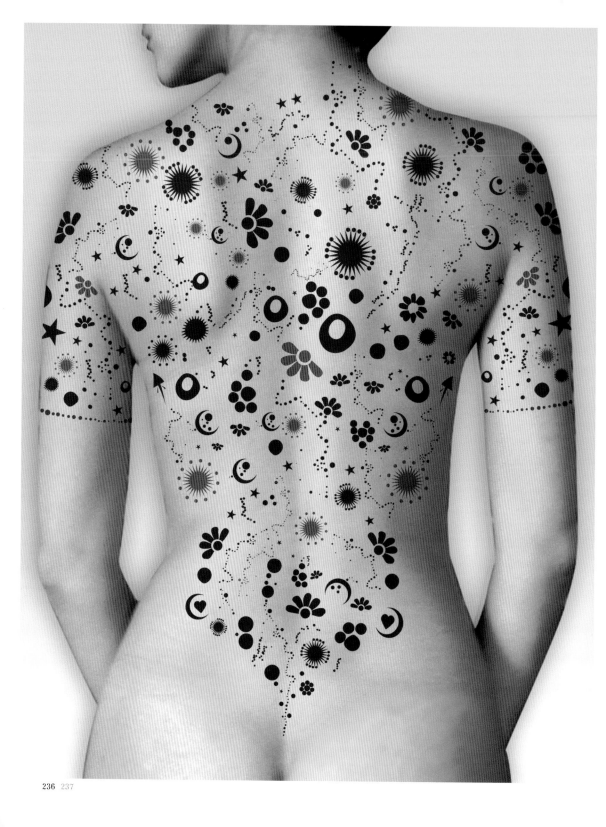

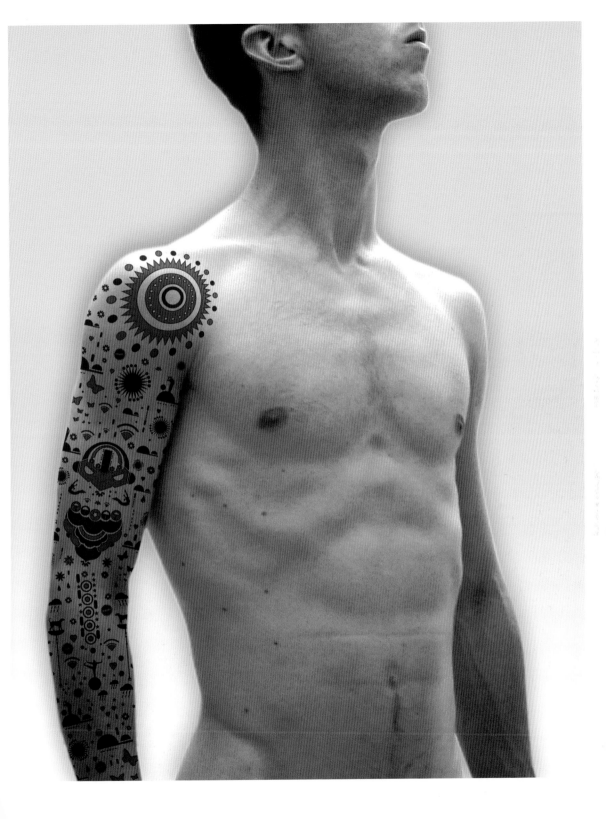

lee misenheimer

New York, New York

Do you have any tattoos? What does tattoo mean to you?
I have a Japanese dragon sleeve on my right arm. For me, it represents a mark of time or place or frame of mind. It also brings me good luck.

What is the first thing that comes to mind when you think of tattoos?
Beauty as well as story.

Where do you want to have your next tattoo(s)? Why?
I would definitely like to get my left arm sleeved as well as getting some work on my chest and neck. As far as why I want these? Not really sure – just because maybe.

Would you like to get your "tattoo icon" as a real tattoo? Why or why not?
Maybe. I think a large "sandwich" piece on my back or perhaps covering my stomach would be very funny!

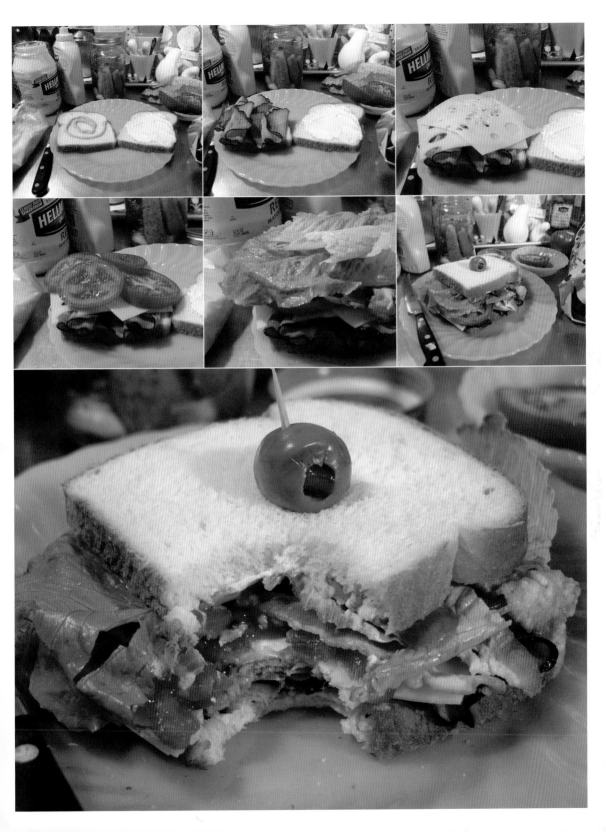

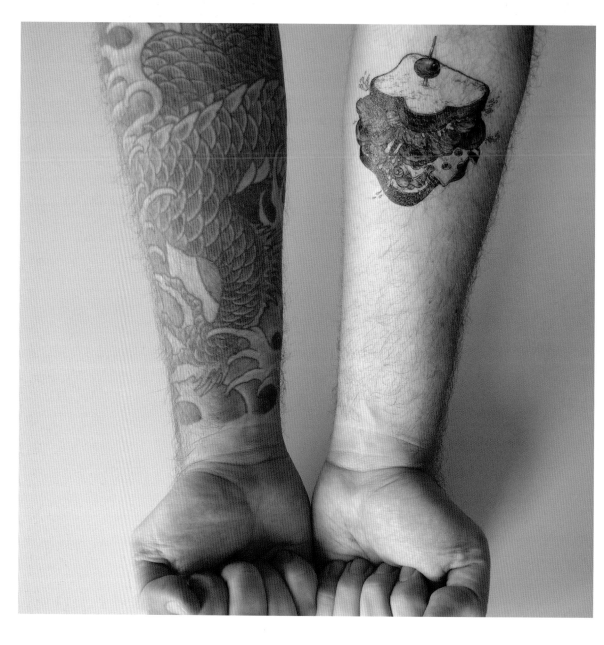

lee misenheimer

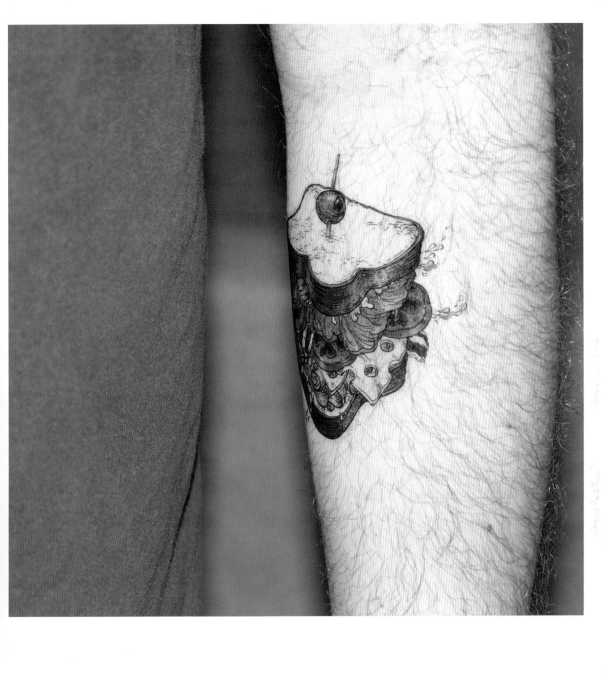

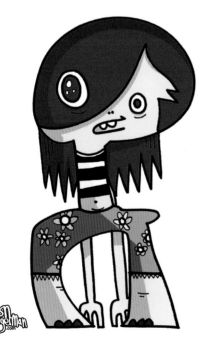

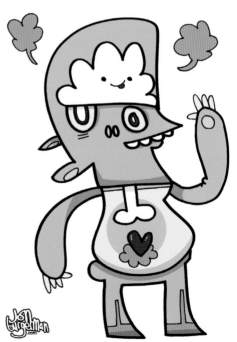

jon burgerman

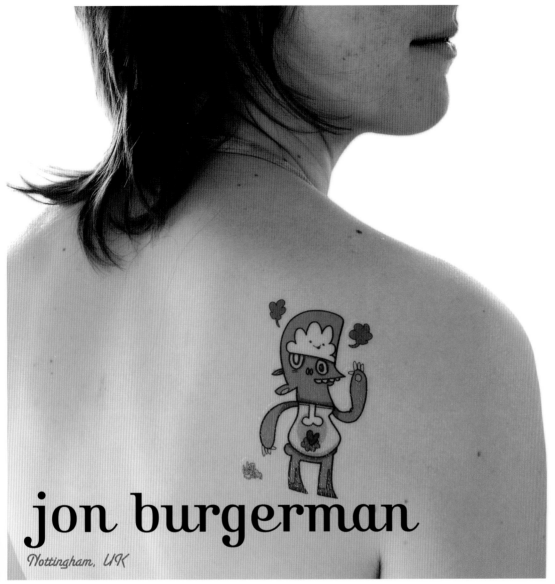

jon burgerman

Nottingham, UK

Do you have any tattoos? What does tattoo mean to you?
No. To me, it means great potential pain.

What is the first thing that comes to mind when you think of tattoos?
Snakes, serpents and limbless lizards, curved and knotted around leather-clad maidens positioned aloft giant motorcycles.

Where do you want to have your tattoo(s)? Why?
I'm not sure I want a tattoo. I'd never be able to choose what to get. I have enough trouble deciding what sort of sandwich to eat at lunch. Whatever I choose I would always lament the ones I didn't go for. Permanence is a big commitment, and I'm not sure I'm really ready for it.

Would you like to get your "tattoo icon" as a real tattoo? Why or why not?
I'd be happy for someone else to have it if they like. Some people already have tattoos of my work, which I think is both crazy and cool.

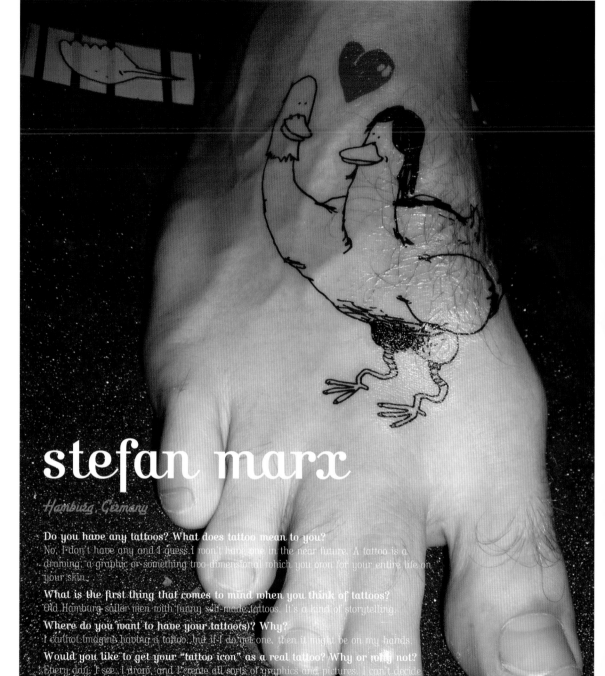

stefan marx

Do you have any tattoos? What does tattoo mean to you?
No, I don't have any and I guess I won't have one in the near future. A tattoo is a
drawing, a graphic or something two-dimensional which you own for your entire life on
your skin.

What is the first thing that comes to mind when you think of tattoos?
Old Hamburg sailor men with funny self-made tattoos. It's a kind of storytelling.

Where do you want to have your tattoo(s)? Why?
I cannot imagine having a tattoo, but if I do get one, then it might be on my hands.

Would you like to get your "tattoo icon" as a real tattoo? Why or why not?
Every day, I see, I draw, and I create all sorts of graphics and pictures. I can't decide
on which one to have on my skin; one that I hope to see every day. My thoughts on my
perfect picture change nearly every day. Maybe, when I find the picture, I will tattoo it
on my skin, but I don't think it's likely.

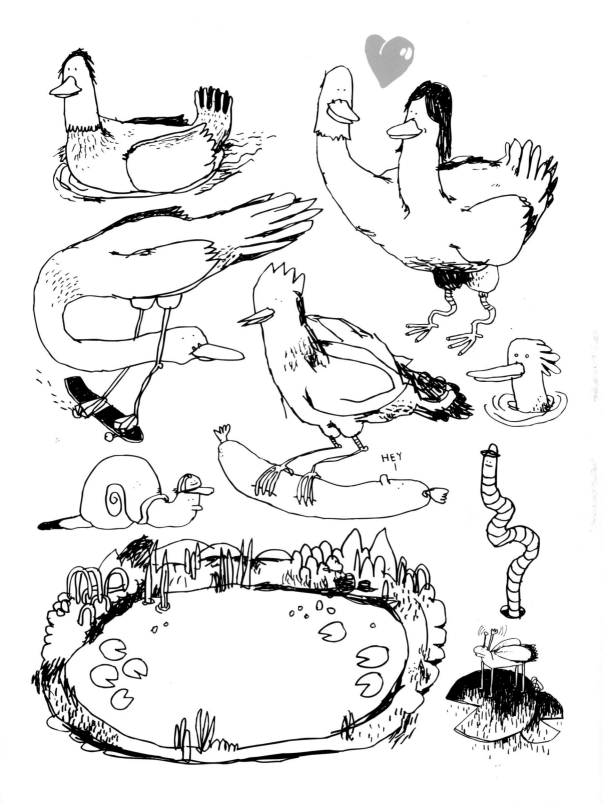

HEY

FOREVER

TOGETHER

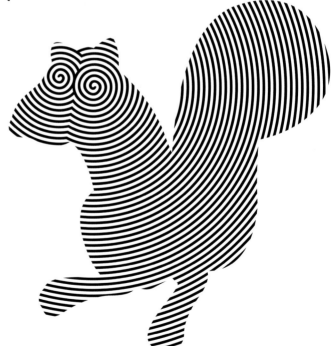

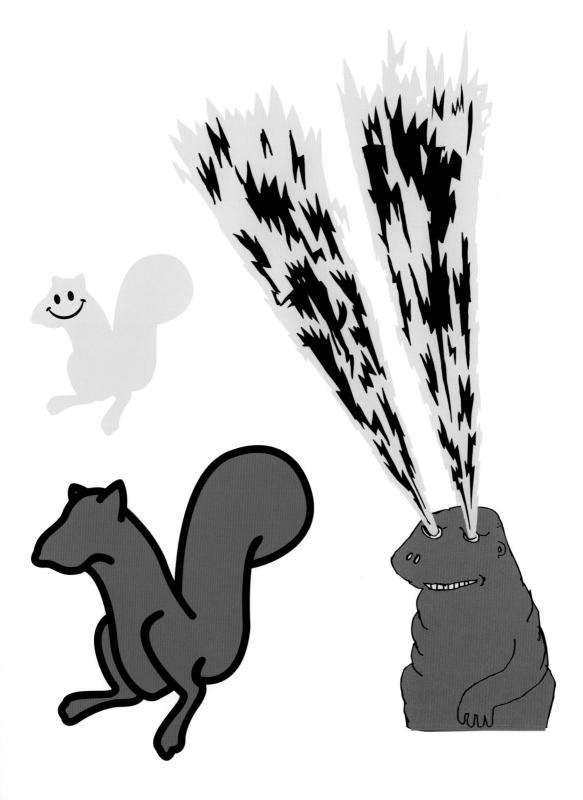

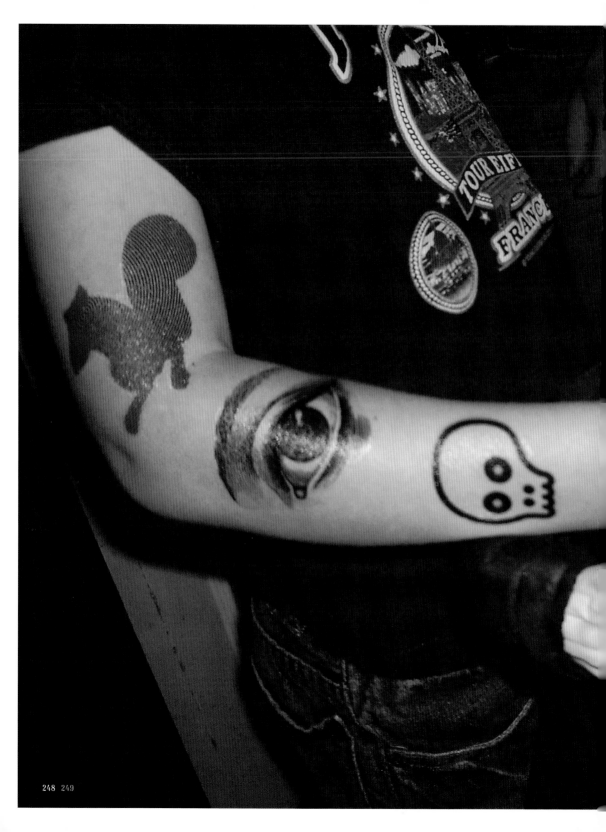

stefan marx

marcus oakley

London, UK

Do you have any tattoos?
No.

What is the first thing that comes to mind when you think of tattoos?
When I was in high school and the heavy metal kids giving themselves homemade tattoos by using knives and Indian ink.

Where do you want to have your tattoo(s)? Why?
Do you mean a real tattoo of a fake one?

Would you like to get your "tattoo icon" as a real tattoo? Why or why not?
No, I wouldn't want to have my "tattoo icon" as a real tattoo. However, once I did briefly think about getting the Beach Boys record label logo tattooed on my arm.

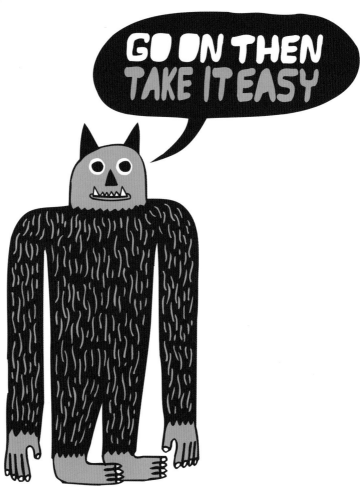

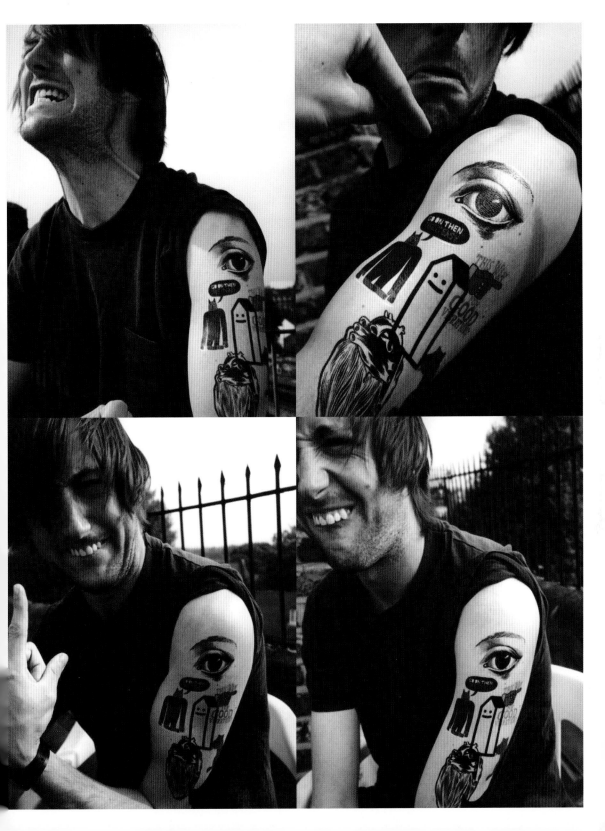

marcus oakley

THIS WAY FOR GOOD VIBRATIONS

HELLO

time for tea

good humour

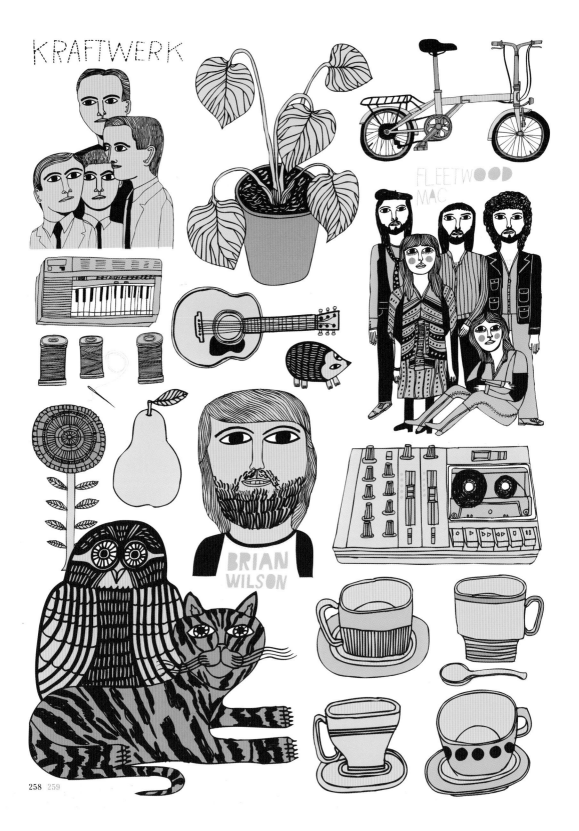

KRAFTWERK

FLEETW**OO**D
MAC

BRIAN
WILSON

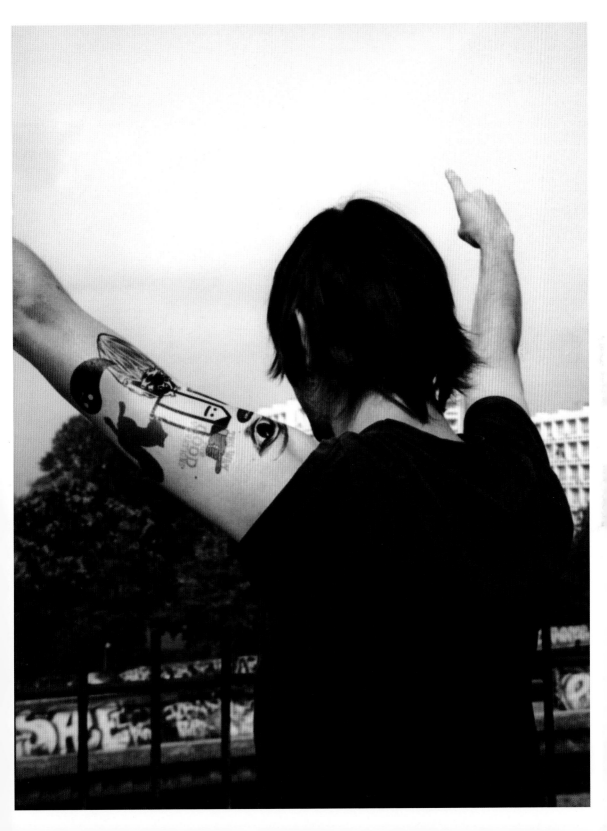

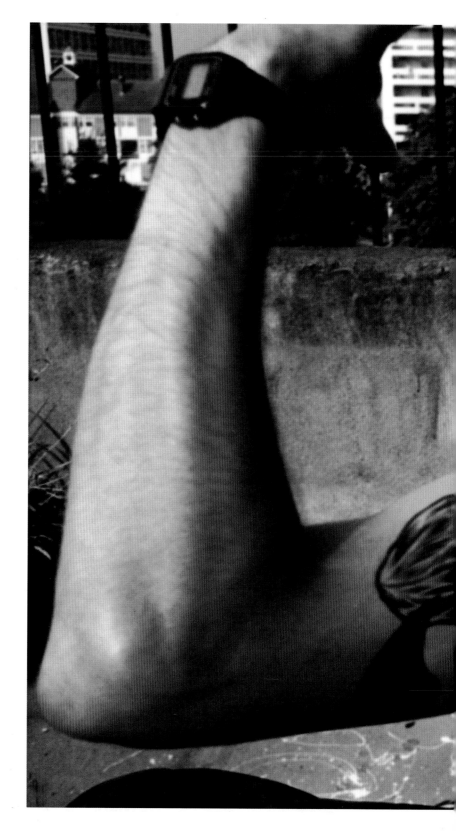

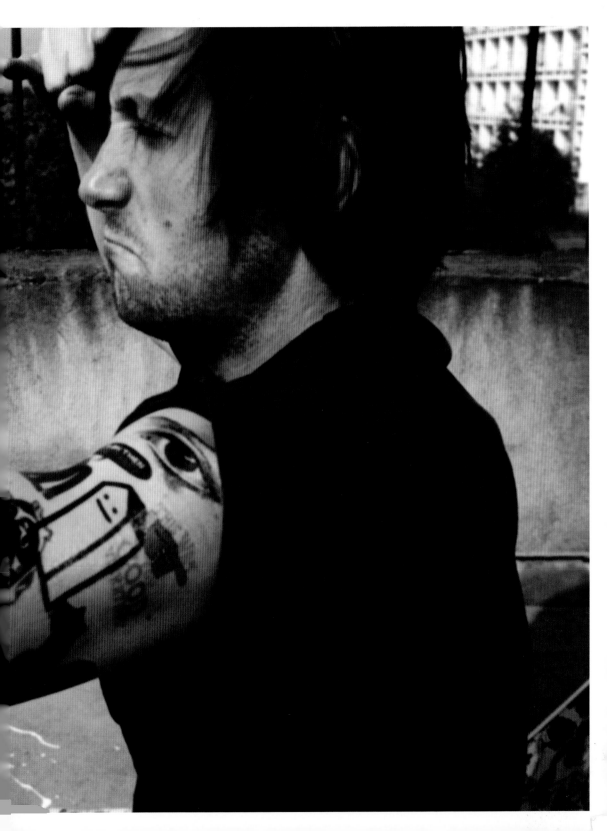

jigaram

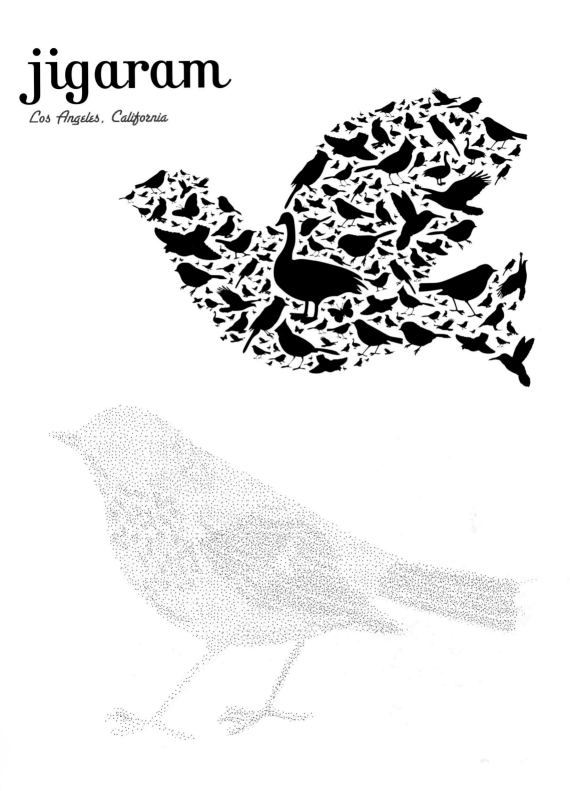

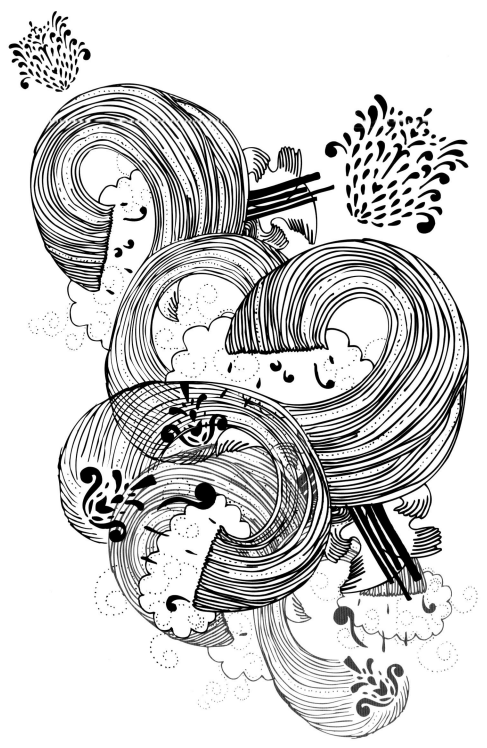

jigaram

körner union

Apples, Switzerland

Do you have any tattoos? What does tattoo mean to you?
I do have a really small tattoo. It's a brown triangle, as if I had a beauty spot gone wrong. Tattoo is for me a medium – maybe to be a bit cooler than the others.

What is the first thing that comes to mind when you think of tattoos?
Guns N' Roses.

Where do you have your tattoo? Why?
My triangle is on my right shoulder. This is a really problematic shoulder that goes off all the time, and I can't do anything about it (except play sports, but that's out of reach). I put my tattoo on the exact place the shoulder goes off, hoping it would heal it. Of course it did not, but I still quite like it there.

Would you like to get your "tattoo icon" as a real tattoo? Why or why not?
I want new tattoos, but I wouldn't like to draw them myself. I guess I would hate them after two months, including my "tattoo icon." I already asked friends to do some for me, but they are too lazy to do it, so I'll probably end up ripping off one of their drawings.

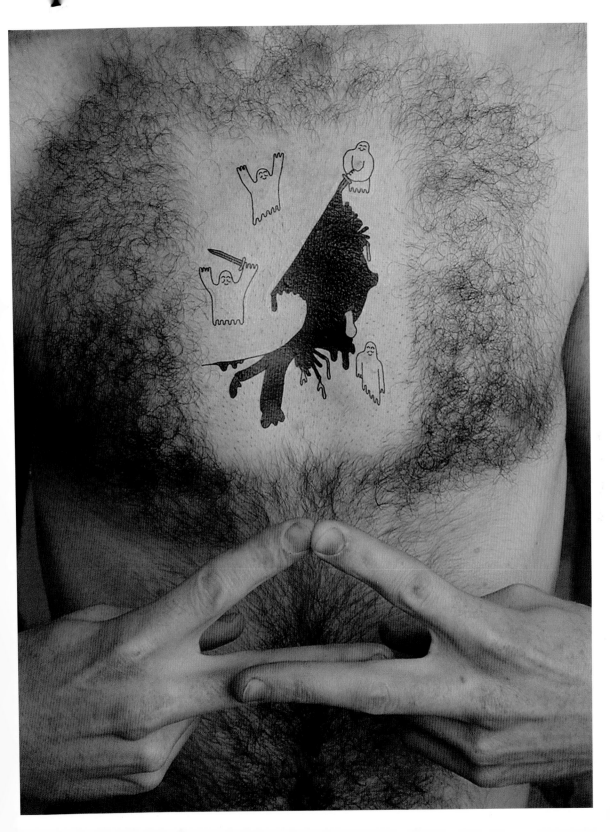

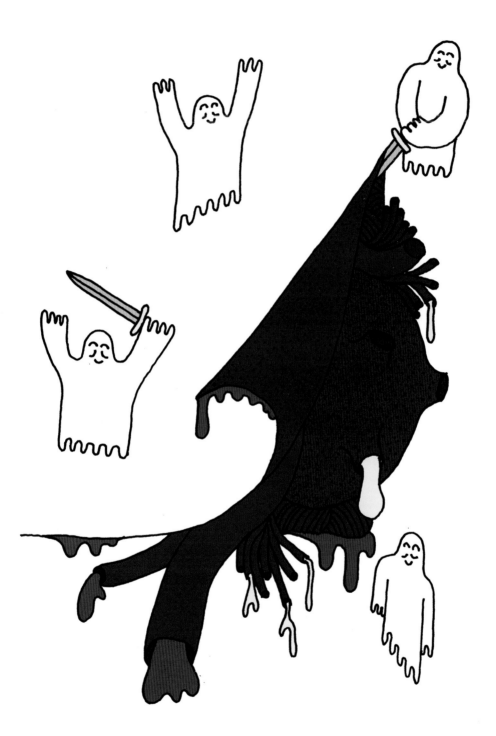

körner union

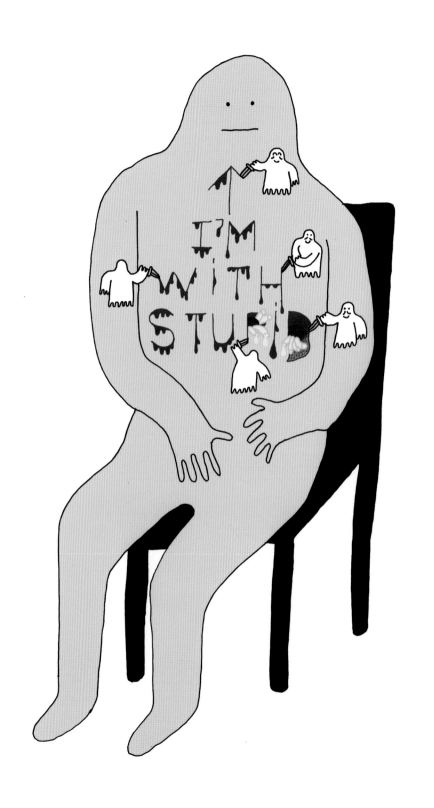

Don't forget to buy:

Milk	$
Bread	$
Eggs	$
Butter	$
Toiletpaper	$
	$
TOTAL	$

hort

Frankfurt, Germany

Do you have any tattoos? What does tattoo mean to you?
Martin Lorenz: No. "Tätowierung" (German for tattoo).
Eike König: No. Nothing.

What is the first thing that comes to mind when you think of tattoos?
Martin Lorenz: How it will look in twenty years.
Eike König: Bad! Bad! Bad!

Where do you want to have your tattoo(s)? Why?
Martin Lorenz: On someone else.
Eike König: Nowhere, please.

Would you like to get your "tattoo icon" as a real tattoo? Why or why not?
Martin Lorenz: No, but it would be handy if you want to shop in a nudist camp.
Eike König: No, thank you.

tomoaki ryuh

Fukuoka, Japan

Do you have any tattoos? What does tattoo mean to you?
I don't, but I always wanted to have tattoos when I was young. I thought having a tattoo was cool. To me it's a symbol of bravery and strength, smells like an anarchy atmosphere.

What is the first thing that comes to mind when you think of tattoos?
A slogan saying "Do it yourself." I don't know why, but probably because there is an unshaken spirit within tattoos and those who have them.

Where do you want to have your tattoo(s)? Why?
I would like to have tattoo on my arms or back. No reason – I just think that stands out a lot.

Would you like to get your "tattoo icon" as a real tattoo? Why or why not?
To be honest, I don't want to have it. Why not? I am sure that I will regret it for being "mafia" in public space. If I want to get one in the future, I will redesign traditional Japanese tattoo called "wabori."

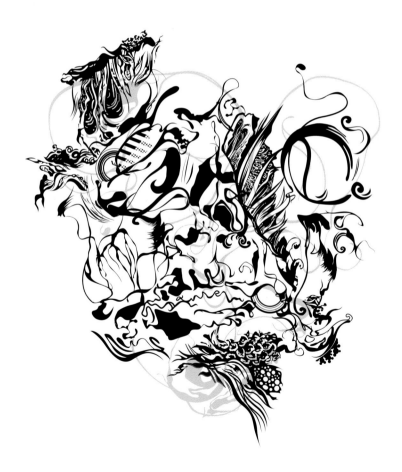

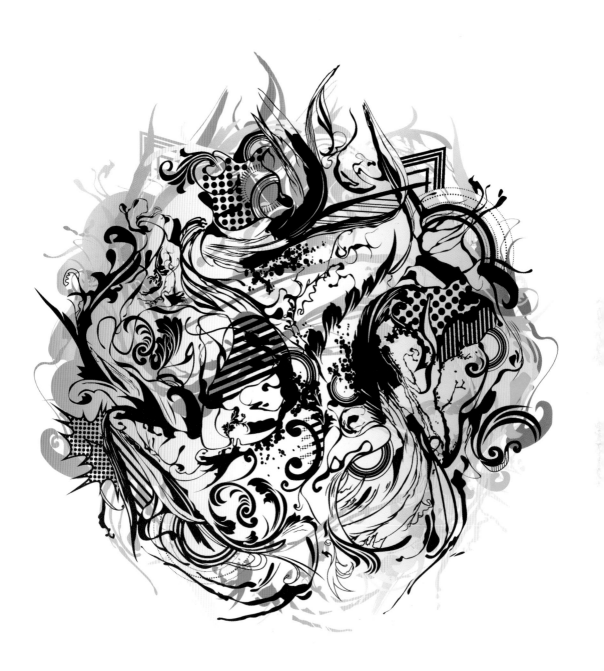

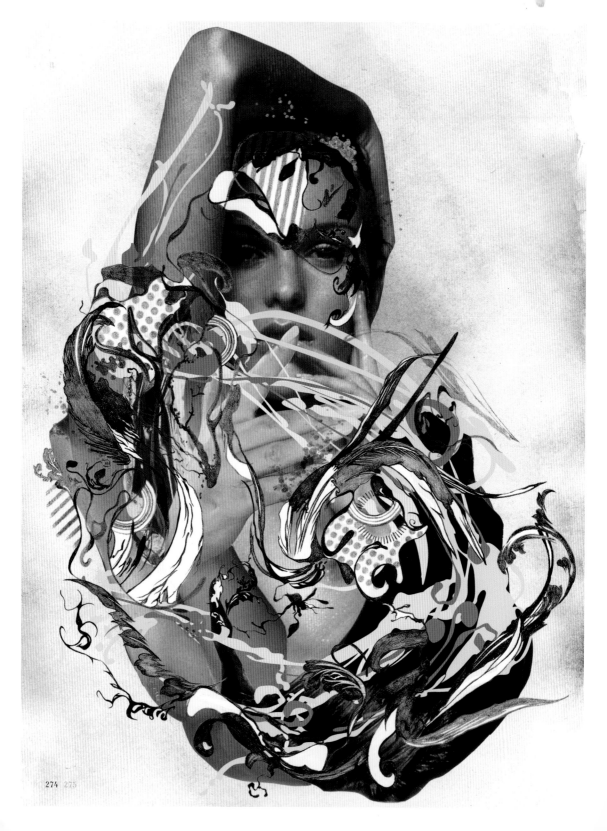

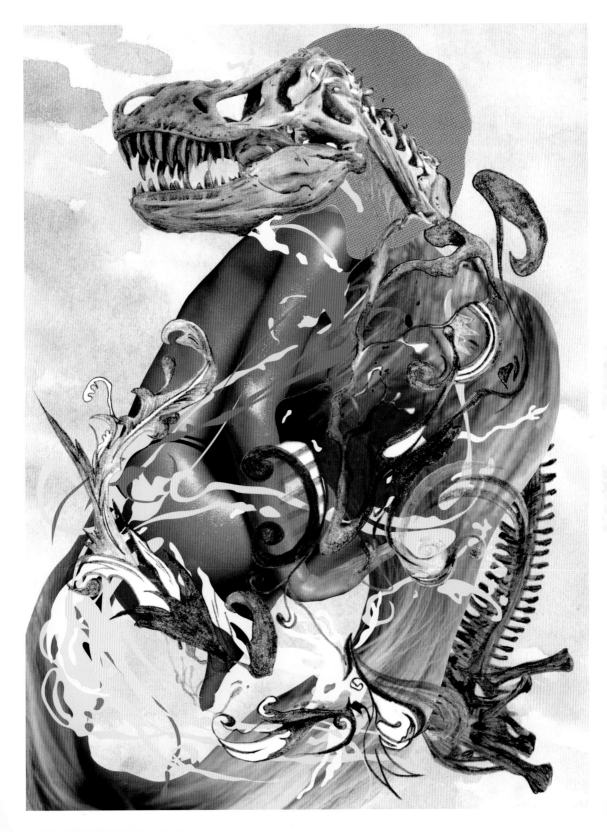

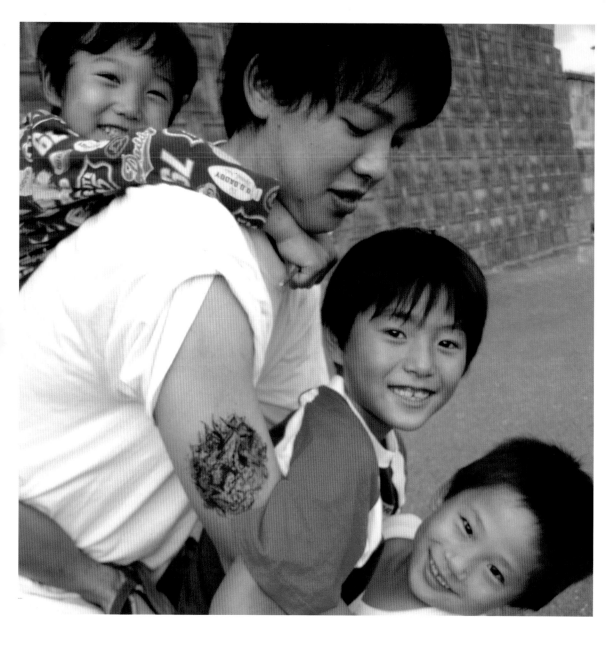

tomoaki ryuh

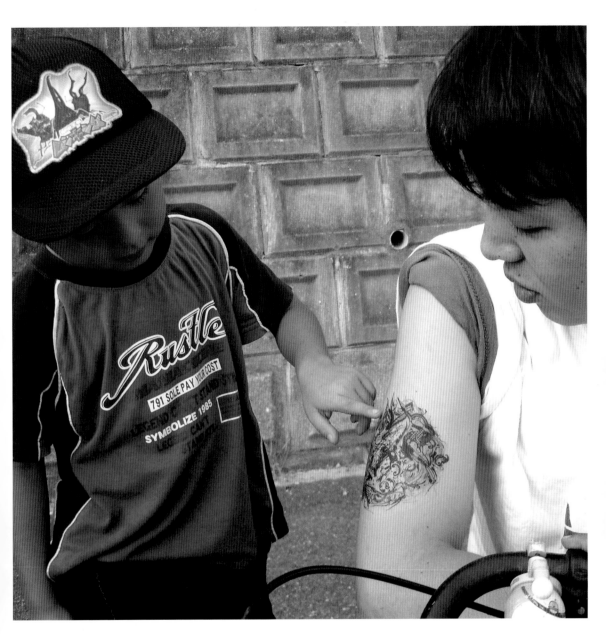

ALWAYS
DREAMIN
OF YOU

THE
WI
HO
TAT

LETS
GO TO
THE BEA
CH

ANY
FOR

tomoaki ryuh

DOO

HE INSS

RIGHTHGS

YOU

ING BEAUTIFUL

NOW BASTARD

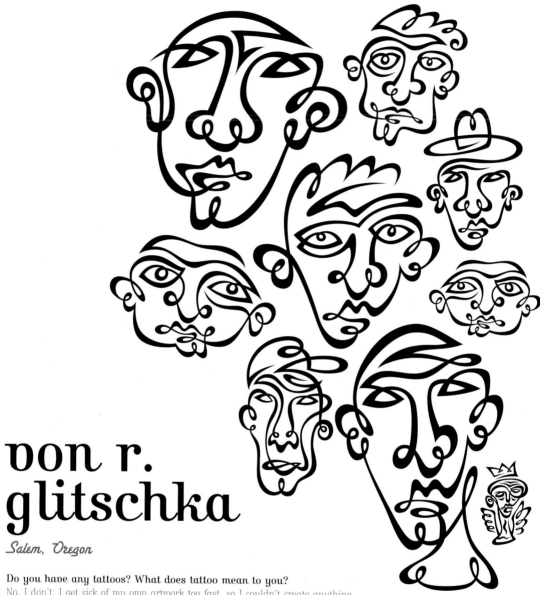

von r. glitschka

Salem, Oregon

Do you have any tattoos? What does tattoo mean to you?
No, I don't. I get sick of my own artwork too fast, so I couldn't create anything that would satisfy me art-wise on my own skin for a lifetime.

What is the first thing that comes to mind when you think of tattoos?
Stereotypically someone who could kick my ass and ride off on a Harley.

Where do you want to have your tattoo(s)? Why?
If I ever do, they'd be hidden. Because I can't kick anyone's ass and I don't own a Harley.

Would you like to get your "tattoo icon" as a real tattoo? Why or why not?
If I ever buy a Harley, then sure.

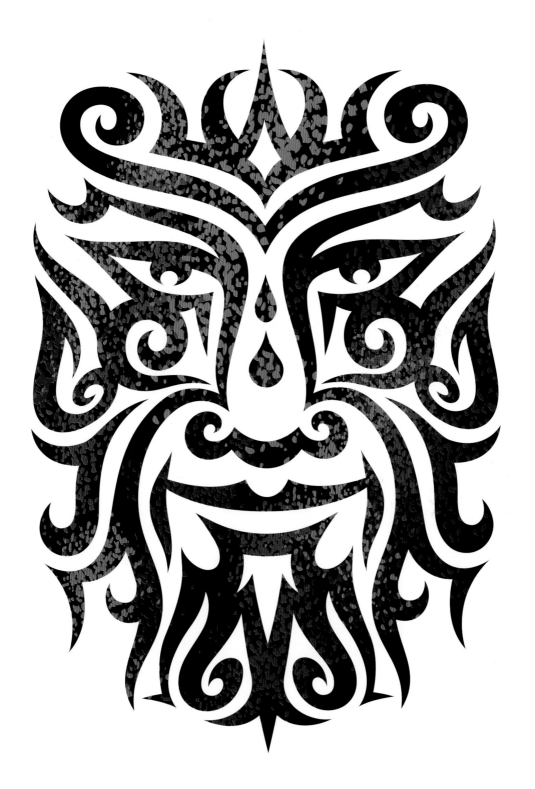

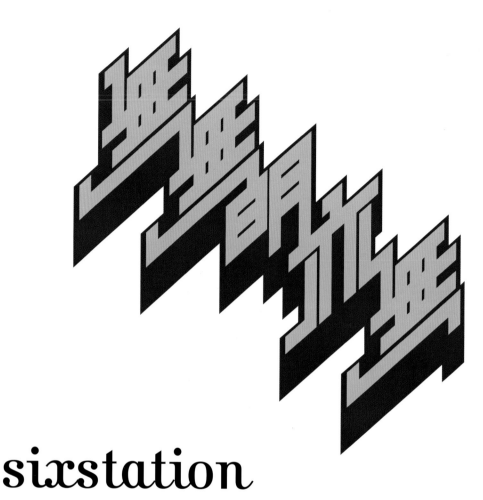

sixstation

Hong Kong, China

Do you have any tattoos? What does tattoo mean to you?
I don't. Tattoo is a personal sign, a mark that one wants to keep until death.

What is the first thing that comes to mind when you think about tattoos?
Gangster.

Where do you want to have your tattoo(s)? Why?
The sole of the foot or the most hidden place.

Would you like to get your "tattoo icon" as a real tattoo? Why or why not?
Sure. I think it will be interesting.

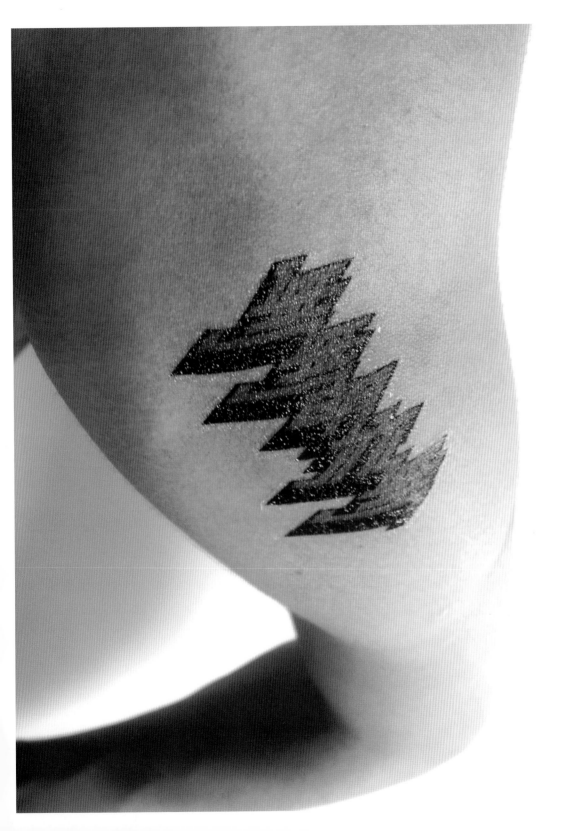

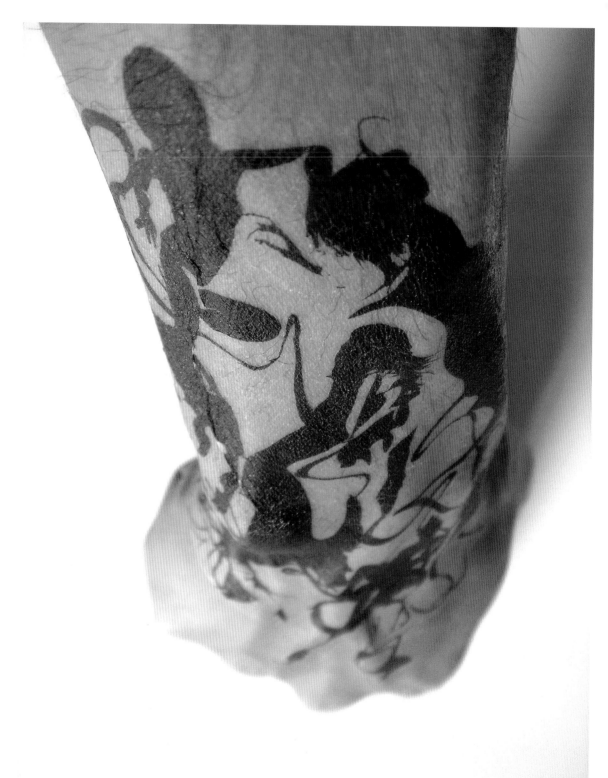

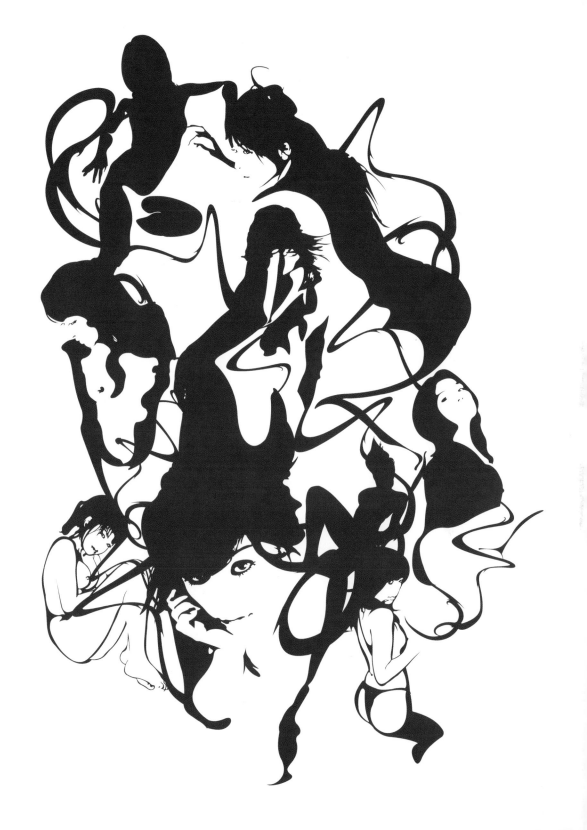

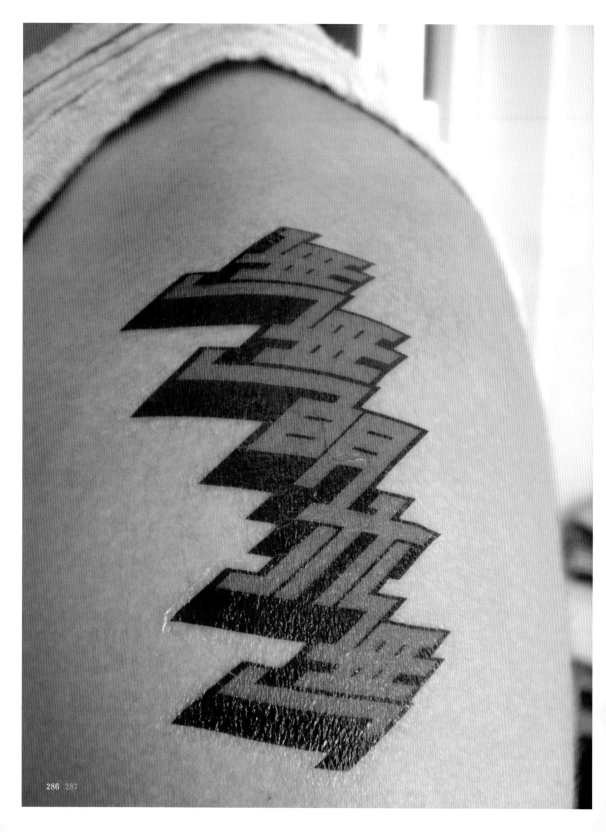

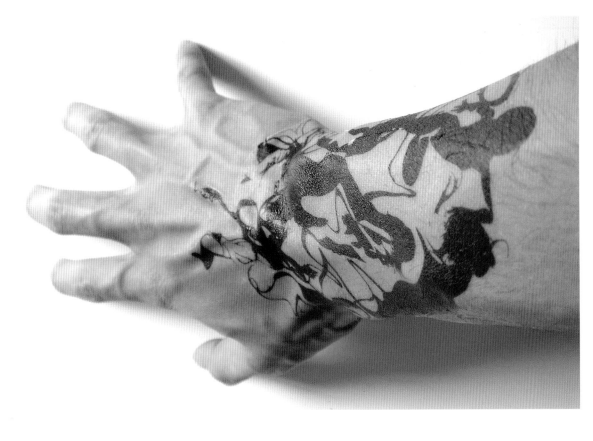

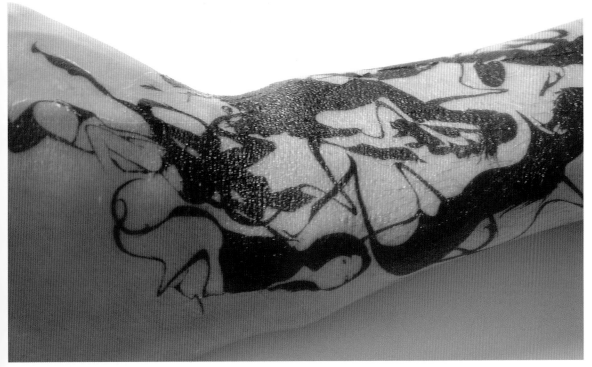

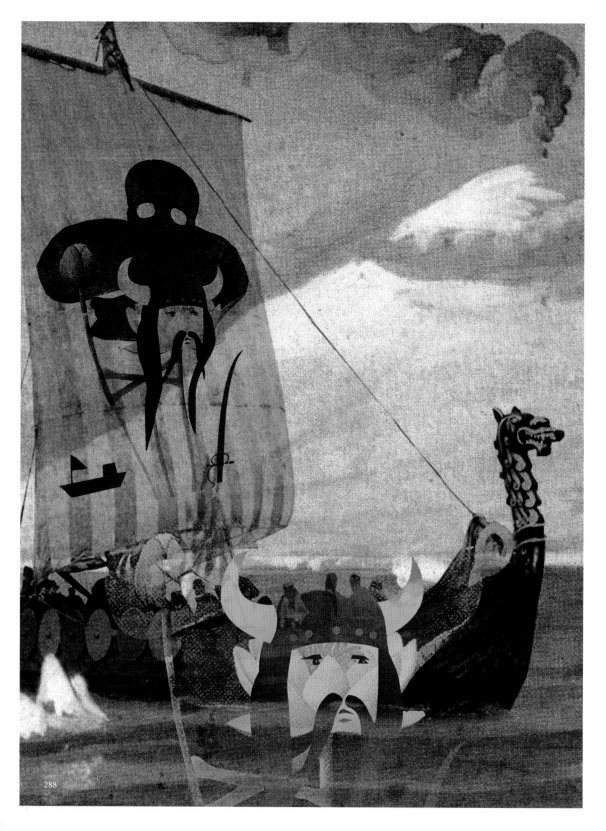

mikko rantanen

London, UK

Do you have any tattoos? What does tattoo mean to you?
No. But I do like tattoos and have considered getting one. I have yet to find an image that
I would like to carry on my skin for the rest of my life.
I think tattoo is a great form of artistic expression. I like the idea of using one's body as a
canvas and decorating it with an artwork that can never be erased. And as there are no
rules, no one can tell you what you can or cannot have tattooed on your skin.

What is the first thing that comes to mind when you think of tattoos?
The strong feelings that people have towards an image or text that they want to carry for
all times.

Where do you want to have your tattoo(s)? Why?
I tend to like tattoos on arms.

Would you like to get your "tattoo icon" as a real tattoo? Why or why not?
I don't think I would, but I wouldn't mind if someone else does.

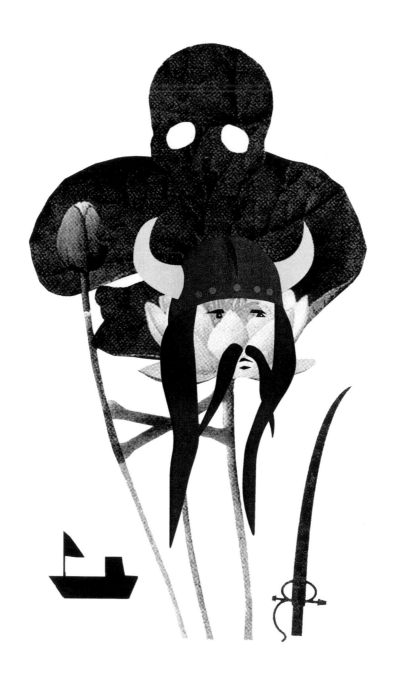

mikko rantanen

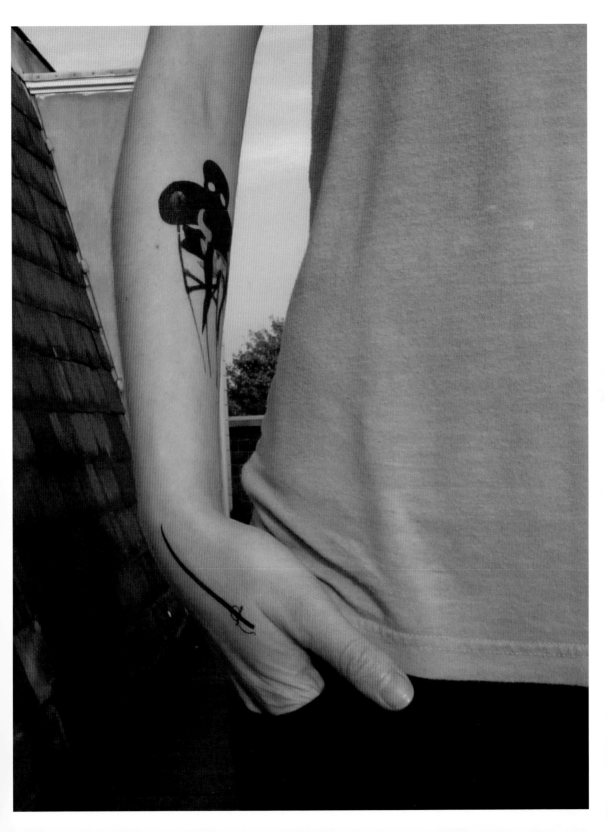

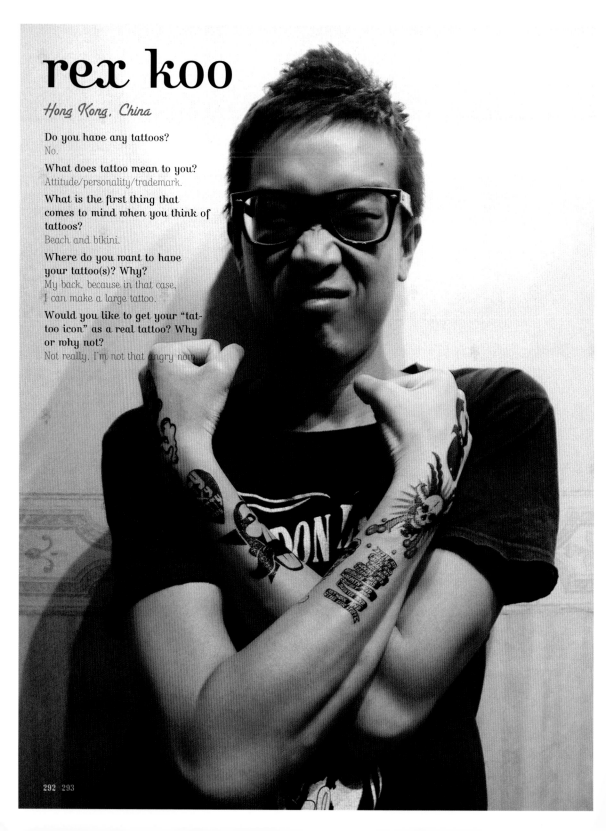

rex koo

Hong Kong, China

Do you have any tattoos?
No.

What does tattoo mean to you?
Attitude/personality/trademark.

What is the first thing that comes to mind when you think of tattoos?
Beach and bikini.

Where do you want to have your tattoo(s)? Why?
My back, because in that case, I can make a large tattoo.

Would you like to get your "tattoo icon" as a real tattoo? Why or why not?
Not really. I'm not that angry now.

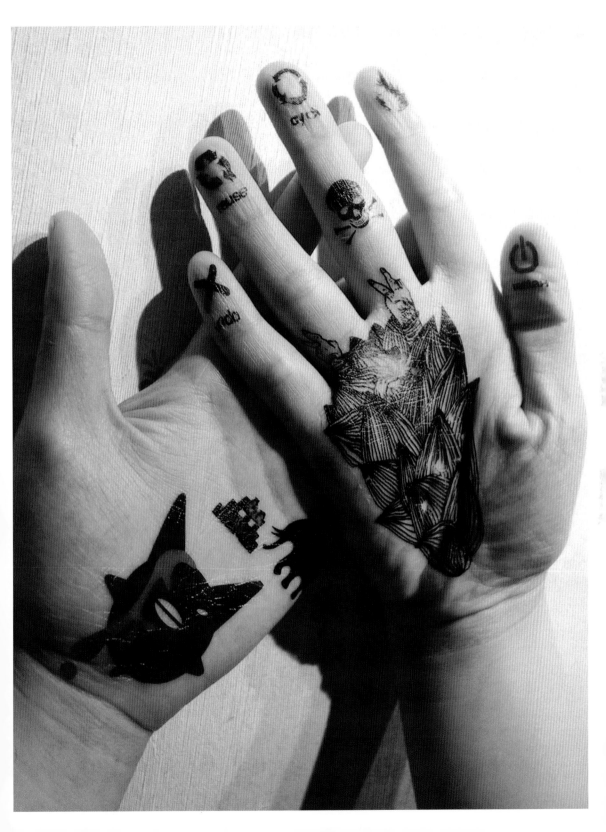

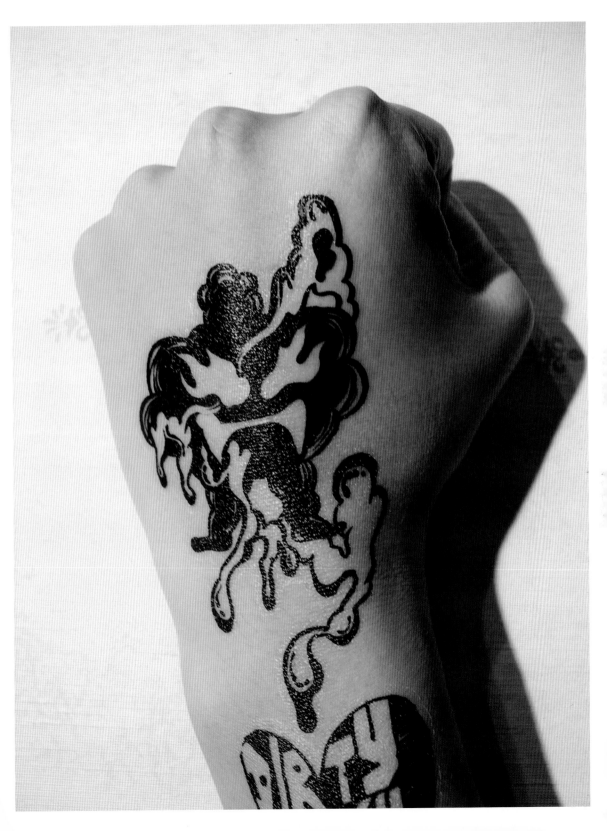

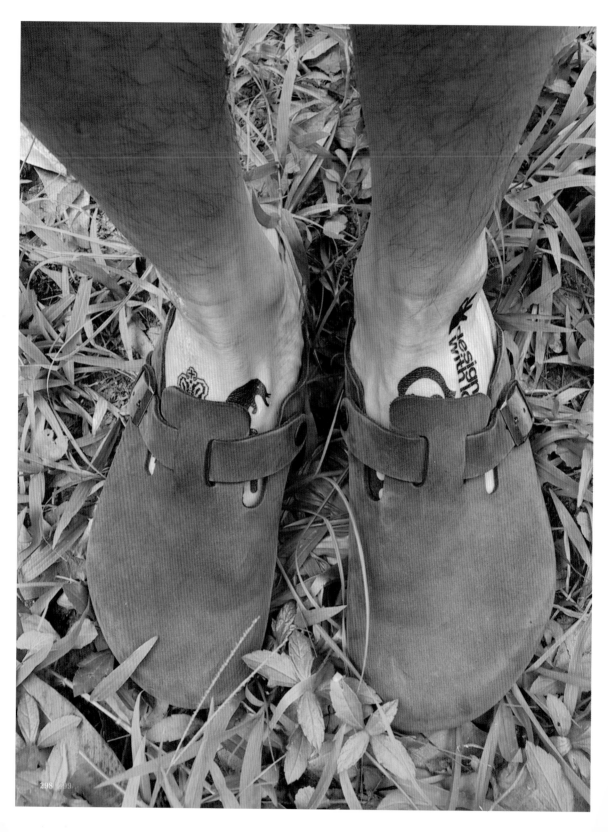

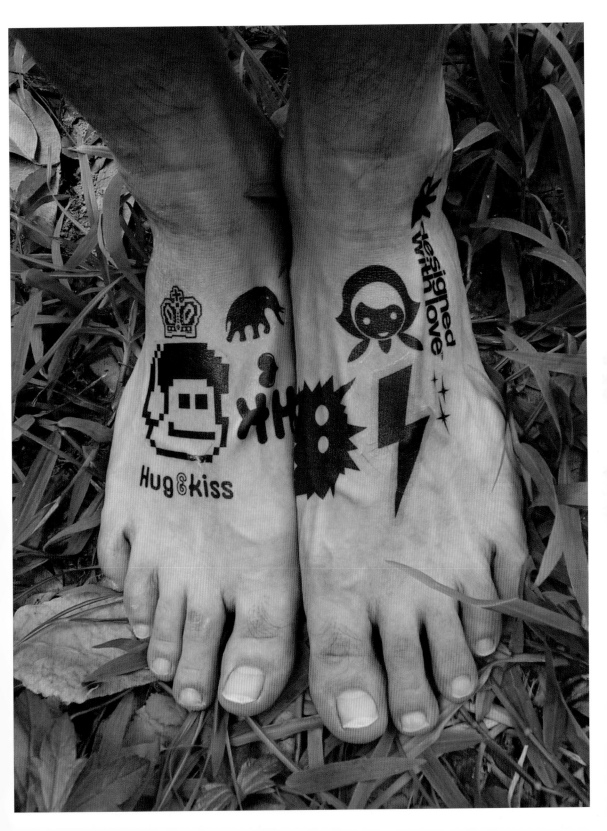

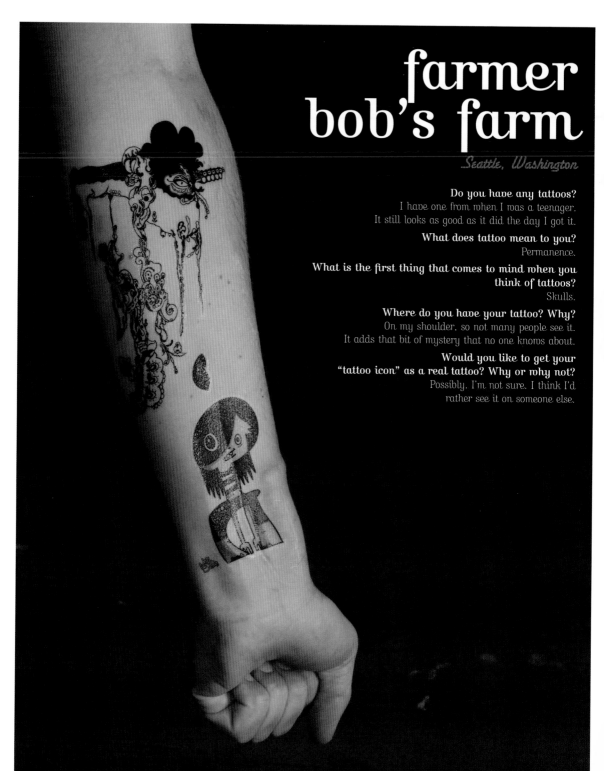

farmer bob's farm

Seattle, Washington

Do you have any tattoos?
I have one from when I was a teenager.
It still looks as good as it did the day I got it.

What does tattoo mean to you?
Permanence.

What is the first thing that comes to mind when you think of tattoos?
Skulls.

Where do you have your tattoo? Why?
On my shoulder, so not many people see it.
It adds that bit of mystery that no one knows about.

Would you like to get your "tattoo icon" as a real tattoo? Why or why not?
Possibly. I'm not sure. I think I'd rather see it on someone else.

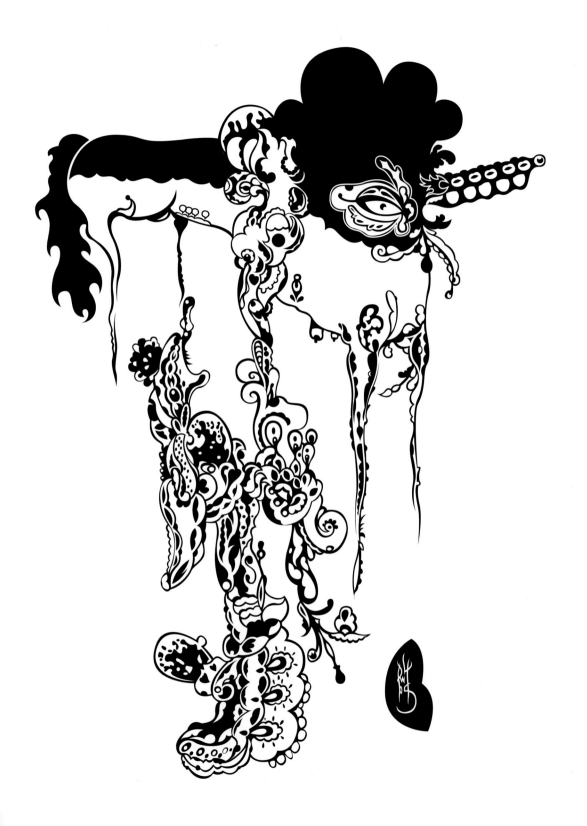

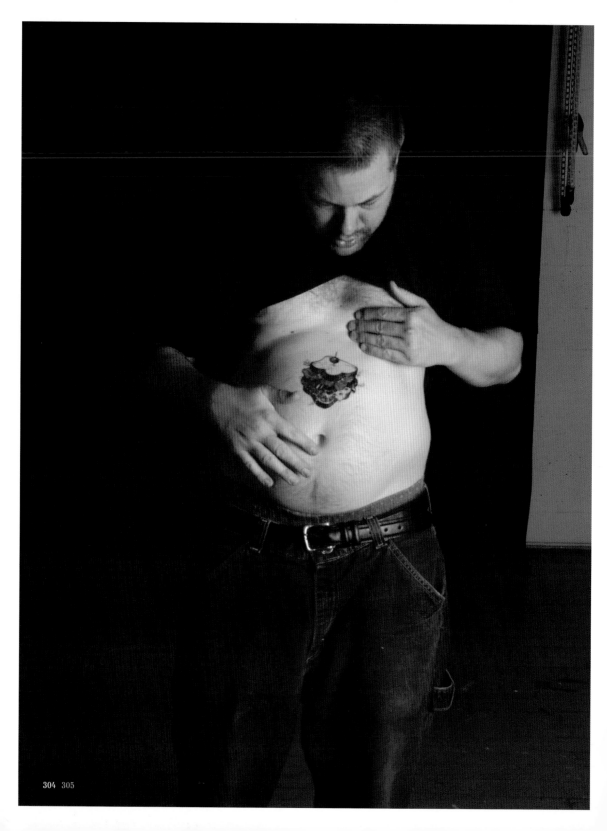

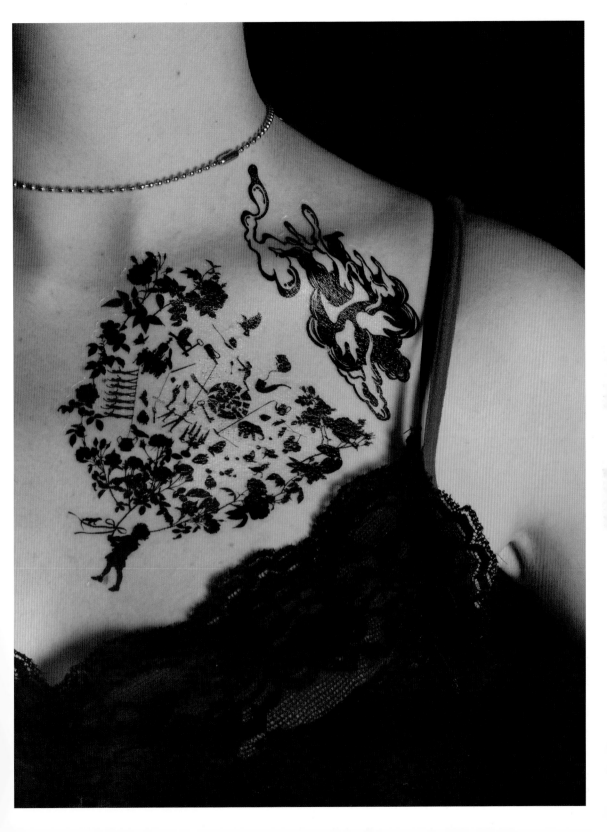

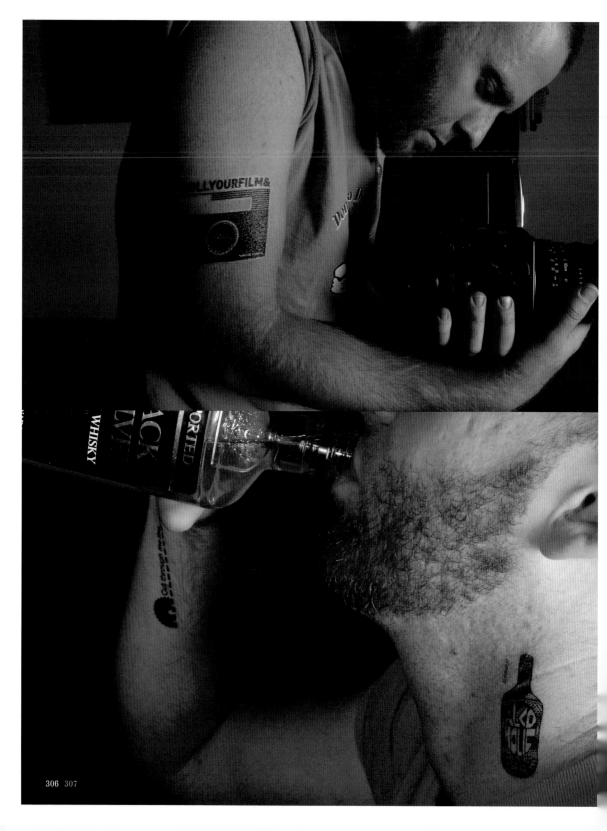

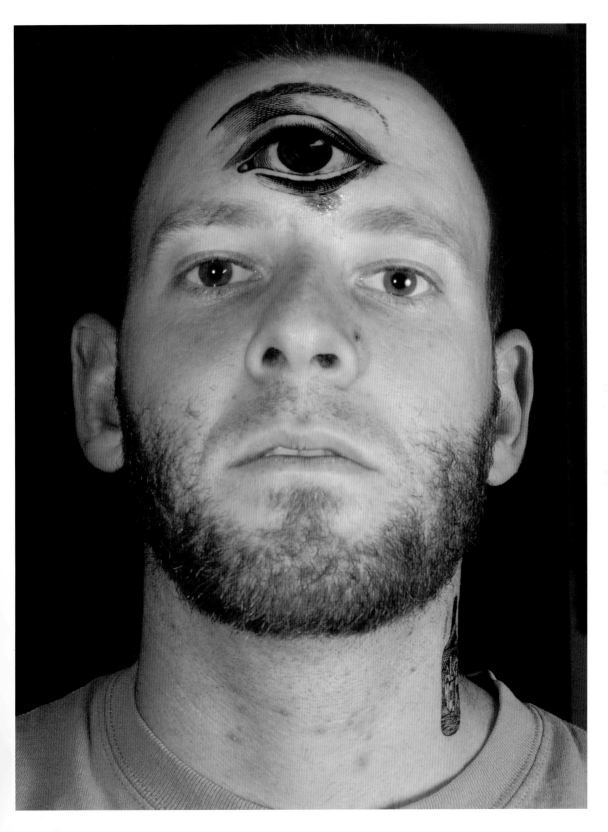

tönky

Rignac, France

Do you have any tattoos? What does tattoo mean to you?
No, I haven't got any tattoos. It is a minimal way of differing from the others. People who have tattoos try to give us a message through them. It is up to us to decipher it.

What is the first thing that comes to mind when you think of tattoos?
The first thing I think of is a big musclular arm with a tattoo that says "I love Mum."

Where do you want to have your tattoo(s)? Why?
I would like to have a tattoo on my hand because I could see it all the time especially when I smoke a cigarette. A great moment of enjoying graphics and sweet drug.

Would you like to get your "tattoo icon" as a real tattoo? Why or why not?
Why not? I think that it is timeless and that I shall not regret it.

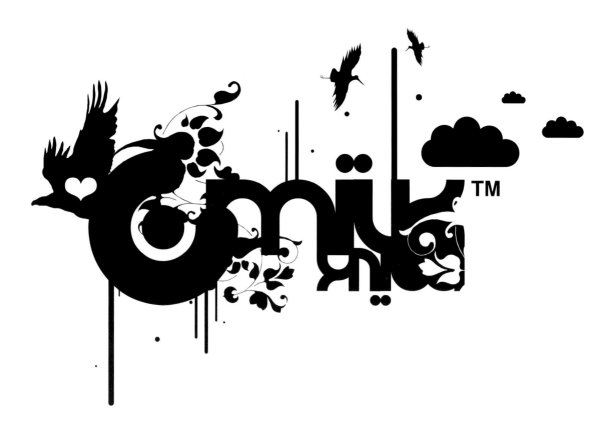

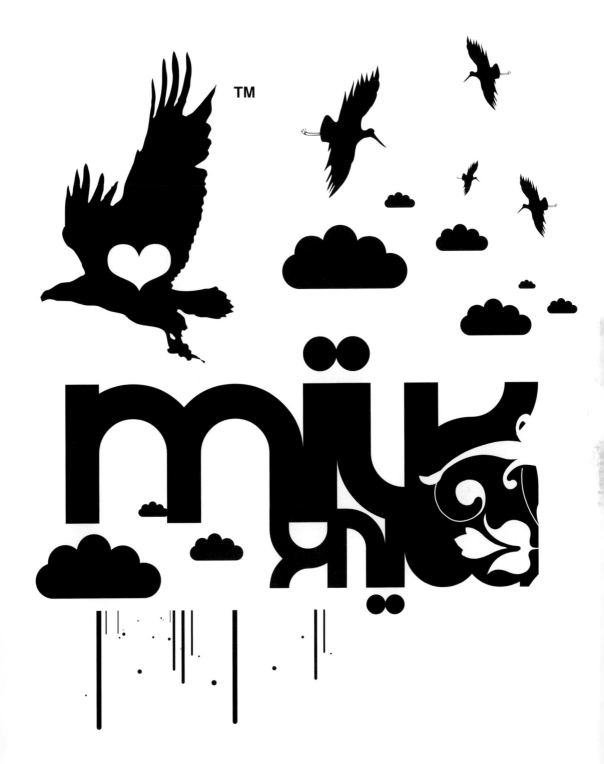

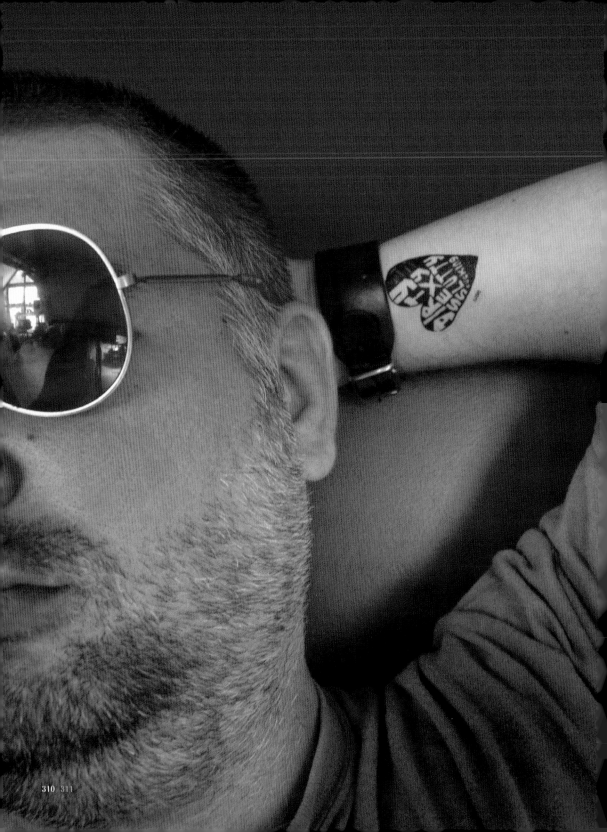

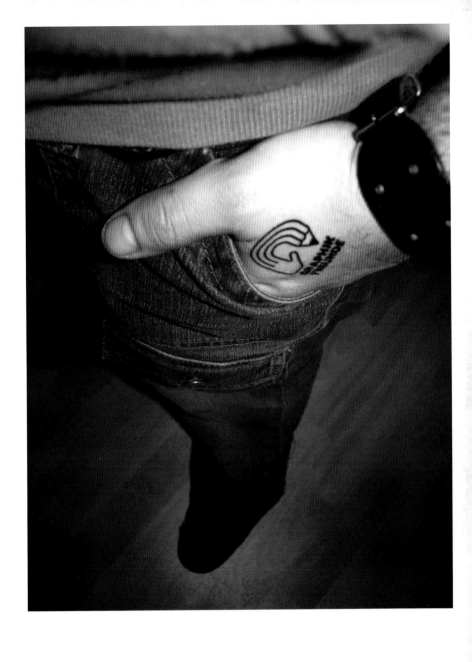

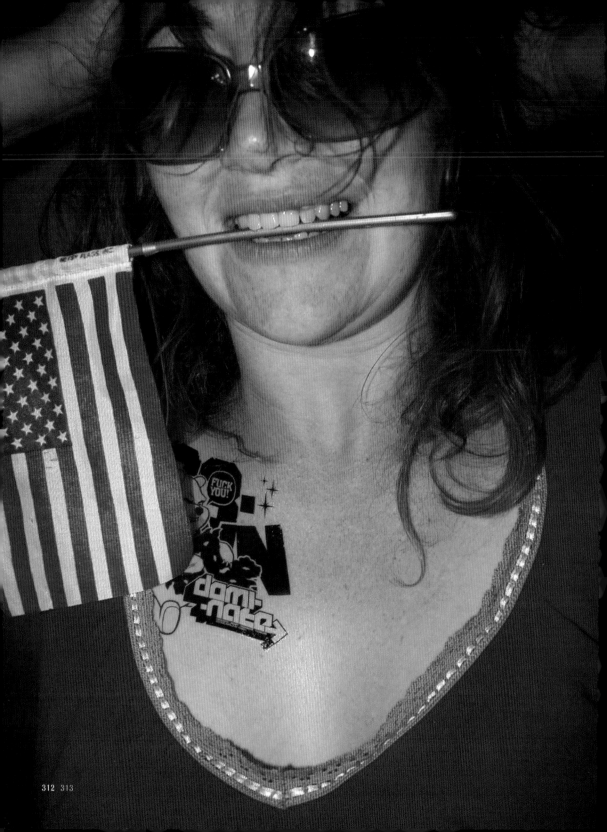

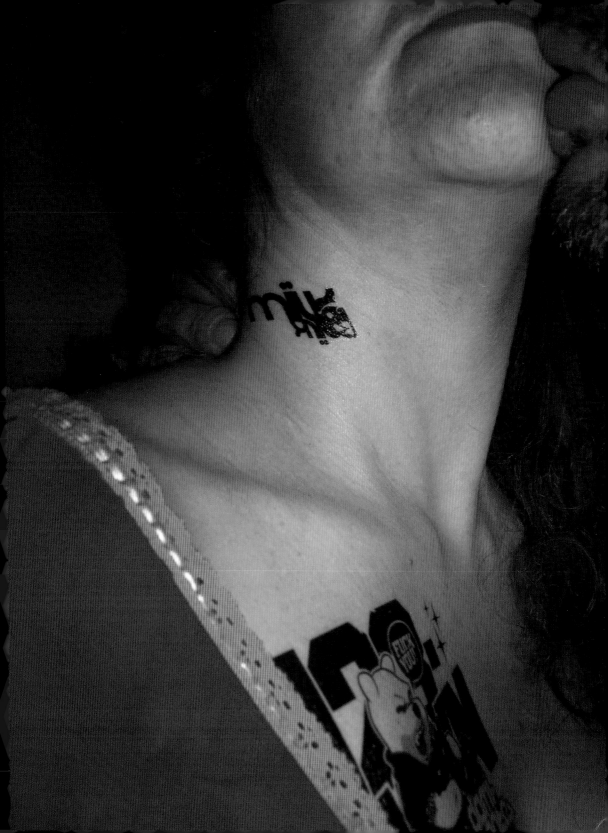

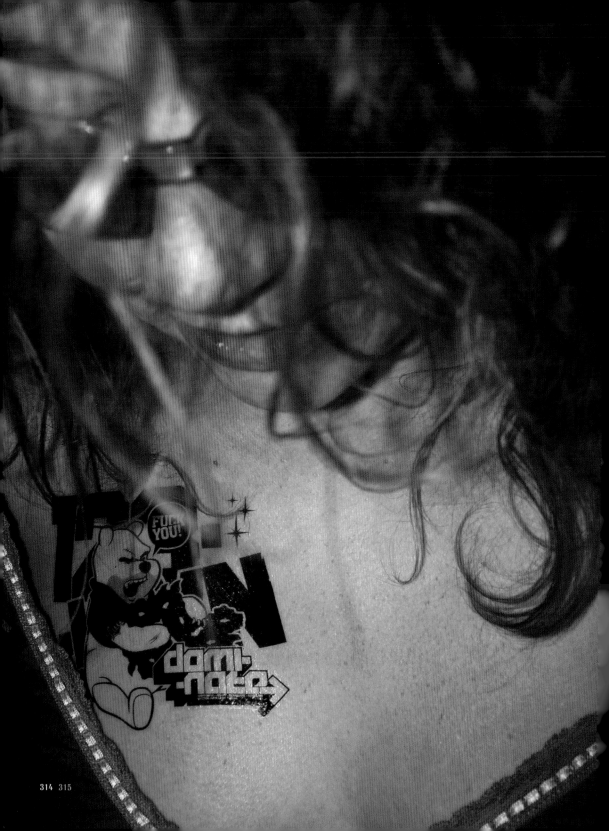

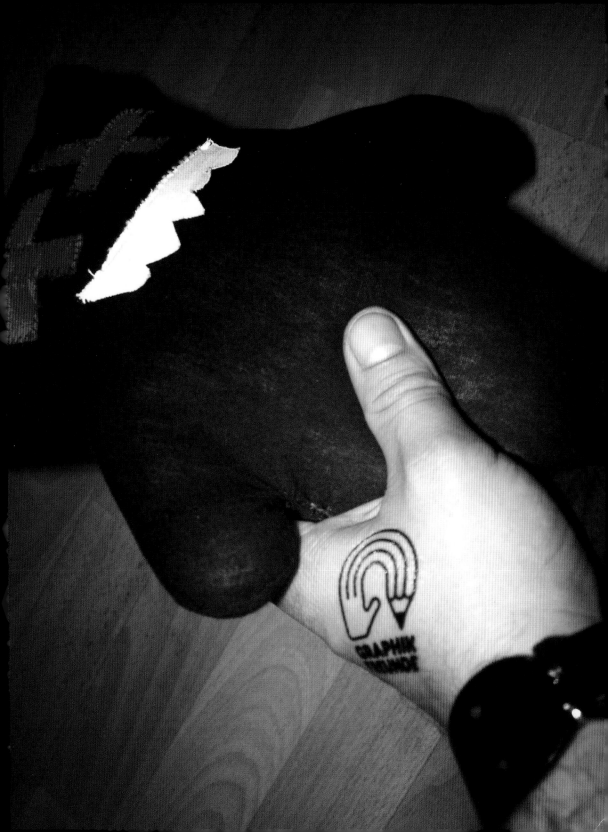

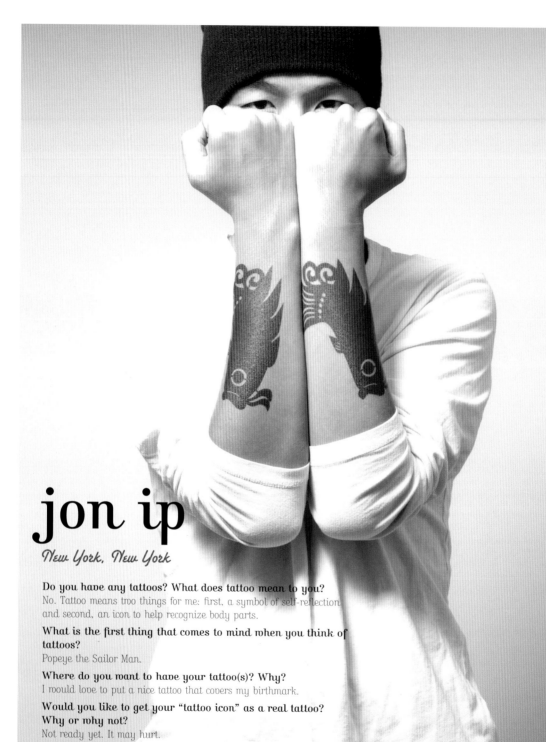

jon ip

New York, New York

Do you have any tattoos? What does tattoo mean to you?
No. Tattoo means two things for me: first, a symbol of self-reflection and second, an icon to help recognize body parts.

What is the first thing that comes to mind when you think of tattoos?
Popeye the Sailor Man.

Where do you want to have your tattoo(s)? Why?
I would love to put a nice tattoo that covers my birthmark.

Would you like to get your "tattoo icon" as a real tattoo? Why or why not?
Not ready yet. It may hurt.

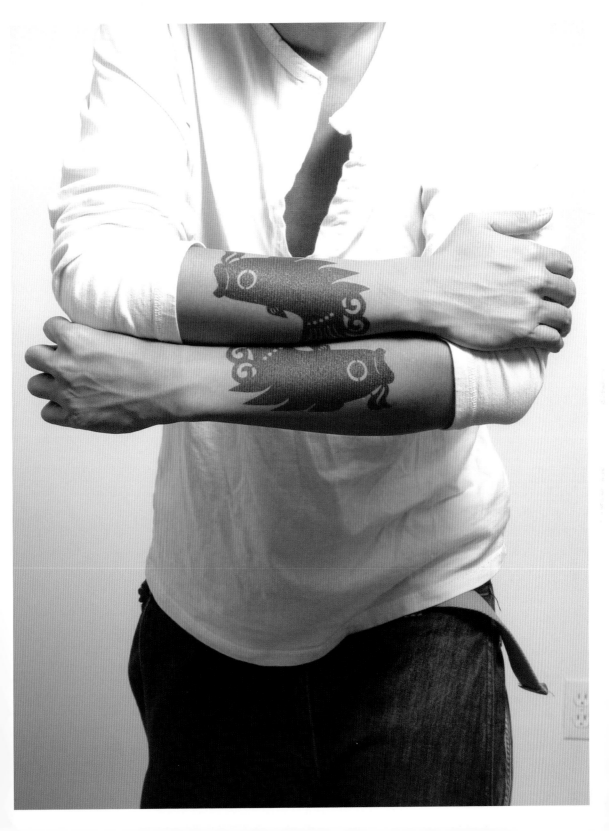

jon ip

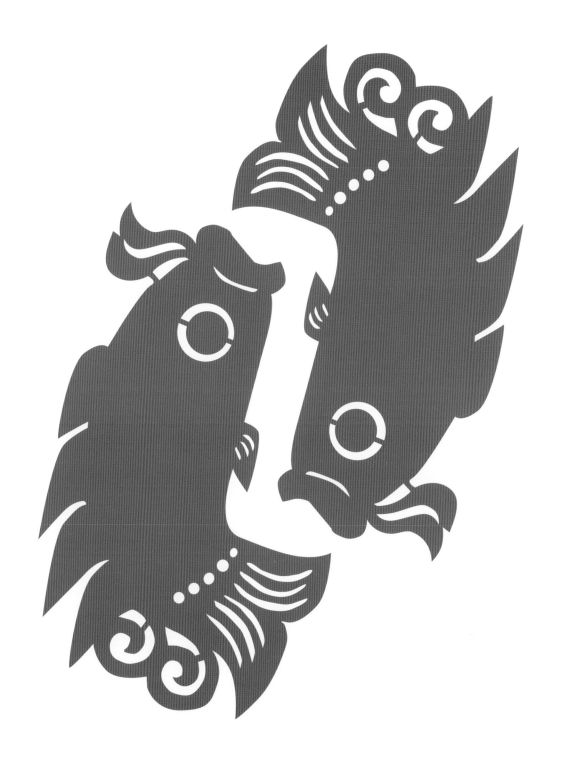

REFLECTION

reflect your mind. your soul. your personality.

jon ip

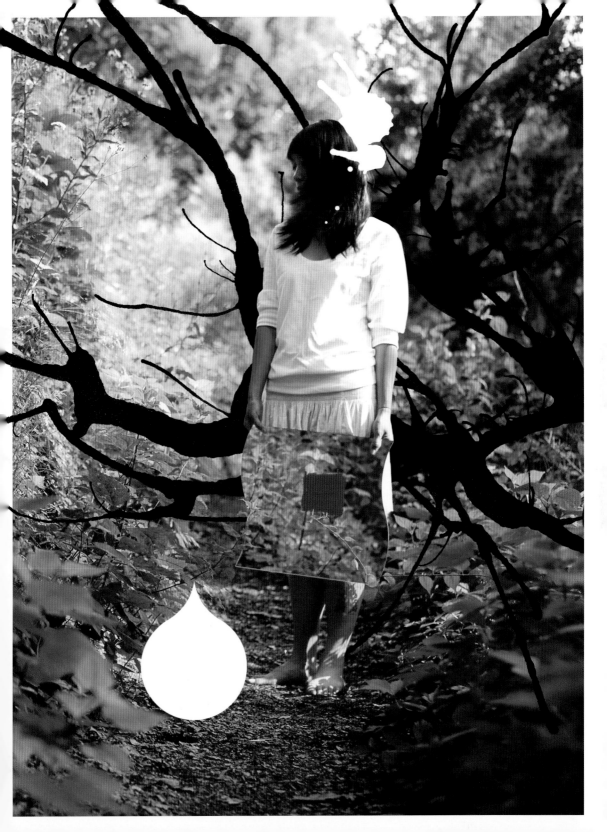

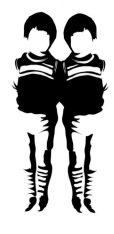

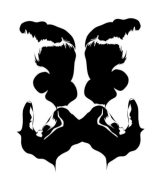

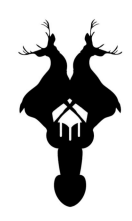

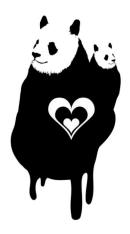

jon ip

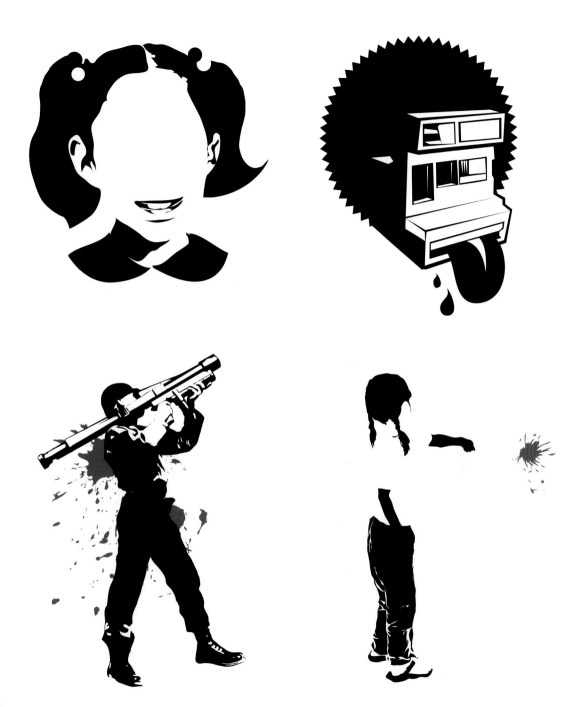

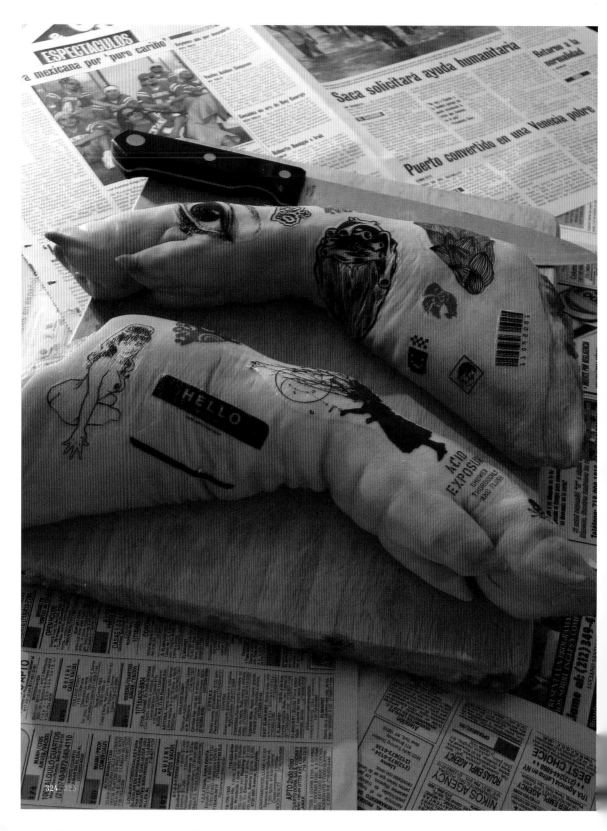

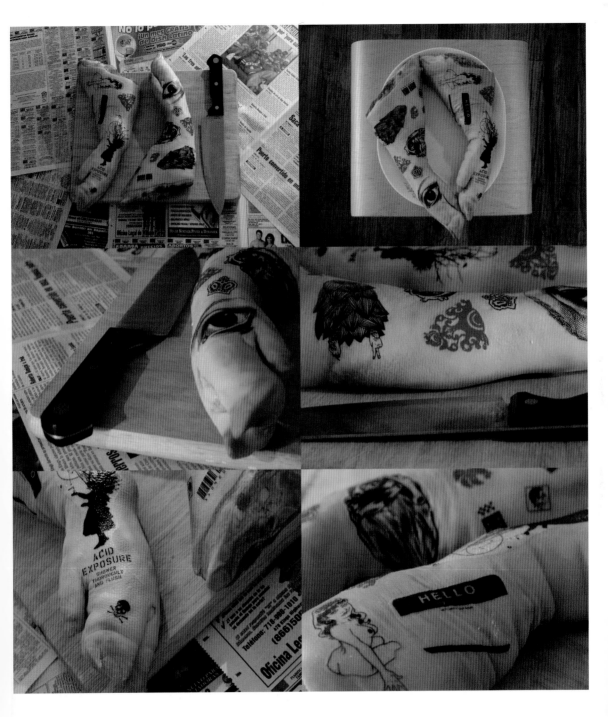

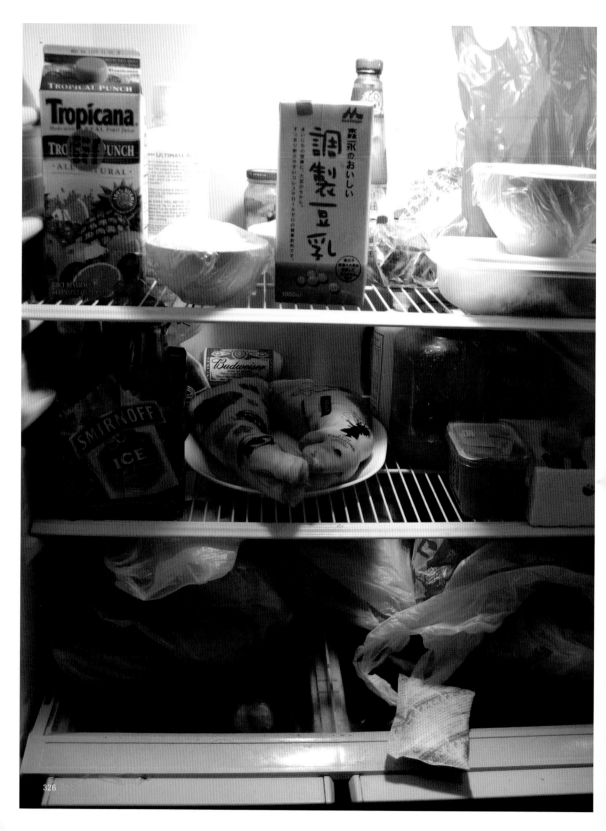

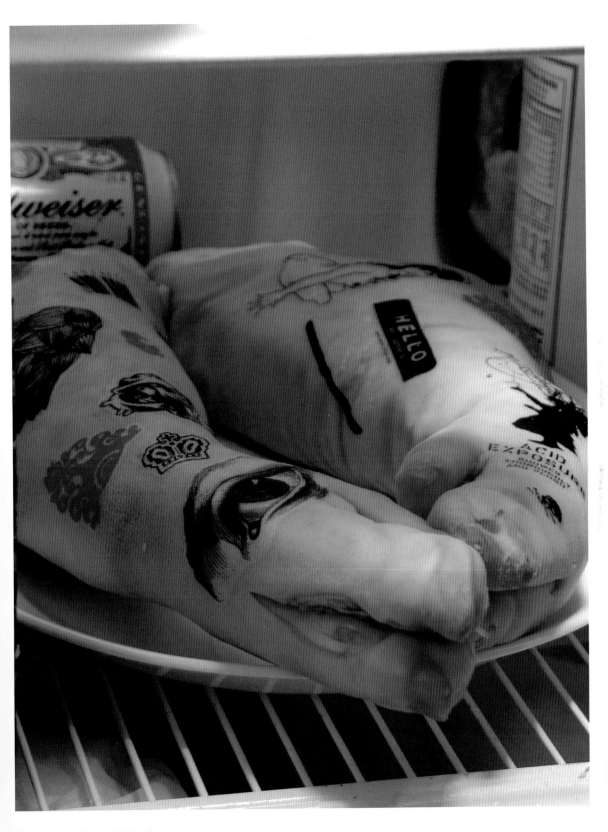

ACID
EXPOSURE

SHOWER
THOROUGHLY
AND FLUSH

ACID
EXPOSURE
SHOWER
Thoroughly
AND FLUSH

tom merckx

tom
merckx

Antwerp, Belgium

Do you have any tattoos? What does tattoo mean to you?
I have freckles, scars, bite marks, strange brown, yellow & red spots everywhere but no tattoos. I love the idea of using the body as a living template, but the idea that the art will be with you for your whole life is less appealing. There might be things I used to like five years ago but would totally wear off me today. I'm glad that these things are not permanently stuck on my body. I've probably met too many people who are going through a lot of trouble hiding or even laser-removing their body art, simply because they don't like it anymore. That's probably why those who are going for a full body tattoo (respect! a lifetime of pain awaits them) always stick to very traditional (mostly Japanese) design. Those designs just don't get outdated.

What is the first thing that comes to mind when you think of tattoos?
Drunk sailors, headbangers ball, Papua New Guinea, Wim Delvoye's pigs, skull & bones, Japanese mafia, pain & suffering, pride.

Where do you want to have your tattoo(s)? Why?
If I were to get one, it would be something small, but obvious. A 9pt line of text saying "My other body is astral," or "If you can read this, I can smell you." I don't really get the idea of going through pain and infection to get something that you don't want people to see, so it'd have to be somewhere more obvious — face or neck maybe.

Would you like to get your "tattoo icon" as a real tattoo? Why or why not?
I'd make it much bigger and more detailed. The size was a bit small to have the impact I wanted (or perhaps my arm is just too fat).

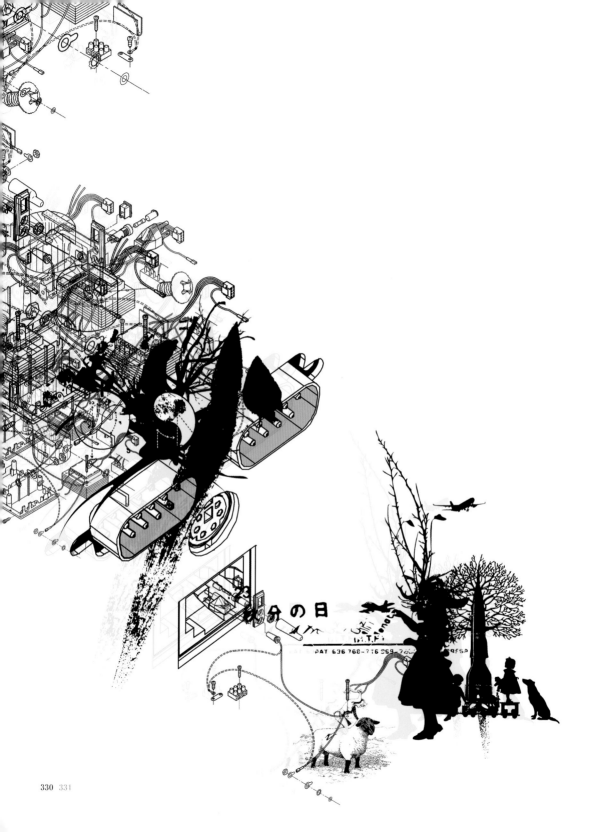

秋分の日

PAT 636 768-716 969-7

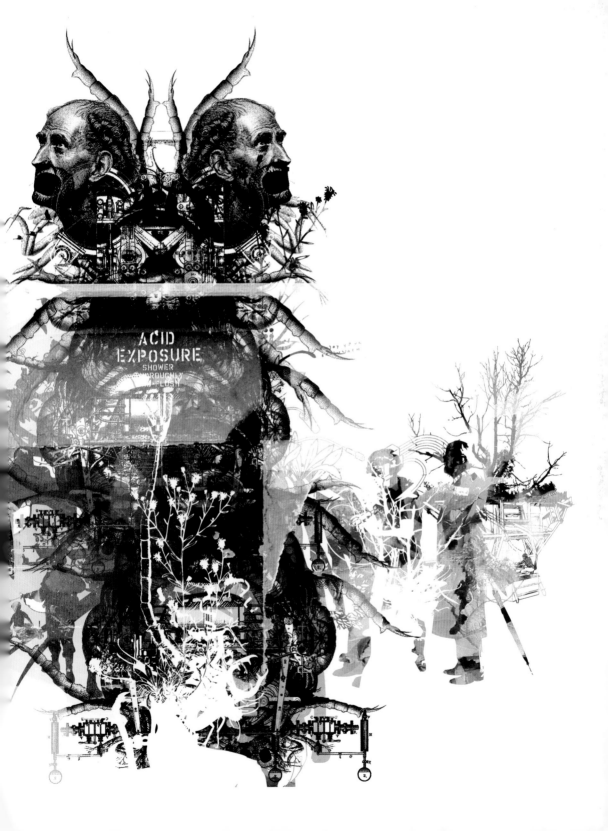

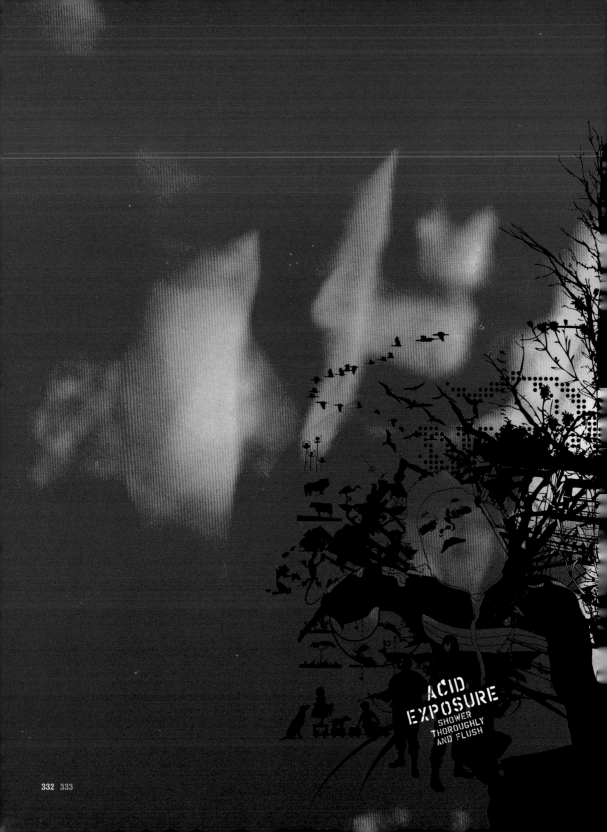

ACID
EXPOSURE
SHOWER
THOROUGHLY
AND FLUSH

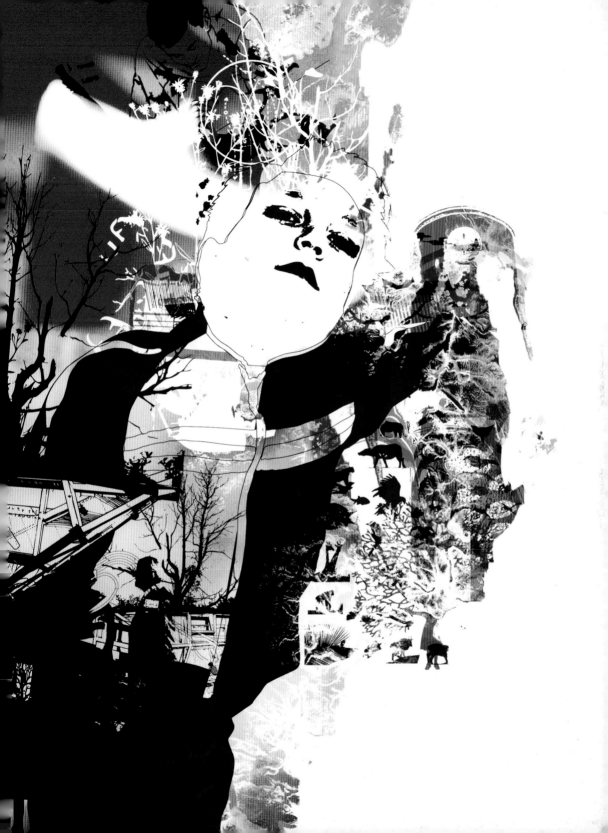

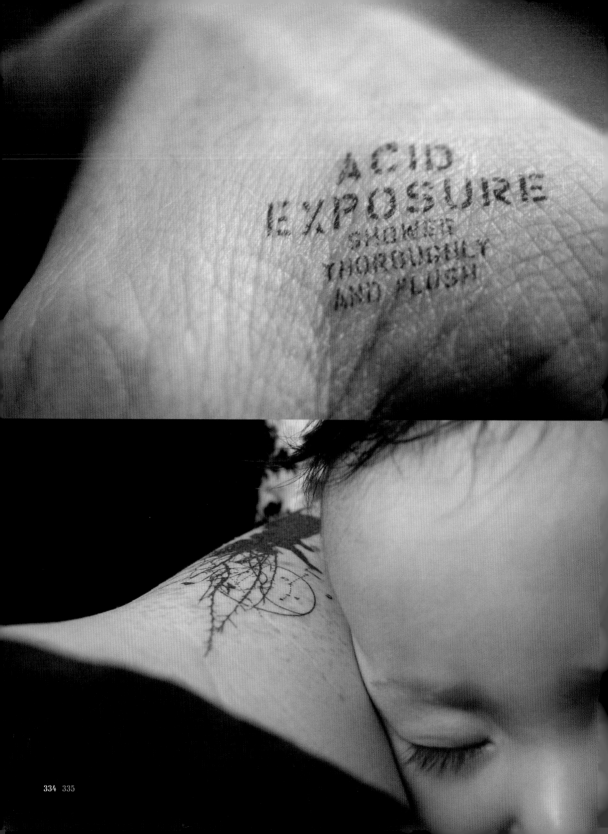

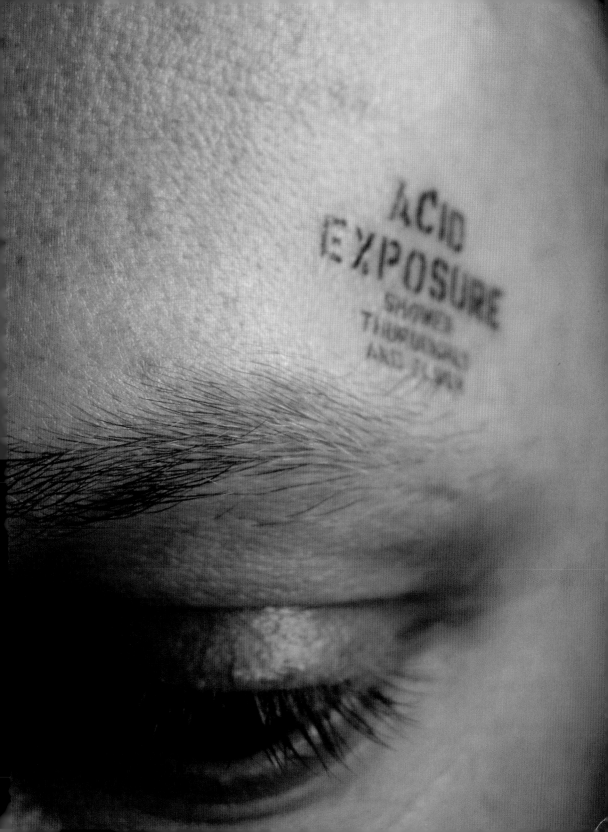

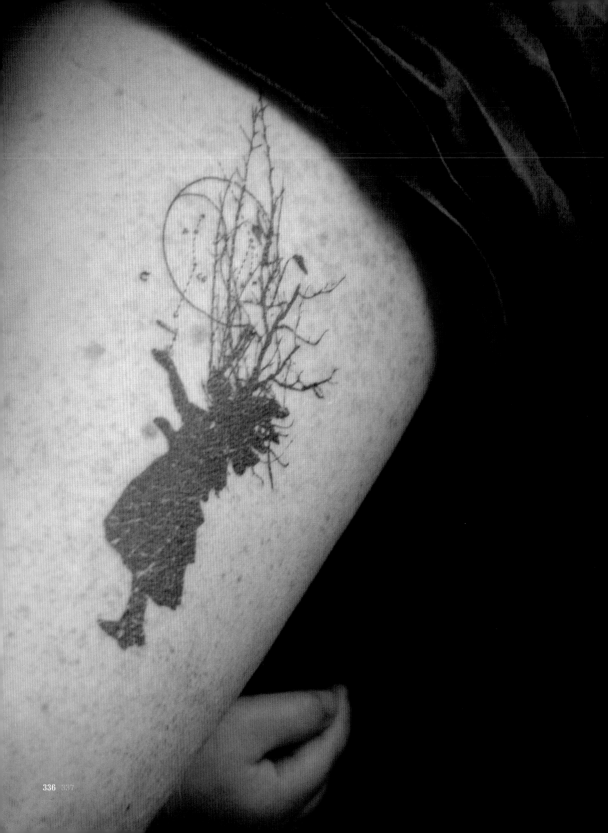

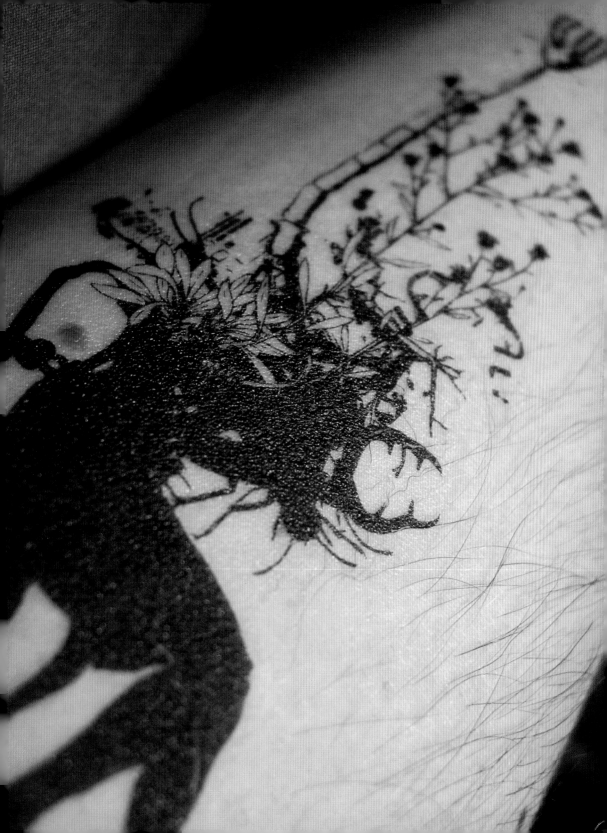

enamel

Tokyo, Japan

Do you have any tattoos? What does tattoo mean to you?
No, I don't have a tatoo.

What is the first thing that comes to mind when you think of tattoos?
What shall I do if I get tired of the design?

Where do you want to have your tattoo(s)? Why?
I would like to have it on my fingers because the design would be splendid. I think about
the hero from the movie "Memento," in which he loses his memory, so he always makes his
own important notes on his fingers. I think that would be my style. On my fingers the tattoo
would say, "Can you really finish your design like that?", "Don't you have better ideas?" or
"Is this the best?" But I think it would be very exhausting, so maybe I'll have one that says,
"That's the best, well done!" I'm not sure, maybe it's better without any.

Would you like to get your "tattoo icon" as a real tattoo? Why or why not?
No, I don't. Because the design is boring to be worn forever.

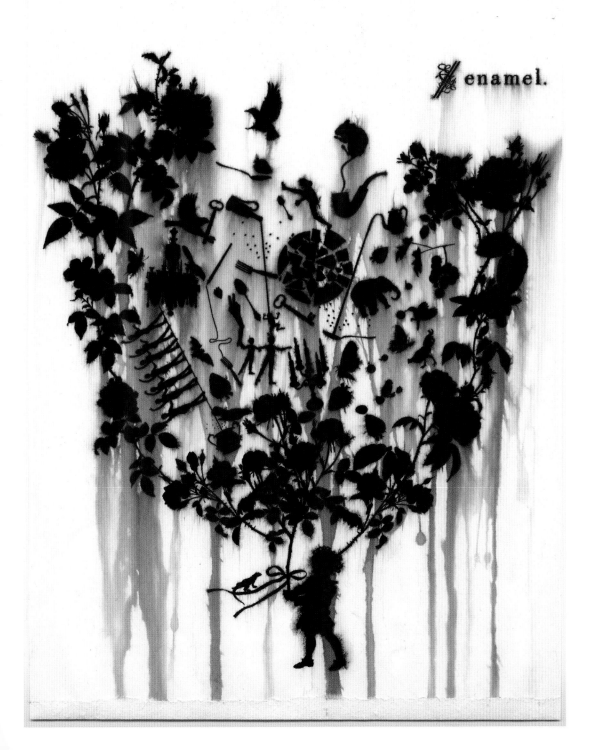

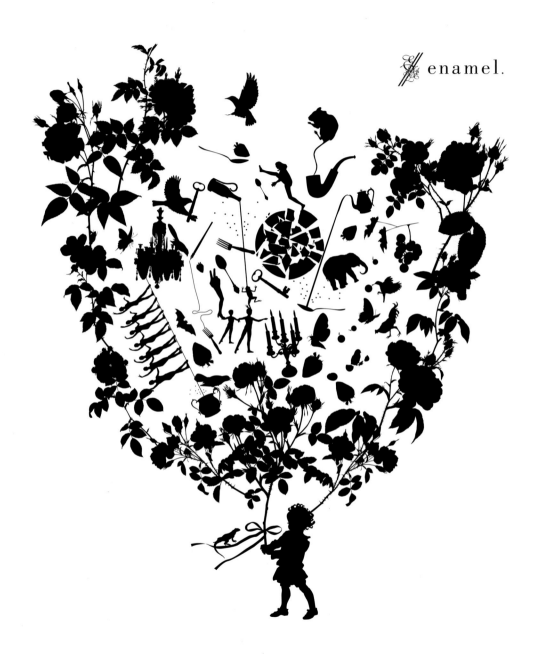

enamel.

enamel

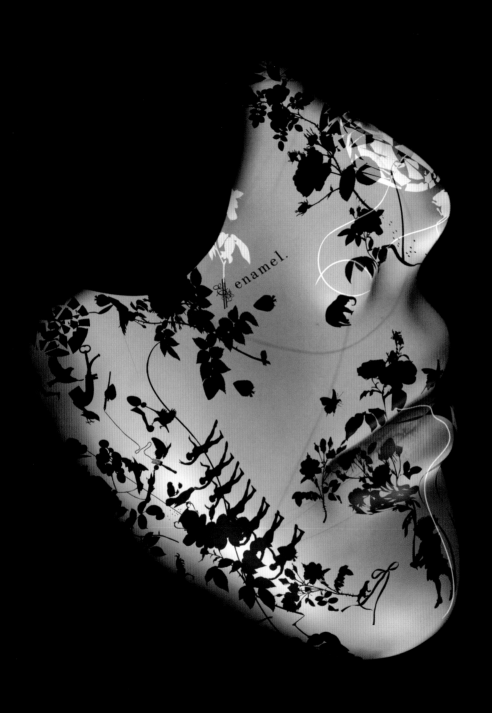

enamel.

musa collective

Lisboa, Portugal

Do you have any tattoos? What does tattoo mean to you?
Some of us have tattoos. It means something personal engraved on your body as a mark of your thoughts at a certain period of your life.

What is the first thing that comes to mind when you think of tattoos?
That my body will be marked with something I believe in at that moment and that it will help to remind me of something I've experienced once in my life.

Where do you want to have your tattoo(s)? Why?
My body is like a blank page – it can be ornamented everywhere depending on the meaning, design and my will.

Would you like to get your "tattoo icon" as a real tattoo? Why or why not?
Yes! Because most of them have been made with relevant provocative meaning that could interact with your body as a kind of sign that's easy to understand.

BulletTarget

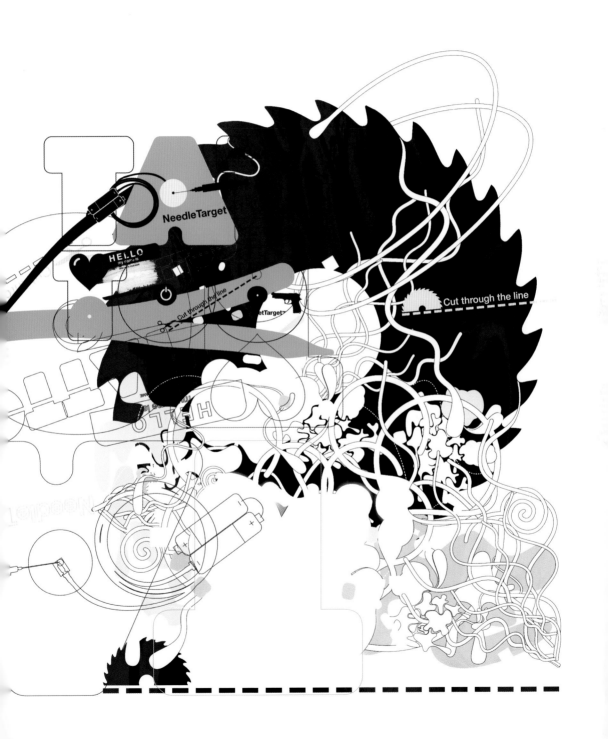

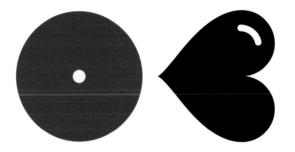

LoveTarget™

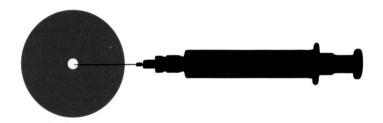

NeedleTarget™

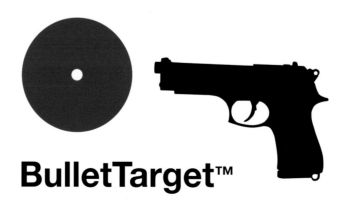

BulletTarget™

musa collective

HELLO

my name is

HERE: WRITE YOUR NAME

Cut through the line

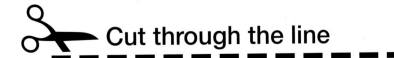
Cut through the line

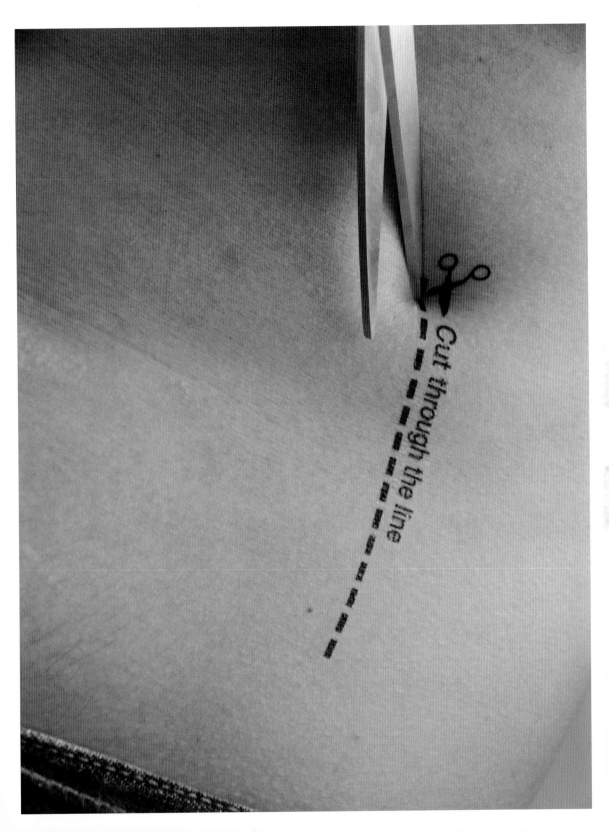

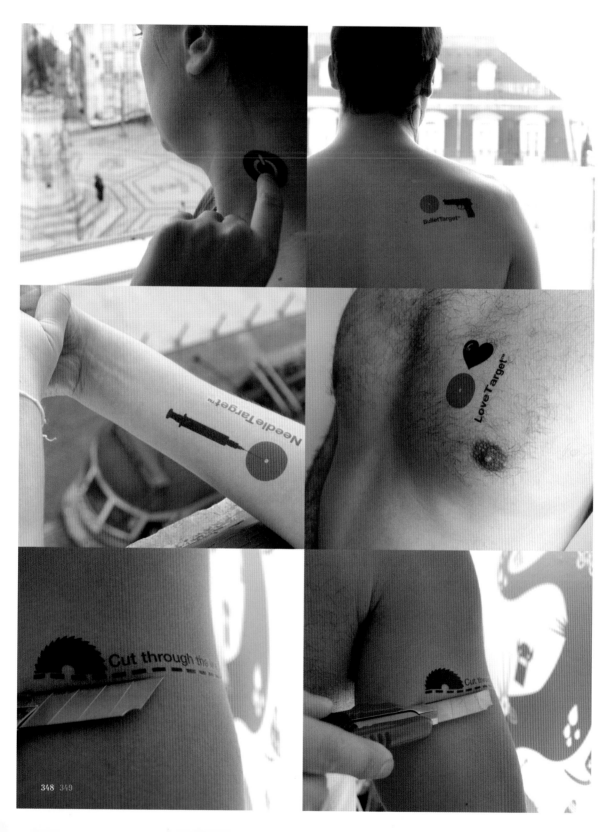

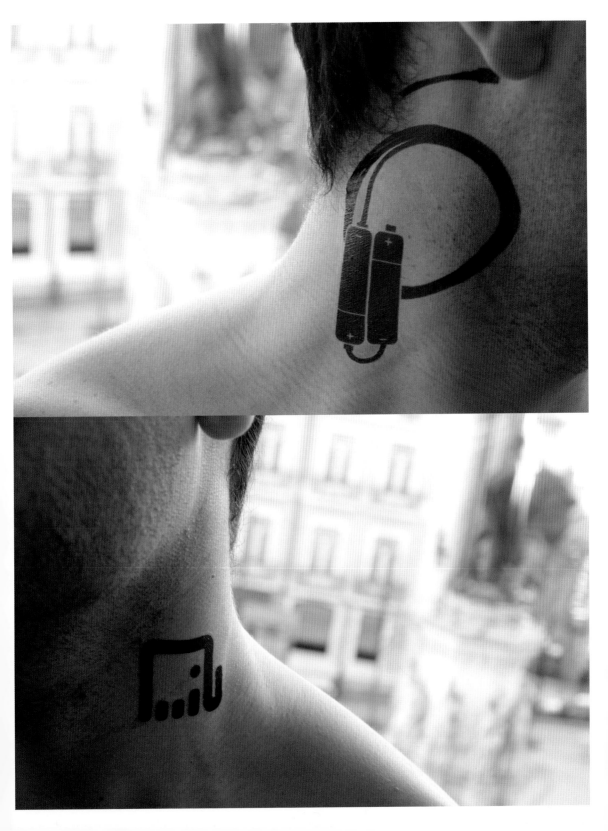

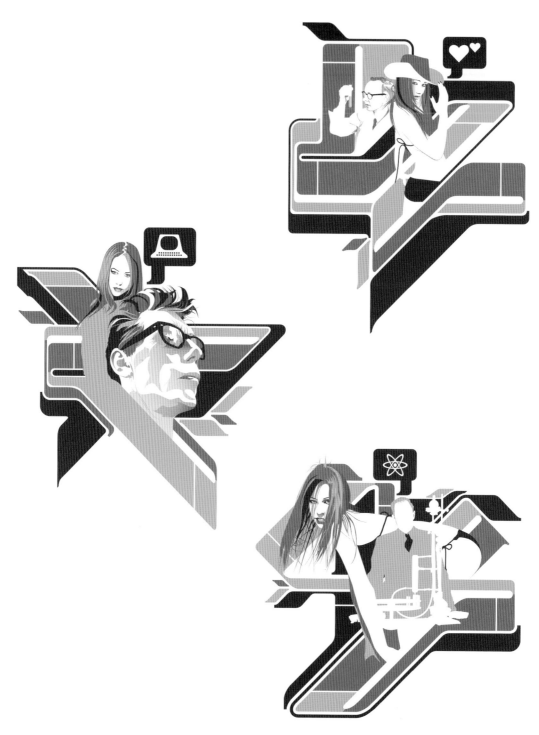

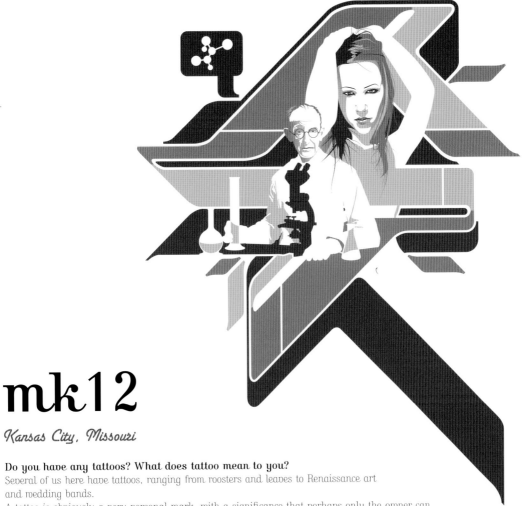

mk12

Kansas City, Missouri

Do you have any tattoos? What does tattoo mean to you?

Several of us here have tattoos, ranging from roosters and leaves to Renaissance art
and wedding bands.

A tattoo is obviously a very personal mark, with a significance that perhaps only the owner can
understand or fully appreciate. I can't speak for the others who have tattoos here at MK12, but for
myself, my tattoos serve as visual reminders of specific times in my life. The desire to have those
"reminders" with me permanently is not something that I can explain, but that is perhaps the
beauty of tattoo art: it needs no justification; it simply is what it is.

What is the first thing that comes to mind when you think of tattoos?

Drunk sailors and punk-rock burnouts.

Where do you want to have your next tattoo(s)? Why?

That would depend on the design. A tattoo should compliment the part of the body it's placed on.

Would you like to get your "tattoo icon" as a real tattoo? Why or why not?

My love affair with my own artwork lasts for a very short period; sometimes it takes only a few
days for me to start to dislike a piece that I've made. I wouldn't trust myself to come up with a
tattoo design so iconic that I wouldn't get tired of looking at it.

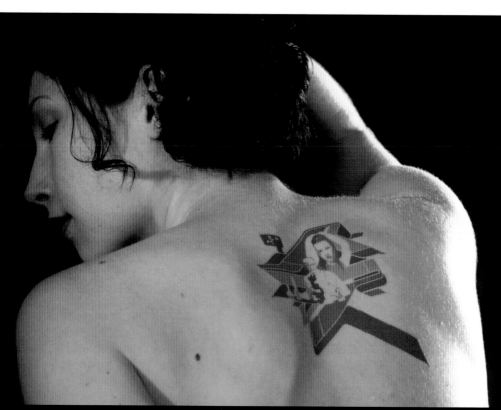

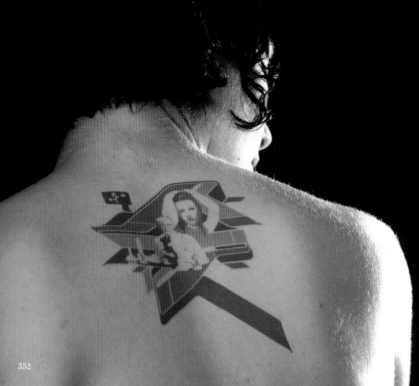

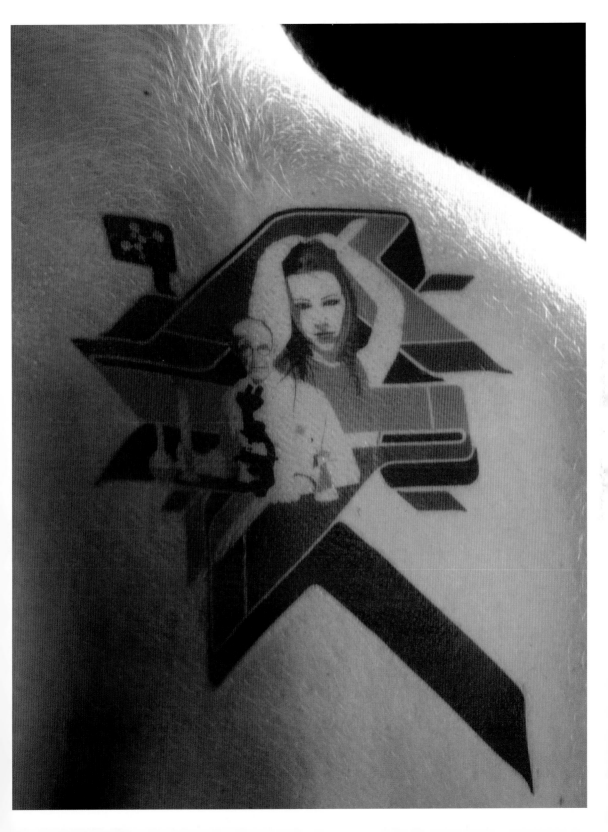

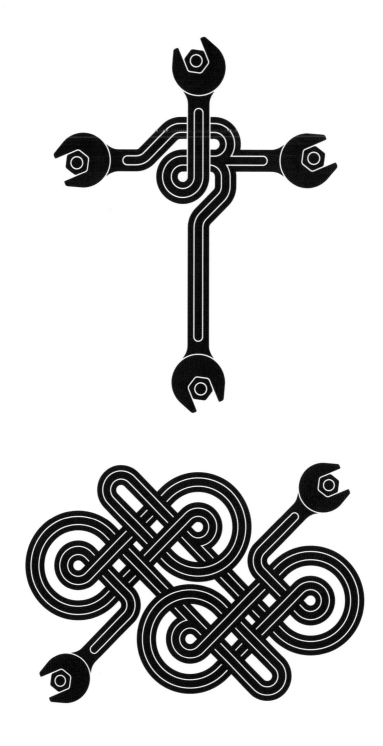

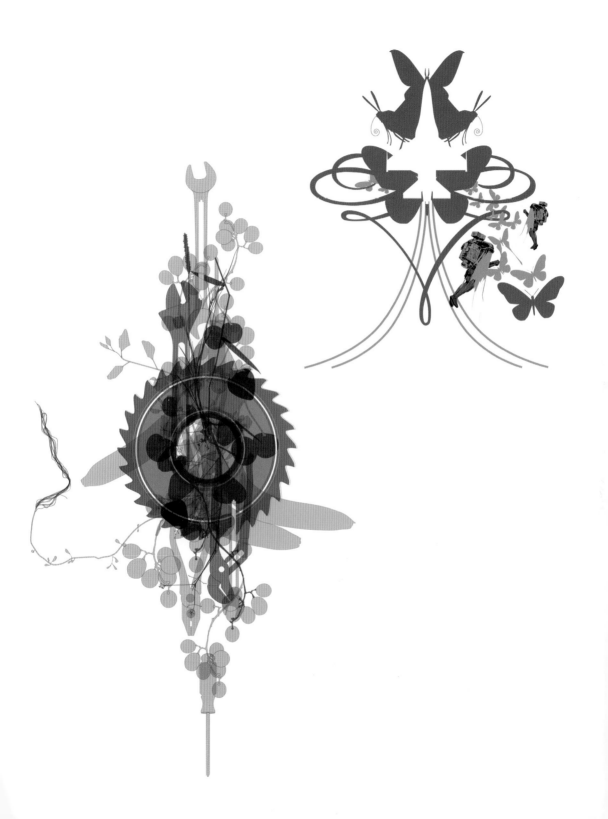

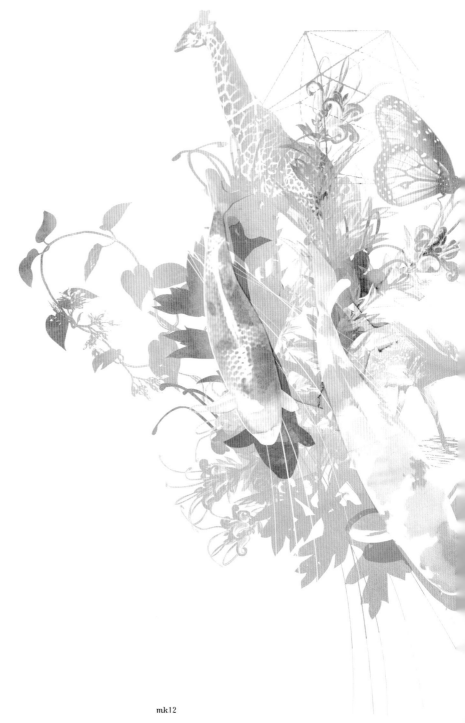

mk12

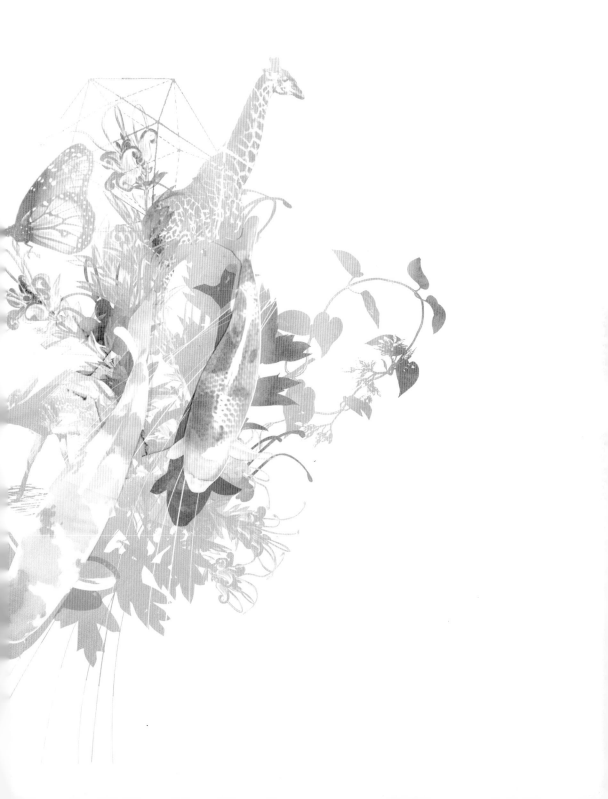

beat 13

Do you have any tattoos? What does tattoo mean to you?
Matt: Physical cultural expression
Lucy: A permanent memory of a time in your life.

What is the first thing that comes to mind when you think of tattoos?
Matt: "Yakuza."
Lucy: I want one.

Where do you want to have your tattoo(s)? Why?
Matt: Across my chest.
Lucy: Hands or feet.

Would you like to get your "tattoo icon" as a real tatoo? Why or why not?
Matt: Possibly.
Lucy: Yes!

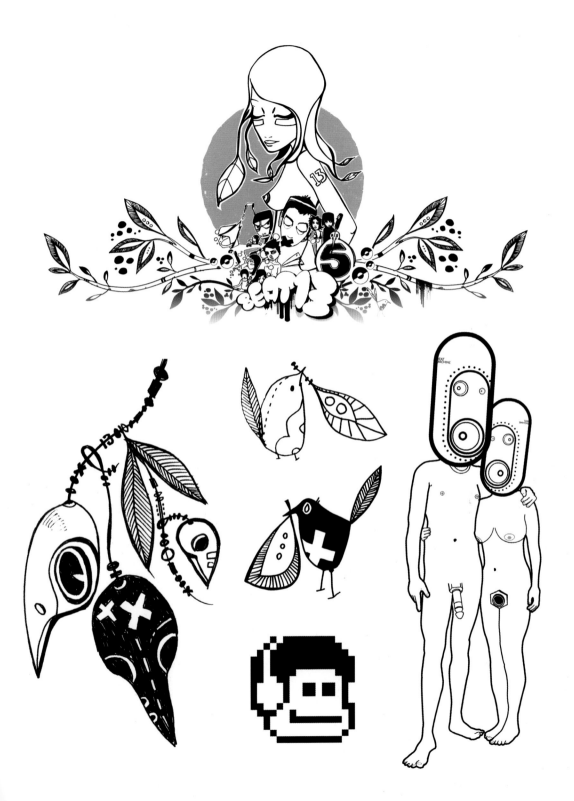

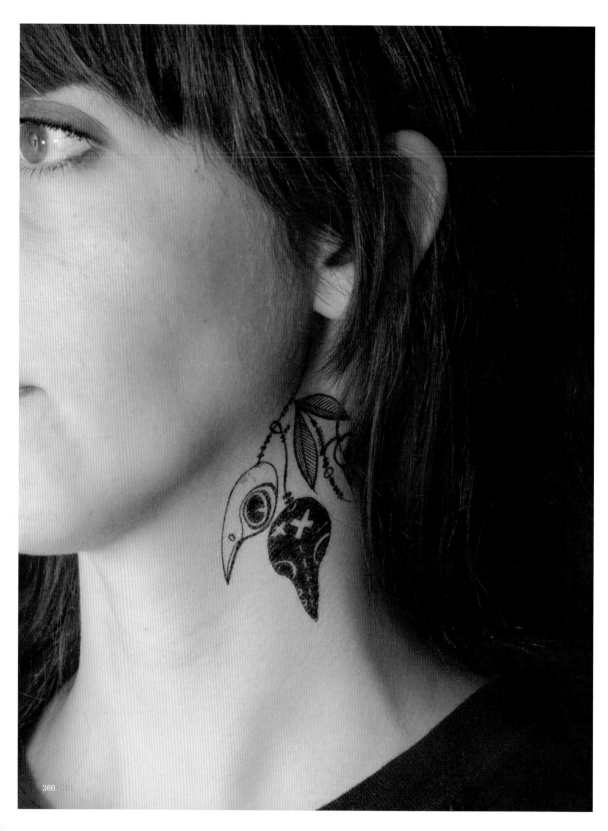

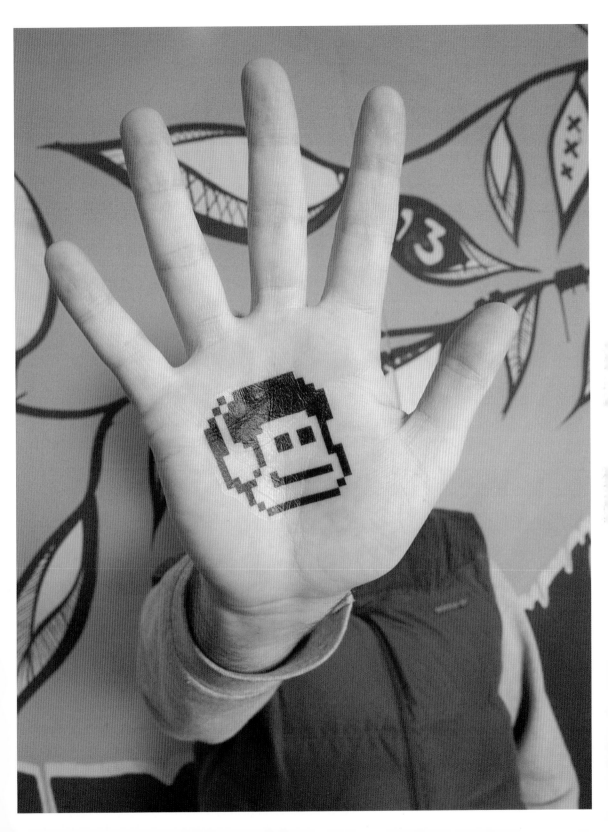

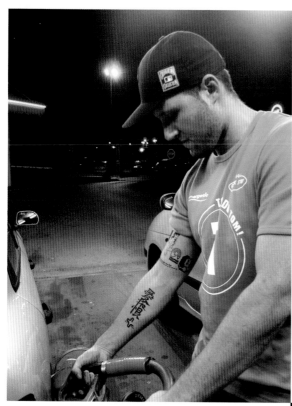
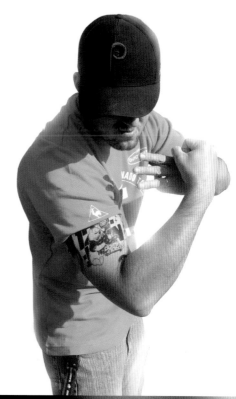
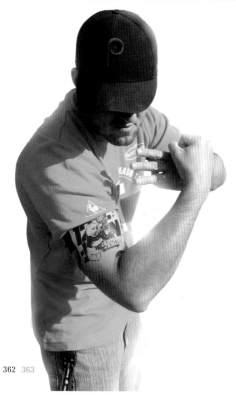
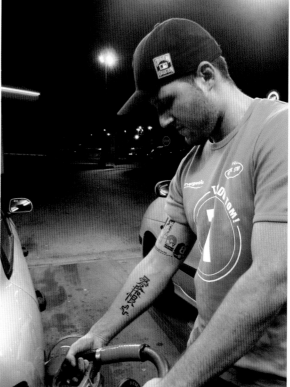

123klan

Haubourdin, France

Do you have any tattoos? What does tattoo mean to you?
Scien : No, I don't. I've wanted one for a long time, but I'm just scared to regret it one day.
Klor: No, tattoos make me think about the ones you get for free inside gum wrappers.

What is the first thing that comes to mind when you think of tattoos?
Scien: Maybe pain.
Klor: Joshua Davis (Praystation.com) He's got half of his body totally tattooed.

Where do you want to have your tattoo(s)? Why?
Scien: Certainly on my forearm, and why? I don't know, maybe to appreciate it sometimes.
Klor: On Scien, because I'm scared to get one, and I think it hurts too much.

Would you like to get your "tattoo icon" as a real tattoo? Why or why not?
Scien: No, because like I told you, I'm just scared to regret it one day. That's also the reason if I have to get tattoo one day I will ask a friend to do something for me. I want something that I'm sure to like until death.
Klor: Yes still on Scien.

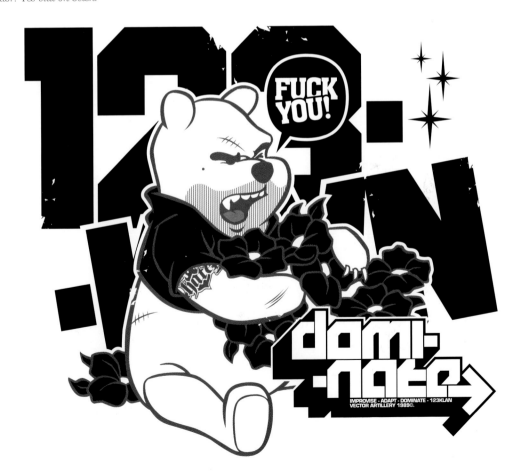

dirty **PaKi** ©

PULKi NASTY

PULKI
May the style be with you.

123 **klan** ™

MRS **Klor**

scien ©
I GOT THE SKILL TO PAY THE BILL

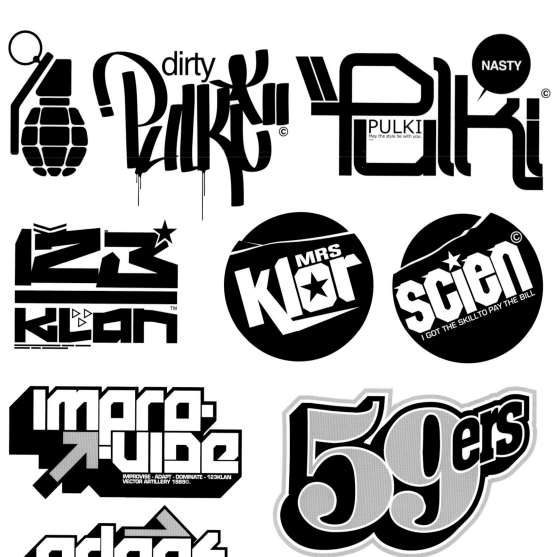

impro-vibe
IMPROVISE - ADAPT - DOMINATE - 123KLAN
VECTOR ARTILLERY 1989©.

59ers

adapt
IMPROVISE - ADAPT - DOMINATE - 123KLAN
VECTOR ARTILLERY 1989©.

domi-nate
IMPROVISE - ADAPT - DOMINATE - 123KLAN
VECTOR ARTILLERY 1989©.

123klan

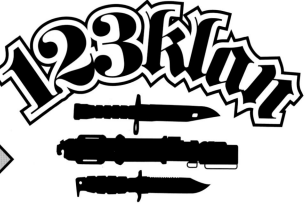

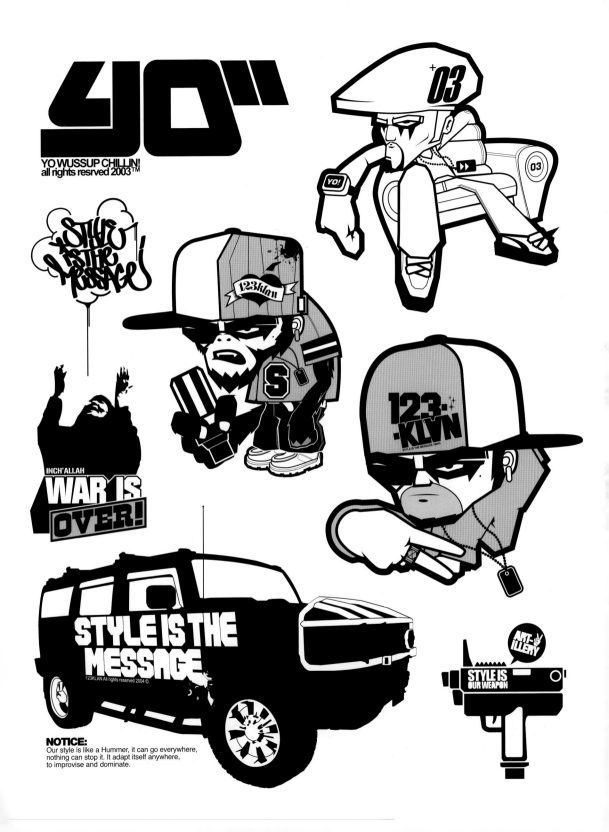

YO"

YO WUSSUP CHILLIN!
all rights resrved 2003™

STYLE IS THE MESSAGE

INCH'ALLAH
WAR IS
OVER!

123·
-KLVN
STYLE IS THE MESSAGE 1984©

STYLE IS THE
MESSAGE

123KLAN All rights reserved 2004 ©.

ART-
ILLERY

STYLE IS
OUR WEAPON

NOTICE:
Our style is like a Hummer, it can go everywhere,
nothing can stop it. It adapt itself anywhere,
to improvise and dominate.

STYLE TALENT POWER

123K™
2005

we love flat colors
▶ Who's your MASTER?

58 BR8

I ♥ MEAT

123 KLYN™

Still in the p... 199...
Style is the m...

MINOR THREAT

adapt

IMPROVISE · AQAPT · QOMINATE · 123KLAN
VECTOR ARTILLERY 1989©.

NOTICE: ⊙ ▶▶

SOMETIMES GOOD GUYZ DON'T WEAR WHITE!

THE BIG MONSTA

milkxhake

Hong Kong, China

Do you have any tattoos? What does tattoo mean to you?
No, we do not have tattoos. We think tattoo is a form of identity imprints on the body,
just like on business cards.

What is the first thing that comes to mind when you think of tattoos?
Japanese gangsters. Joshua Davis who is well-known for his tattoo.

Where do you want to have your tattoo(s)? Why?
Definitely on the back near the hip. A tattoo can be a statement about yourself, and we
want to make it more fun.

Would you like to get your "tattoo icon" as a real tattoo? Why or why not?
Why not?! Because they are our works, and we do love identity.

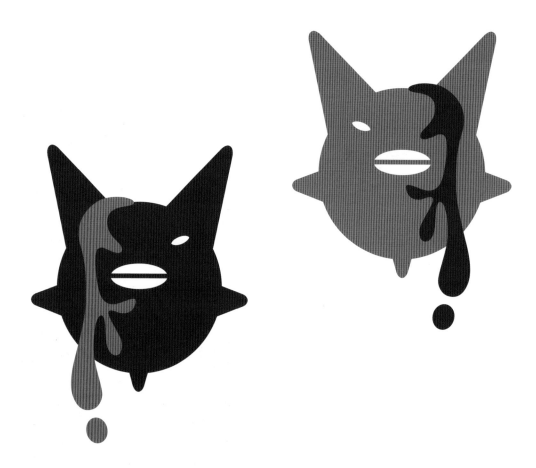

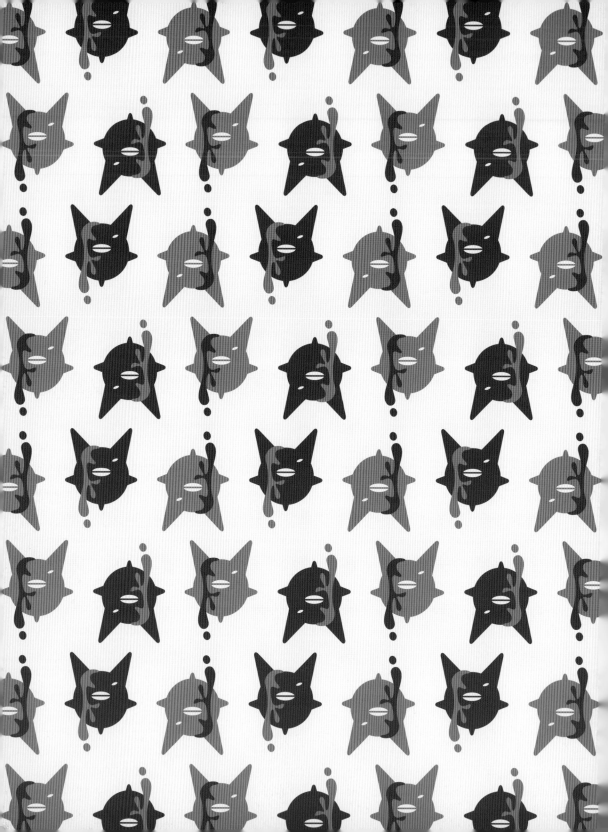

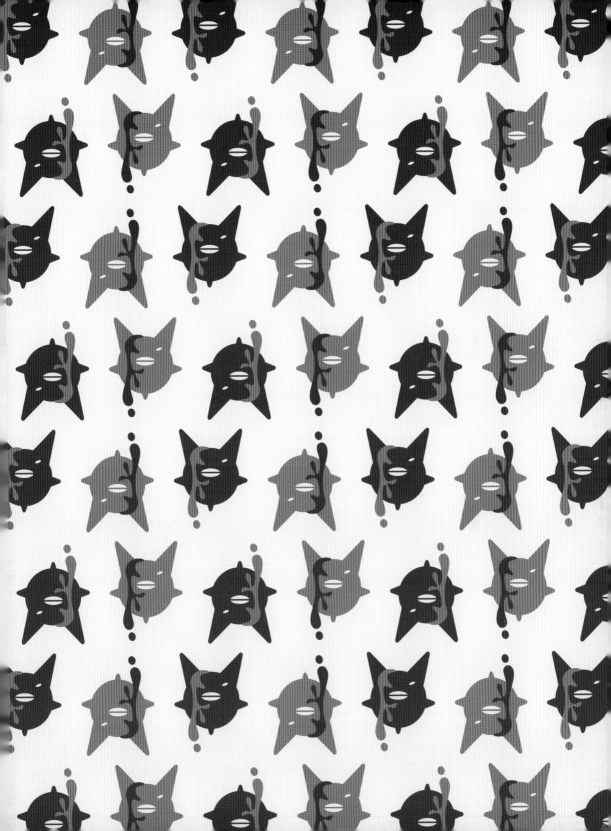

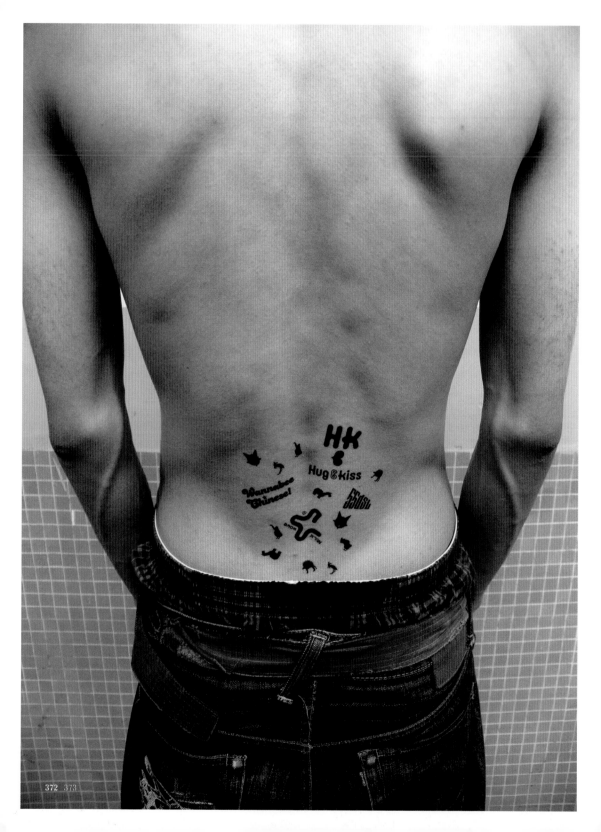

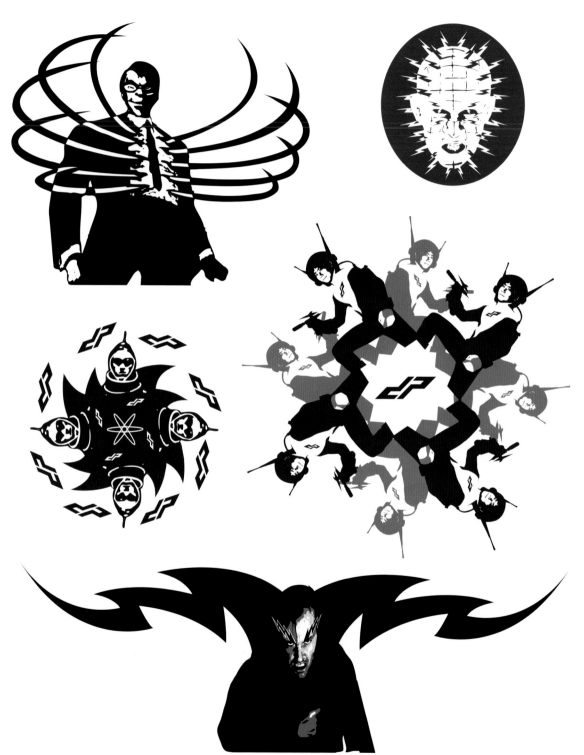

dopepope

New York, New York

Do you have any tattoos? What does tattoo mean to you?
None for me. I generally appreciate a tattoo on others. I totally respect and admire the
artwork involved. I just don't wish to mark my body in such a way. I can be indecisive at
times, and I know I'd like my tattoo when I first get it, but be sick of it way too soon after.

What is the first thing that comes to mind when you think about tattoos?
Woody Woodpecker with a cigar.

Where do you want to have your tattoo(s)? Why?
I once considered doing my entire back. I like the idea of not being able to see it easily,
so I don't grow bored with it.

Would you like to get your "tattoo icon" as a real tattoo? Why or why not?
I'll probably never get a tattoo, but hypothetically I'd love my designs to be tattoos.
I'd be proud to be inked with my own work.

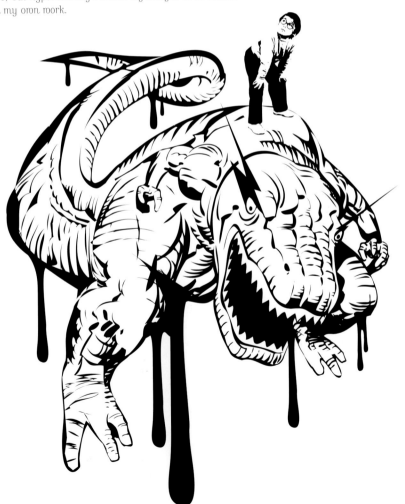

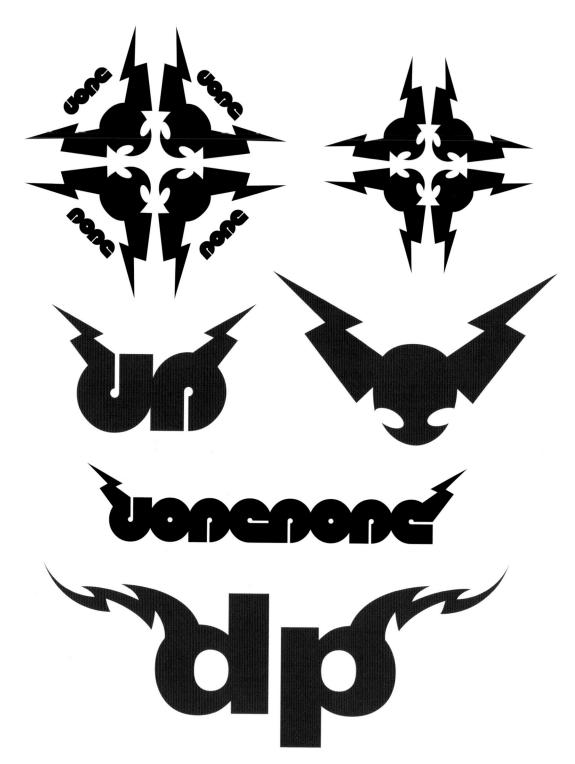

dopepope

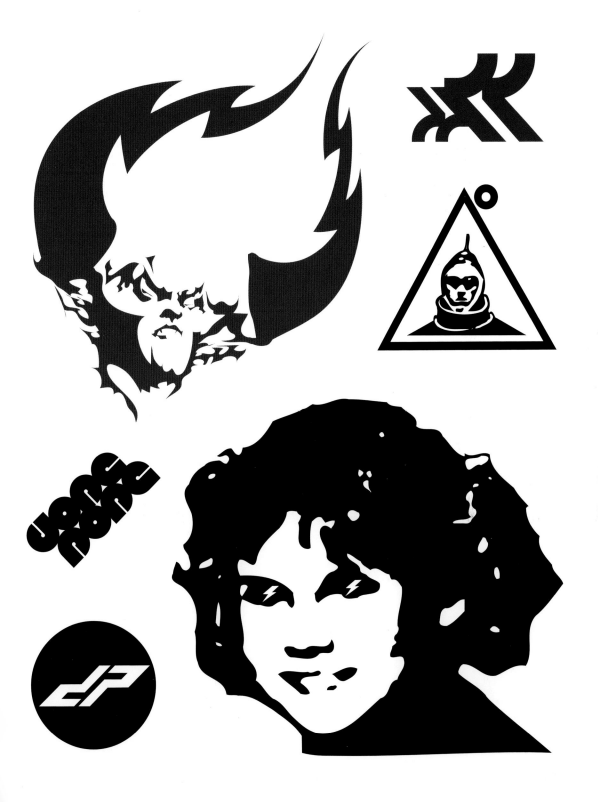

computer head

Hong Kong, China

Do you have any tattoos? What does tattoo mean to you?
Represents personality.

**What is the first thing that comes to mind
when you think of tattoos?**
Gangster.

Where do you want to have your tattoo(s)? Why?
Back of my neck.

**Would you like to get your "tattoo icon" as
a real tattoo? Why or why not?**
No. It's not the best one.

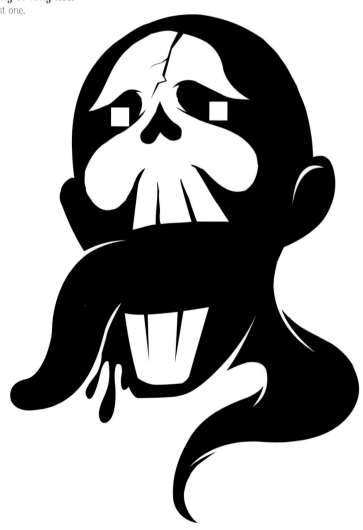

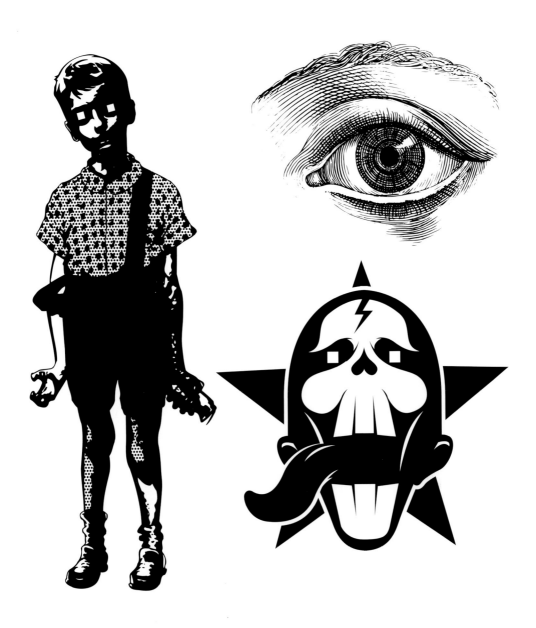

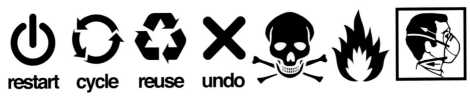

restart cycle reuse undo

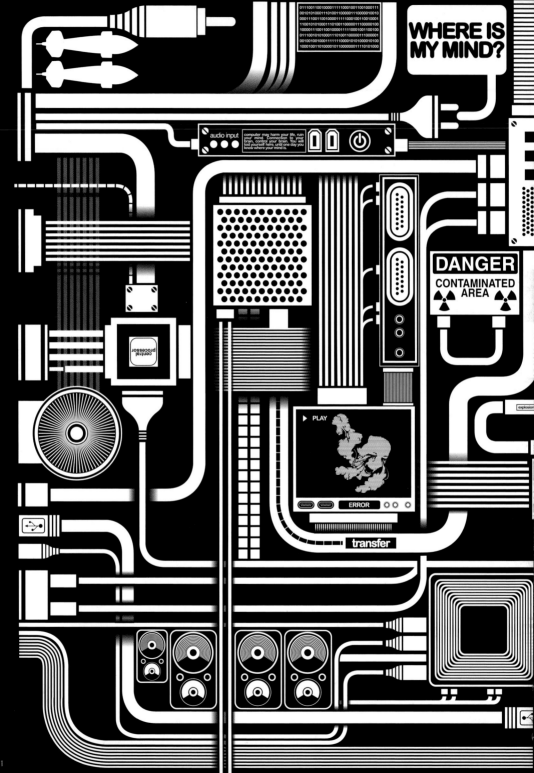

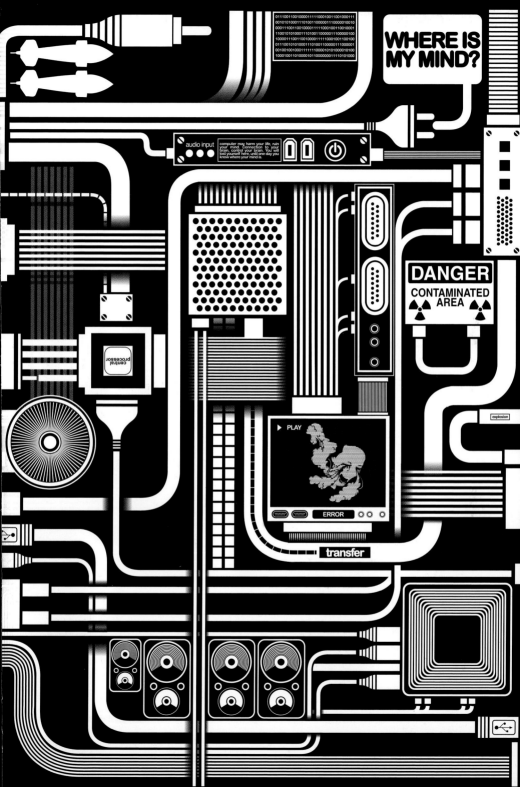

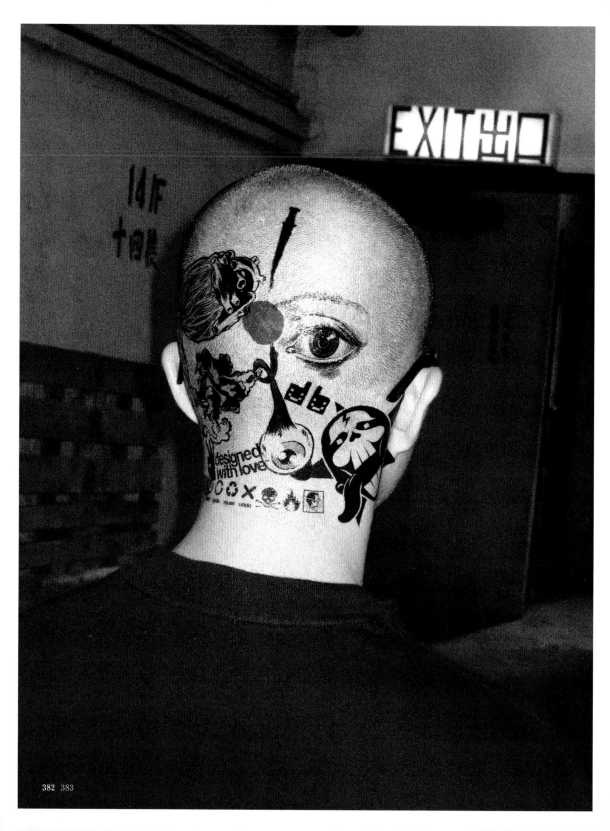

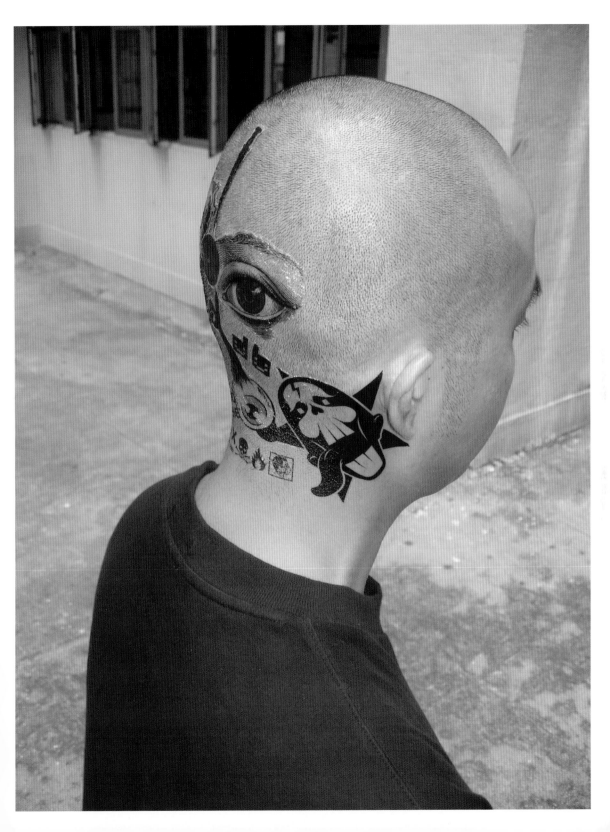

stapelberg&fritz

Stuttgart, Germany

Do you have any tattoos? What does tattoo mean to you?
No. We don't like tattoos that much.

What is the first thing that comes to mind when you think of tattoos?
See question 1.

Where do you want to have your tattoo(s)? Why?
See question 1.

Would you like to get your "tattoo icon" as a real tattoo? Why or why not?
See question 1.

bestboy

friday riders night

designed
with love™

designed
with type™

GRAPHIK
FREUNDE

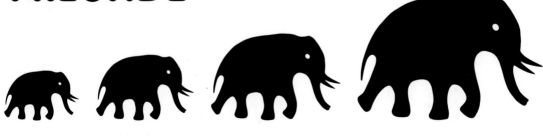

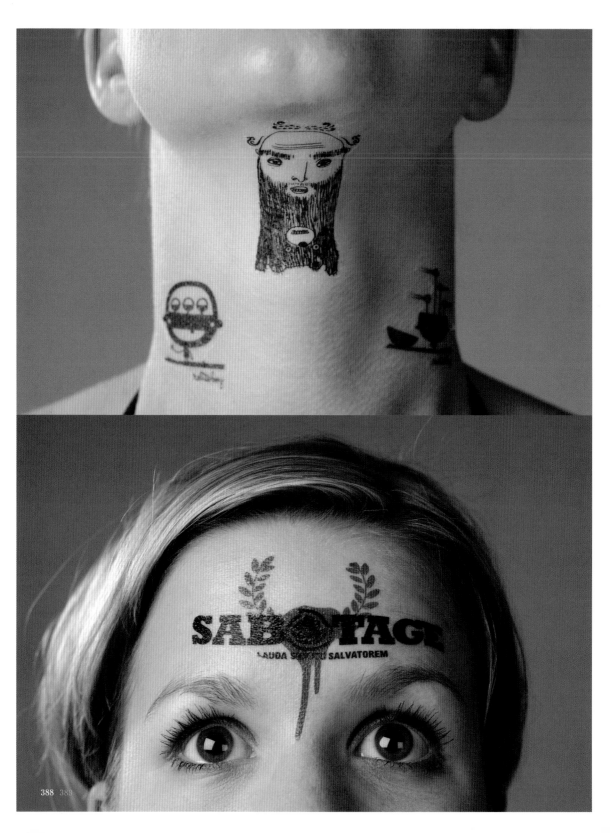

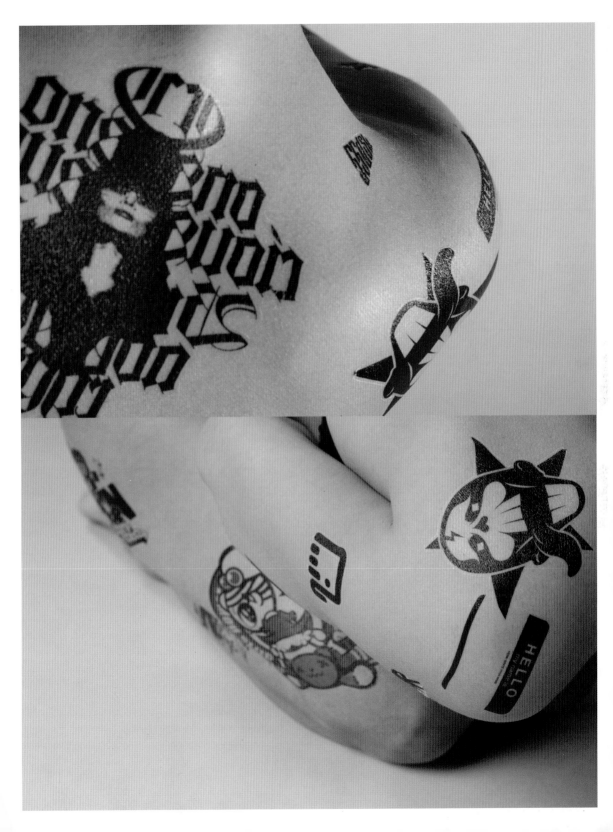

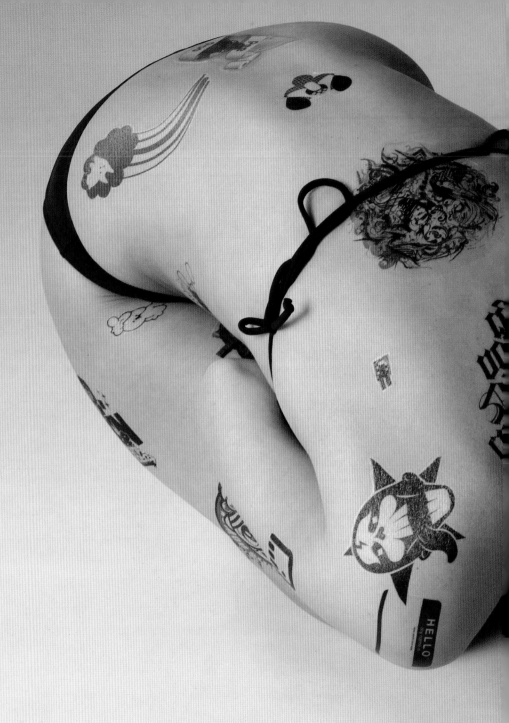

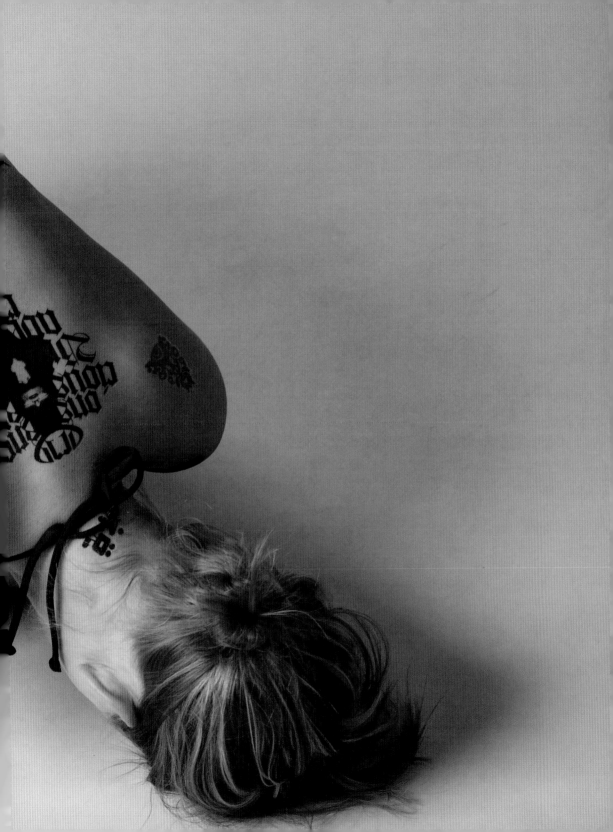

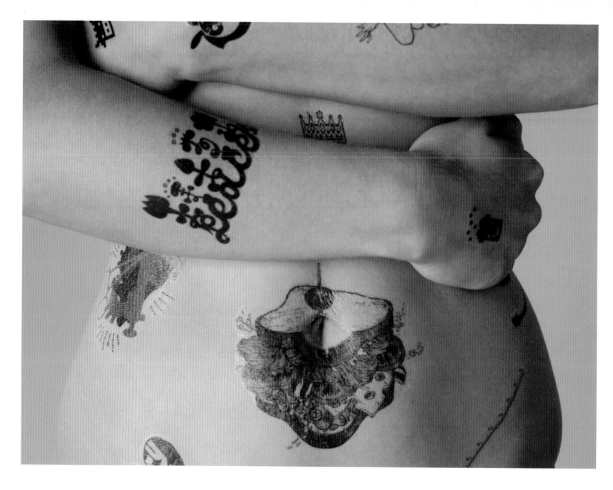

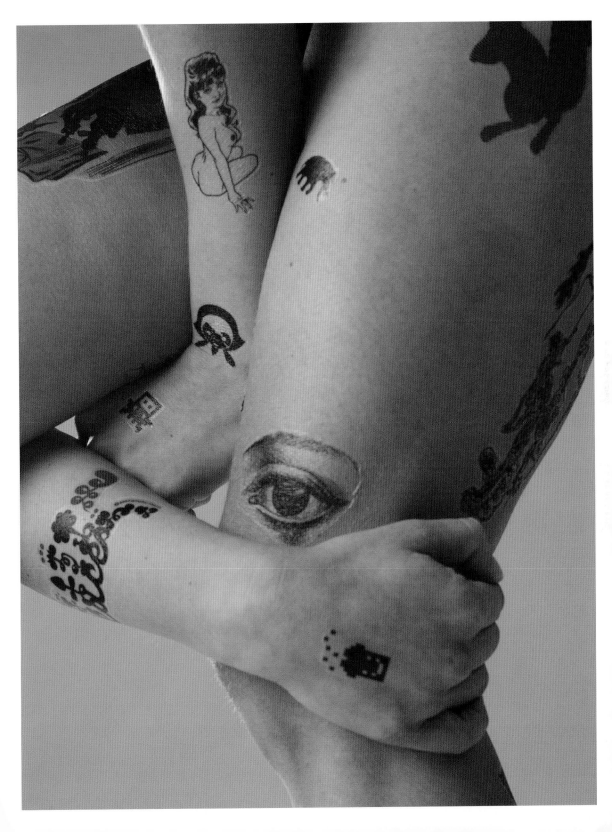

panism

Hong Kong, China

Do you have any tattoos? What does tattoo mean to you?
No. I don't. I think tattoo is a kind of graphic communication, telling others
who you are or reminding yourself who you want to be.

What is the first thing that comes to mind when you think of tattoos?
Japanese gangster.

Where do you want to have your tattoo(s)? Why?
Arms. Everyone can see it.

Would you like to get your "tattoo icon" as a real tattoo? Why or why not?
Maybe, but fake is more fun.

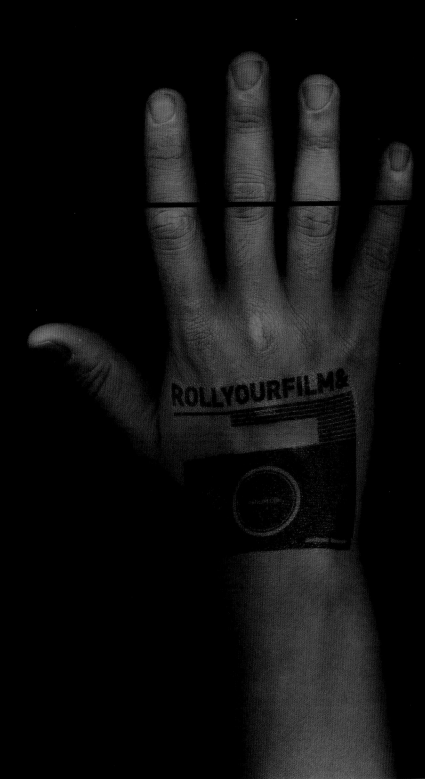

ian wright

London, UK

Do you have any tattoos? What does tattoos mean to you?
No. It means tradition.

What is the first thing that comes to mind when you think of tattoos?
Commitment.

Where do you want to have your tattoo(s)? Why?
No idea.

Would you like to get your "tattoo icon" as a real tattoo?
Not yet!

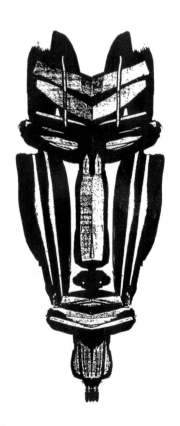

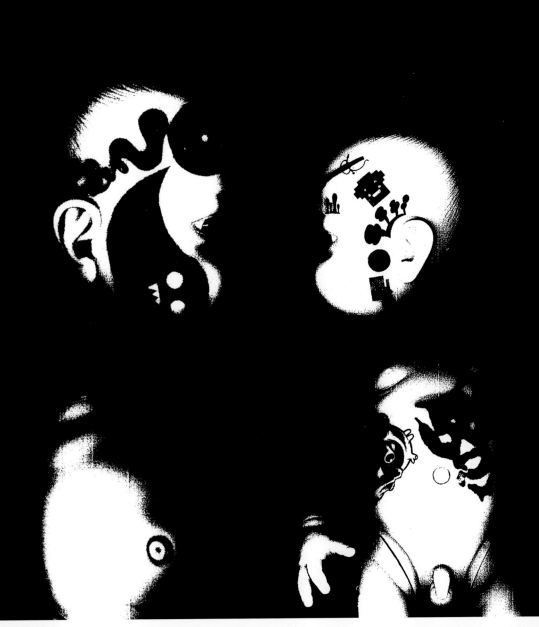

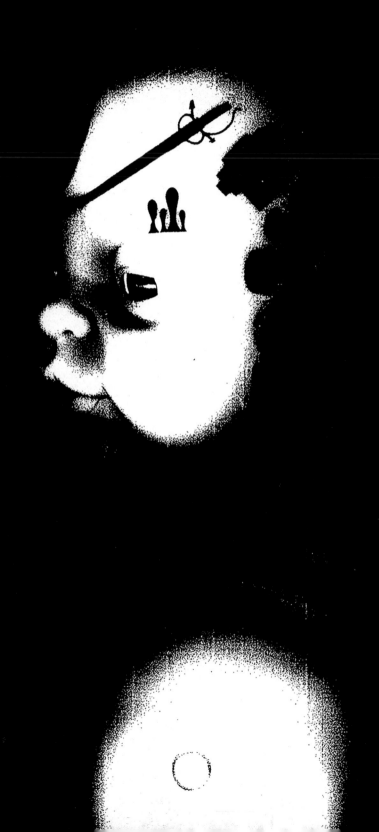

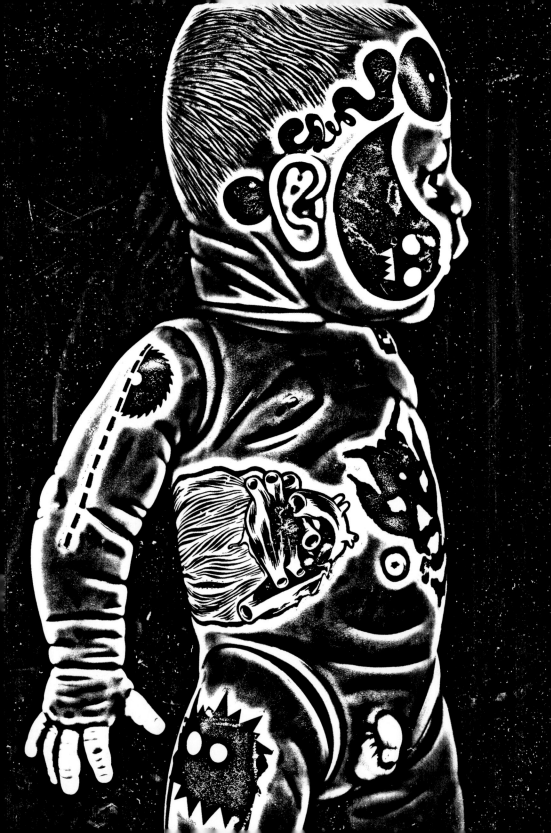

dainippon type organization

Tokyo, Japan

Do you have any tattoos? What does tattoos mean to you?
No. Pain.

What is the first thing that comes to mind when you think of tattoos?
Pain.

Where do you want to have your tattoo(s)? Why?
No, thank you.

Would you like to get your "tattoo icon" as a real tattoo? Why or why not?
No, thank you.

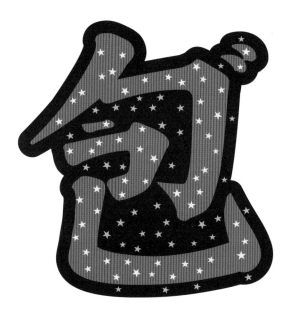
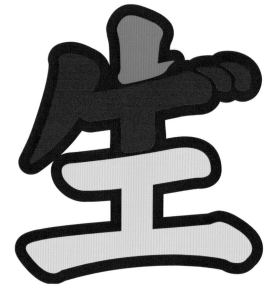

功 秀 今

足 夜 号

光 与 与

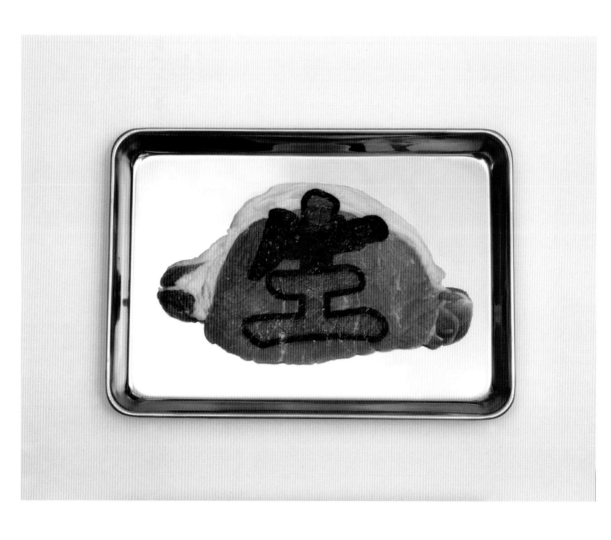

dainippon type organization

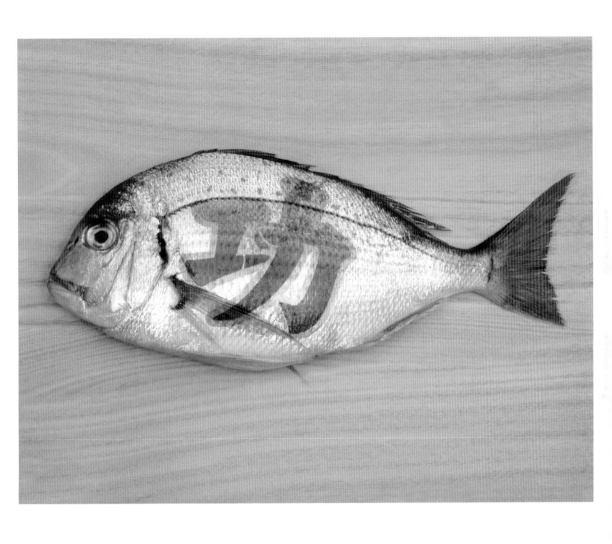

WIG-01

LOVE

HATE

mig-01

Lincoln, UK

Do you have any tattoos? What does tattoo mean to you?
I haven't got any tattoos. I wouldn't want to wear anything on my skin for the rest of my life. Fashions change.

What is the first thing that comes to mind when you think of tattoos?
Permanent.

Where do you want to have your tattoo(s)? Why?
Somewhere discreet.

Would you like to get your "tattoo icon" as a real tattoo? Why or why not?
I wouldn't want any "real" tattoos, but I think temporary transfers are a good alternative.

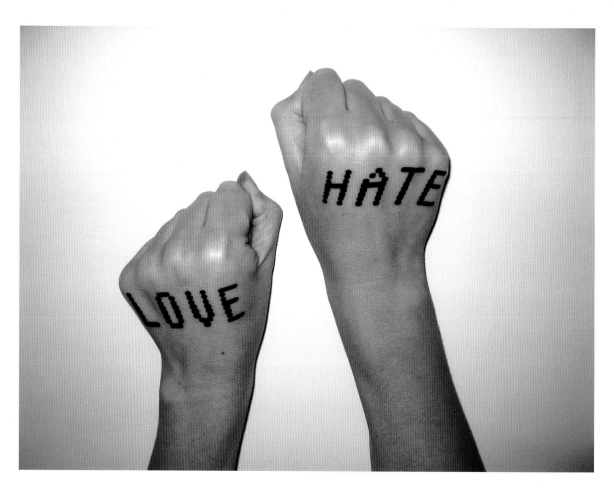

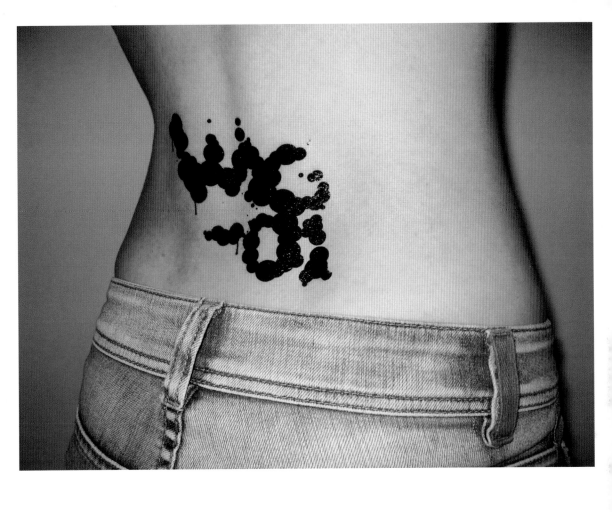

norm

Zurich, Switzerland

Do you have any tattoos? What does tattoo mean to you?
No. A tattoo is an unremovable device.

What is the first thing that comes to mind when you think of tattoos?
Henry Rollins.

Where do you want to have your tattoo(s)? Why?
We don't want any.

Would you like to get your "tattoo icon" as a real tattoo? Why or why not?
We don't want any.

TOONICEFORWORDS

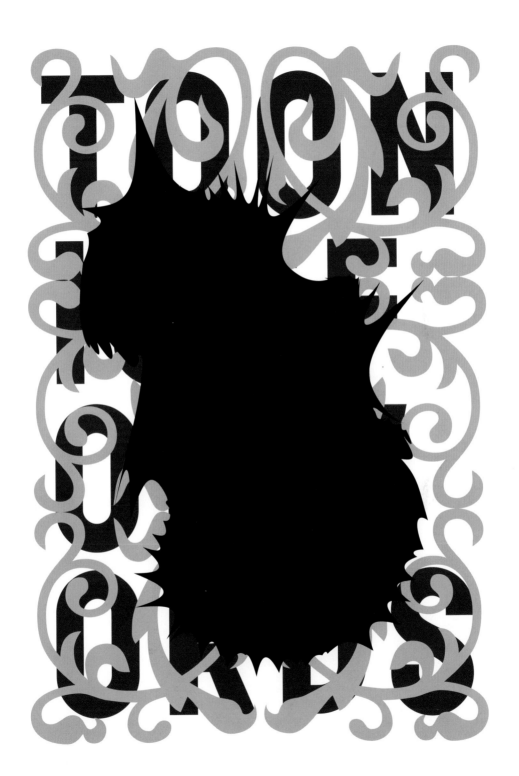

TOONICEFORWORDS

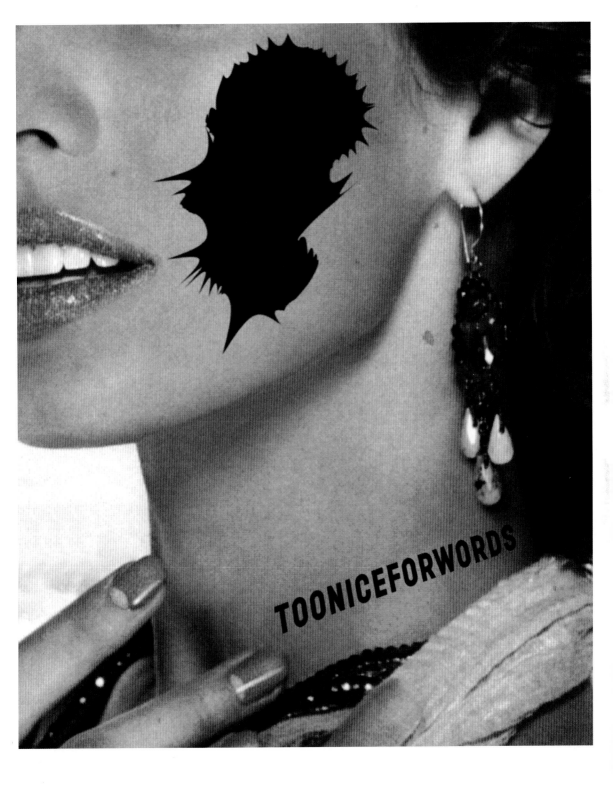

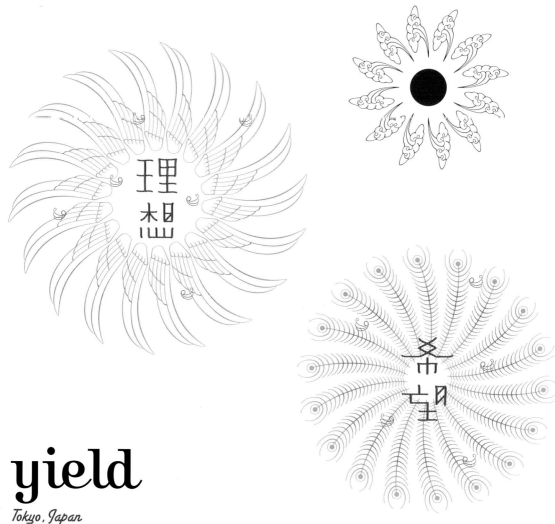

yield
Tokyo, Japan

Do you have any tattoos? What does tattoo mean to you?
No, I don't have any. It means surprise, scary, decision, regret and tradition of Japan to me.

What is the first thing that comes to mind when you think of tattoos?
"Yakuza."

Where do you want to have your tattoo(s)? Why?
I don't want to have any tattoos because it could be too painful. But if they are fake, I want to have huge tattoos like "yakuza."

Would you like to get your "tattoo icon" as a real tattoo? Why or why not?
No, I wouldn't. I lose interest easily, so removable fake tattoos are better for me.

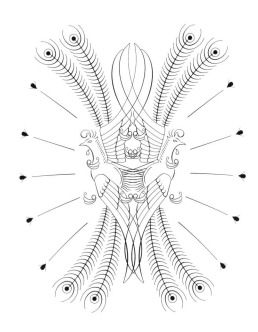

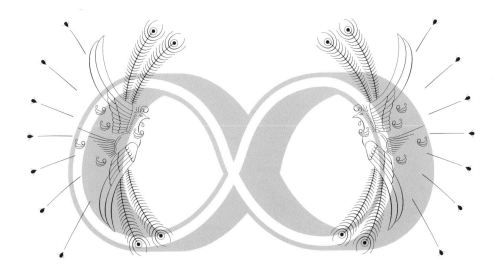

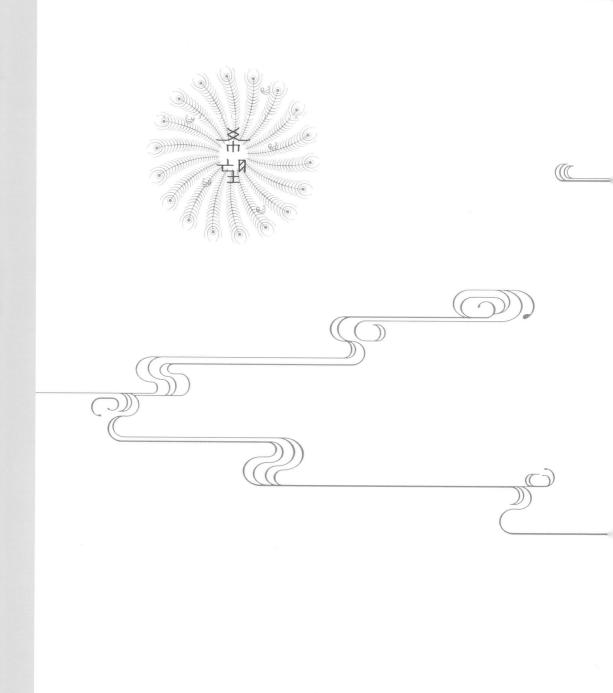

視

g fuck'n ¥
€apitalit

Visual Language

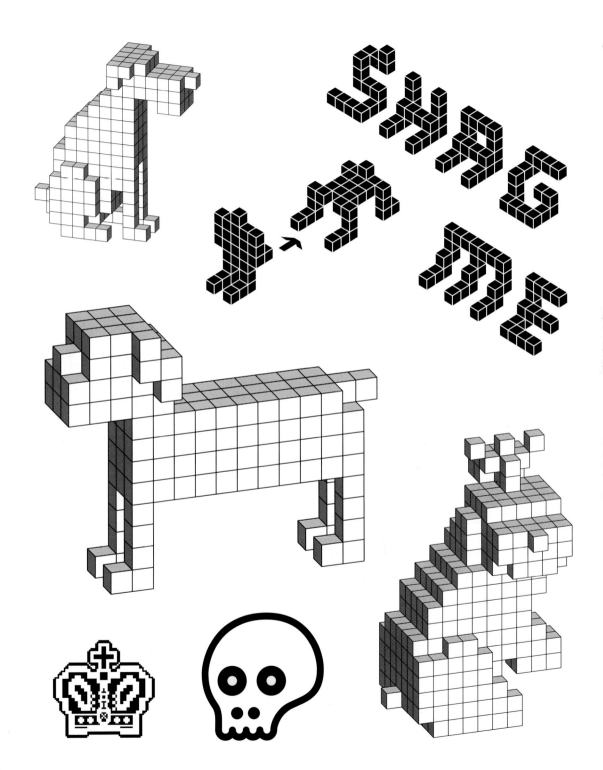

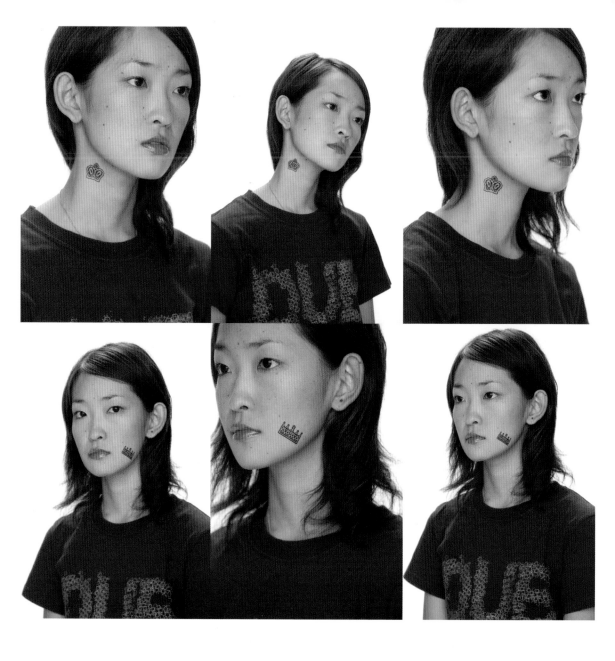

yield

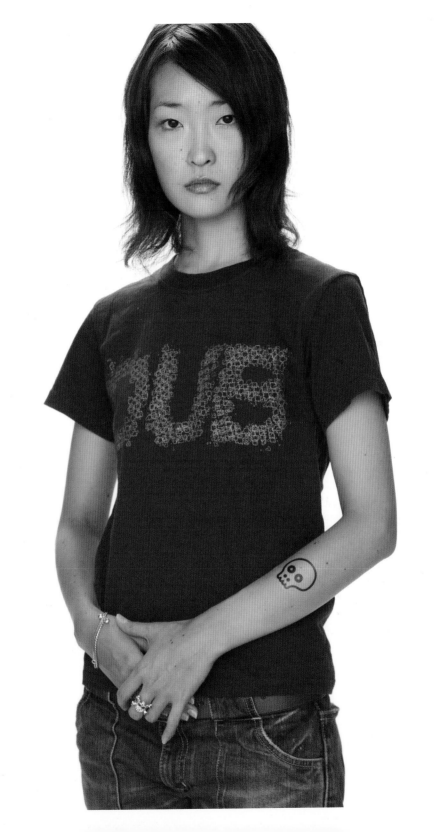

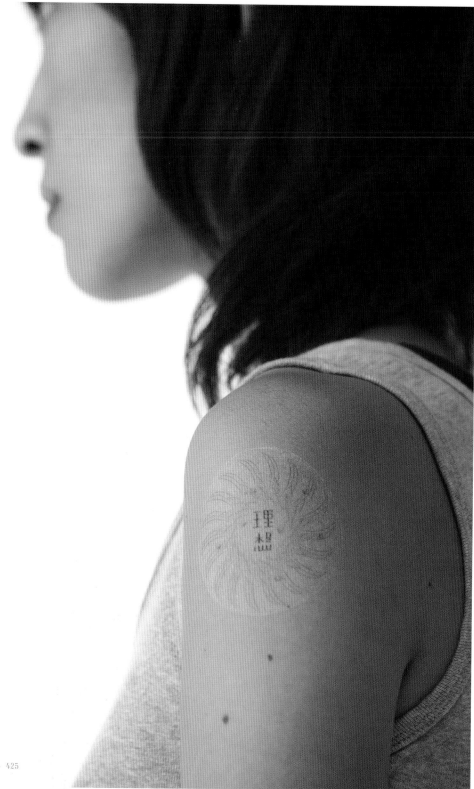

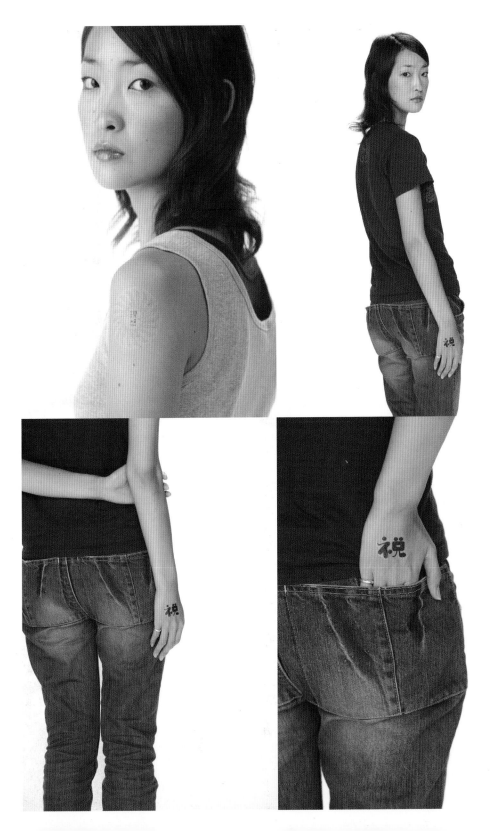

123klan

www.123klan.com

Founded by Scien and Klor in 1992, 123Klan have been big on the graffiti scene since 1989. When they discovered Neville Brody's work on typography, graphic art became a logical extension of their graffiti writing. 123klan were the first to blend graffiti writing and graphic art on the web, making it not just an exhibition tool but also a new creative medium. The screen, like a blank wall, became a space to be laid out. In parallel, the influence of graphic art could be seen on their walls; everything revolved around lettering. For these trailblazers, graffiti writing and graphic art are closely linked and, as they say themselves, "Style is the message."

abiuro

www.abiuro.com.

Alexandre Braga, a.k.a. Abiuro, is from São Paulo, Brazil. Since 1999 he has worked in different areas and aesthetics of graphic design, illustration and art. His clients include MTV, GNT, Bravo!, Ellus, V.ROM, Simples, Trip Magazine and many others. His work was published in "Semi-Permanent 05" book by Design is Kinky, "Rojo" Magazine, "Dos Logos," "Pictoplasma," "Resfest Brasil" by De's, "Sketchel Book" by Jeremy Ville, "Res" Magazine among others.

achilles greminger

www.nudesign.ch

An illustrator and graphic designer based in Zurich, Switzerland.

beat13

www.beat13.co.uk

A name Matt Watkins and Lucy Mclauchlan used for initiating creative projects, involving themselves and other collaborators. Since 1999, Lucy and Matt have combined their talents to produce art, illustrations, exhibitions and installations while also working on numerous projects individually. Matt's background includes creative design and animation roles with Jamie Hewlett's Zombie team and Lucy has received international recognition as an artist in numerous exhibitions and publications around the world.

benjamin güedel

www.guedel.biz

Born in 1968, Güedel has been working for years creating and editing comics. Since 1998, he has been working as an illustrator.

cheeky sweet graphics

www.cheekysweetgraphics.com.

Founded by Thibault Choquel who after studying firm's communication, worked on several multimedia projects as a web designer in France for a year. He then decided to move to Copenhagen, Denmark in 2002, where he was employed by the Roskilde Music Festival as a senior designer and team leader. After returning to France in 2003, he worked for several communication firms as a senior designer. In 2004, he decided to work freelance. Today the experience continues as he joined with Nicolas Dhennin to form Studio Poana.

computer head

www.computer-head.com.

Sam Yu-Sum Lo, a.k.a. Computerhead, graduated from the HK Polytechnics University in 2001 majoring in visual communications. After graduation, he has worked in different fields such as event productions, advertising and fashion graphic. Lo has also worked on different kinds of graphic projects and exhibitions. In 2004, he launched his personal website as his creative platform to share his works and keep producing different kinds of illustration and graphic works.

dainippon type organization

www.dainippon.type.org

Established in 1993, Dainippon Type Organization is an experimental typography team. From the Japanese and English alphabet, they have deconstructed, shaped and formulated a fresh typography that hasn't lost the irresistible Japonesque feel.

db-db

www.db-db.com.

Francis Lam is the founder of the online design community db-db.com. He has worked on graphic and interactive projects using digital and tangible media. In 2003 he edited and designed the book "Pixel World," published by IdN and Laurence King.

dopepope

www.dopepope.com.

Joe Lucchese, a.k.a. Dopepope, is a New York City artist specializing in bizarre character design and his own brand of illustrative graphics he calls "Experimental Aesthetics." An illustrator since childhood, he swerved his talents into the world of digital photo retouching and effects, as well as graphic design. Dopepope lends his fantastic imagery to magazines, record companies, collaborations, and gallery shows as often as possible.

driv

www.drivdriv.tk

Driv loves graphic design. He also enjoys creating his own characters, illustration, drawing, street art, or any kind of media that can express his thought. The creation of Driv's work often consists of accidental overlapping and multiplication. He believes that the process of deconstruction and reconstruction is endless until something interesting happens.

eddy so

A graphic designer in Hong Kong, who loves to make funny things. And he doesn't like to write.

eighthourday

www.eighthourday.com.

They are Katie Kirk and Nathan Strandberg. Kirk is an illustrator and designer who works in print, packaging and interactive. After stockpiling duct tape and saltines, Kirk and fellow designer Strandberg quit their cushy jobs and started the design boutique "eighthourday" in February of 2005. Kirk now lives and works in Minneapolis, Minnesota.

enamel

www.enamel.jp.org

Started as a hobby in Tokyo in 2001, enamel is Ishioka Ryoji, the graphic designer and Sayuri Ishioka, the bag designer. Every Sunday, they channel their atelier into a showroom/shop and open it as their "only Sundays."

evaq

www.evaq.com.

Asif Mian a.k.a. Evaq, is a New York based fine artist, designer and video director. Self-taught in graphic design, animation and video, Mian's work heavily relies on his background in drawing, painting and sculpture. Recently, he has directed music videos; exhibited his artwork internationally in magazines, books and shows; and designed for print and fashion. Overall, Mian's work focuses on exaggerating and abstracting aspects of society to create wholly inventive reinterpretations. A music video made from a pop-up book; post-apocalyptic toys; drawings created from sound waves; and mixed media paintings are all part of Mian's world. Mian has worked with 2K/Gingham Clothing, mtv2, Burton Snowboards, Definitive Jux Records, The Roots and others. Mian has exhibited his personal work in New York, Los Angeles, Vancouver, France and Tokyo.

farmer bob's farm

www.farmerbobsfarm.com

Robert Hardgrave, a.k.a. Farmer Bobs Farm, has inhabited the city of Seattle for the past 13 years. He adores caffeine in the form of coffee, delicious breakfasts and listening to death metal. He enjoys many different mediums, yet always uses drawing as a foundation.

fl@33

www.flat33.com

A London-based multidisciplinary design studio working on visual communication. FL@33 was founded by Agathe Jacquillat and Tomi Vollauschek in July 2001, after obtaining their MAs from the Royal College of Art. In October 2004, they also founded the "graphic art & fashion boutique" Stereohype.com. FL@33s' mission is to create a professional, vibrant, fresh and artistic body of work while keeping a balance between commissioned and self-initiated projects and publications. Their first monograph entitled "design&designer_033 – FL@33" was published in May 2005 by French Pyramyd Editions. Their international clients include MTV/VH1, Laurence King Publishing, Royal Festival Hall, Sacla, BBC, GraficEurope, Alsop Architects, Groupe Galeries Lafayette, among others.

furi furi company

www.furifuri.com

Established in 1998, Furi Furi Company is a design team based in Tokyo that has expanded worldwide. Furi Furi covers every aspect of design from consulting and planning to media promotions, combining their unique Manga aesthetics with a generous helping of adult madness. Their famous characters break through all language barriers and appeal to a broad audience, not only within pop culture. Well-respected right across the board, in merchandising, advertising, toy design and other media, their ability to style Japanimation characters with amazing precision and inner logic, emotion and motivation, has secured them a key role in the creation of computer game characters for Sega, Nintendo and Sony.

gaga inc

www.gagainc.com

Founded in 1999, Gaga Inc. strives for one thing and one thing only – the perfect balance between idiotic fun, elegant design, ice cream gulping and absolute laziness. So far they have been very serious about the ice cream and the laziness part, and being idiots too. Among their selected clientele are exclusive brands such as Pierre Cardin, Citibank, Micro-soft, Rolls Royce, U.S Army and Rolex. After surviving for so many years, they want to thank a kind lady, Mrs. Rudovich, who slips food under their door everyday.

happypets

www.happypets.ch

Composed of a group of three graphic designers working together, Happypets are Patrick Monnier, Violène Pont and Cédric Henny. They produce from an experimental lab in the creative domain and collaborate constantly with different people. They consider themselves as graphic jockeys, Gj, as they believe that a visual is created by mixing, assembling different bits and pieces, from old and new works, signs and images that compose the Happypets environment-bank. They create all their own images, illustrations, photos and types, mixing them with existing graphic material such as computer icons or logotypes.

hort

www.hort.org.uk

An office for graphic design in Frankfurt am Main in Germany, Hort is Eike Fritz Gerwin König, who was born in 1968 in Hanau, and Martin Lorenz, who was born in 1977 in Hanover. Both of them studied graphic design in Darmstadt without graduating. In 1994, Eike opened his own studio called Eikes Grafischer Hort, and since 2001, he has been running it together with Martin. Their portfolio includes corporate identities for companies and bands, logos, websites, photos, illustrations and corporate systems. They do art direction and graphic design for culture, fashion, music, magazines and everything that they feel connected with.

ian wright

www.mrianwright.co.uk

An image maker since 1978, Wright has been working across illustration and design. He is currently involved in large-scale modular installations for clients such as Issey Miyake NYC, The British Museum, Brinkworth Architects, Playlounge and Milliken Carpet. Enjoying the unpredictability of materials, his work has encompassed the use of salt, cassette tape, rubber stamps, drawing pins, carpet squares, beads and badges as well as more traditional drawing materials.

insect

www.insect.co.uk

A London-based design group, Insect was set up by Paul Humphrey and Luke Davies eight years ago, after discovering their mutual admiration for all things six-legged, dark and twisted. They mix illustration, photography, typography and taxidermy into their work for the youth market and music industry. Over the past year they have also been concentrating on producing commercially available artwork for www.picturesonwalls.com and for exhibitions in London, Paris, New York and Tokyo. Their clients range from small record labels to global brands such as BBC Worldwide, Adidas, Orange Mobile, Jaguar, MTV, Vans and Levi's. As gifted technical geniuses, Insect's fanatic approach to youth culture and the music industry is full of passion and enthusiasm, enabling Insect to cultivate one of the most distinctive, edgy and hectic visual representations in the contemporary design and illustration landscape.

jigaram

www.jigaram.com

jody barton

www.jodybarton.co.uk

A UK-based illustration artist, Barton does various kinds of print and screen work after studying in London. Usually using black and white and drawing on an internal world of bizarre morbidity, he has recently worked for clients including MTV, Greenpeace, Mambo Surfwear and the Glastonbury Festival. His work was shown recently in London, Tokyo, Madrid and Paris. He makes one-off items including clothing, skateboards and bicycles and has written and illustrated a number of books. Barton is represented by Big Active.

jon burgerman

www.jonburgerman.com

Draws, paints, clicks and sleeps, Burgerman has also exhibited around the world in great cities including New York, Los Angeles, London, Hong Kong, Paris, Melbourne and Derby. His work has been featured in publications such as "The Guardian" newspaper, "Graphic," "Pictoplasma," "Stick 'Em Up," "Computer Arts," "Designed to Help," "The Fundamentals of Illustration" and "This Is A Magazine." He received a D&AD Silver Award nomination for his work with Levi's, produced advertising campaigns for Gortex, Snickers and Puma, designed a sick bag for Virgin Atlantic and has had his character animations played at international concerts and festivals. His future plans include exhibitions, events and workshops as part of the UK illustration collective Black Convoy, a follow-up to the book "Hello Duudle" and a range of vinyl designer toys with manufacturer Flying Cat.

jon ip

www.aobavision.com

Born in Hong Kong, Ip is a New York-based designer. He has been working for numerous design firms since he graduated from Pratt Institute. He majored in computer graphics, while spending time exploring photography, illustration and visuals. He has previously participated in events such as the "WE" exhibition, "A2" exhibition in Hong Kong, the "Nake" exhibition in New York, and part of the "Get it Louder" exhibition in China. His work has been showcased in various magazines and books worldwide. For him, design gives a space to escape from the realistic world and lets him freely express his personal feelings. He also enjoys collaborating with designers and artist of different backgrounds.

jorge alderete

www.jorgealderete.com

A pop illustrator, Alderete uses trash culture, 50's science fiction films, wrestling and surf music imagery in his illustrations, animations and comics. As an independent animator, he has worked for MTV Latin America and Japan, Nickelodeon Latin America and Brazil. He has been the coordinator of the animation section on the internet for MTV Latin America. He is the co-owner of the independent record label Isotonic Records. Currently he works in his lab in Mexico City as an illustrator for different publishing and media ventures in Argentina, Mexico, Spain, Italy, Germany, Portugal, the United States, Switzerland and Finland.

kabo

homepage.mac.com/ajito_tk/Menu8.html

Born in Tokyo, Kabo started her career as a professional photographer in 1993. Her main focus is photography for fashion magazines, music magazines and advertisements. In 1998, she took photographs for the film shooting site of the movie titled "Dragon Heat" and met the director, Eric Krook, and started working for his company Double X Workshop Production in Hong Kong. Since then she set up her second base in Hong Kong and started shooting photographs for magazines, advertisements, CD covers and music videos with her original and unique style of photography. In 2003, she held the exhibition "Now you see it, Now you don't" at the IdN gallery in Hong Kong. The photo book with the same title was released at the same time.

kinpro

www.kin-pro.com

Chisato Shinya, a.k.a. Kinpro, started working as an illustrator in 1989. Her solo exhibition "Visible shape/Invisible shape," "Imagine Story" and "Peeping Navi" were all held at Soso café, which were produced by Shift, and e-zine. There was also "Gigei, Rising Sun Rock Festival 2004 in Ezo." Kinpro set up an original fashion brand "Nozoky" with four friends. Her illustrations are published in "Grimm," "Anderson," "Designed To Help" by Die Gestalten Verlag and "LeBron James:Chamber Of Fear" by Nike. She has participated in projects such as "ChilliChilly" produced by ChilliChilly; "Maxalot Wallpaper Collection" produced by Maxalot; and "Hotel Fox" produced by Project Fox.

klaus haapaniemi

www.klaush.com

A London-based illustrator and graphic artists, Haapaniemi's has worked as the key print designer for Diesel Style lab and as creative director and illustrator for Italian fashion label Bantam. He is one of the Britain's leading fashion illustrators whose latest work contains such highlights as designs for Christmas windows for the Selfridges department store and special edition Christmas storybook made together with celebrity writers. He is regular contributor for trendy news magazine "Observer" and freelancer for many fashion companies. One of his recent commissions include a print collection for French fashion house Cacharel. His own wall tapestry collection is currently under production in Italy. Haapaniemi's monogram book "Giants" is published both in UK and the US.

körner union

www.koernerunion.com

Active in numerous different fields of art and design, Körner Union's motto is "gather everything, separate everything."

lee misenheimer

www.destroyrockcity.com

Hailing from the Carolinas and now based in Brooklyn, New York, Destroy Rockcity is the ongoing work of Lee Misenheimer. Destroy Rockcity arose out of post-graduation boredom in the summer of 1994 as a self-published magazine of drawings distributed at punky house shows.

made

www.madebymade.no.

A design studio from Oslo, Norway, Made consist of three healthy and bright individuals. Made does everything, but their clients often hire them to do design and art direction. Sometimes they do it at night, sometimes blindfolded, sometimes backwards and sometimes one more time with feeling.

marcus oakley

www.banjo.dircon.co.uk

Originally from Acle, a village in Norfolk, Oakley was influenced to be an illustrator and artist by many ways including his childhood experience in Norfolk, the wonderful harmonic and melodic music of the Beach Boys, the pastoral delights of the countryside and friendly-and-not-so-friendly animals that inhabit it. Over the last few years his work has been related to the 1970s. He has been looking back at things in memories and the innocence of it all. His interest is in things that he didn't really know about at the time or was too young to appreciate, such as Fleetwood Mac's 1977 album "Rumours" or in general the aesthetic beauty of the decade's architecture, fashion, graphics and typography.

martí guixé

www.guixe.com

In addition to working in Barcelona and Milan as an interior and industrial designer, Guixé has also been periodically working as a design advisor in Seoul and living in Berlin. He formulated a new way to understand the culture of products. He started to exhibit his work in 1997 – works that characterizes the search for new product systems, the introduction of design in food ambits and presentation through performance. His nonconventional gaze provides brilliant and simple ideas of a curious seriousness. He is based in Barcelona and Berlin, where he has worked as designer for companies such as Authentics, Camper, Cha-cha, Chupa-Chups, Desigual, Droog Design, Essencial mediterraneo, Imaginarium, Isee2, Pure Lustre and Saporiti. Recent publications include "Marti Guixé 1:1" and "Marti Guixé Cook Book." He has exhibited at MoMA (New York), MuDAC (Lausanne), MACBA (Barcelona) and Centre Pompidou (Paris).

michael moser

Mlein Press is a small company founded by Michael Moser in March 2002 that specializes on typographic illustration, typographic logos and special typographic solutions. They are now working for books, magazines and small graphics.

mikko rantanen

www.mikkorantanen.com

Originally from Finland and currently based in London, Rantanen has worked for various clients including Paramount, Orange, "Arkitip" and "The Face" after graduating from Central Saint Martins College in 2003.

milkxhake

www.milkxhake.org

A Hong Kong-based design group, Milkxhake has specialized in visual communication, identity and interactive design since 2002, mixing multiple ideas and images is their indulgence. The "X" in Milkxhake alludes to their continuous idea of "mixing" and "multiplying." They believe authentic design mix with an essence of good concept can make changes to our surroundings and perceptions of lives. "Mix it a better world." is their motto. They actively contribute to many media, and their work has been recently awarded in the Tokyo Type Directors Club 2004 in Japan. In 2004, Milkxhake joined Fabrica, the Benetton Research Communication Centre in Italy to create various creative projects.

mk12

www.mk12.com

An artist collective and design lab, founded by Ben Radatz, Jed Carter, Tim Fisher, Shaun Hamontree and Matt Fraction in their hometown of Kansas City in 2000. Art school fugitives, the five have carved a unique niche for MK12 in the design world, where art, commerce, film and music happily coexist. MK12 is now eleven people, with John Dretzka, Maiko Kuzunishi, John Baker, Teddy Dibble and Chad Perry also on the roster. MK12 has completed broadcast and commercial design work for clients including Diesel, The Sci-Fi Channel, MTV, Cartoon Network, TNT, AXN and Fox Movie Channel, as well as music videos for Hot Hot Heat, Funstorung, Common, and The Faint. Their award-winning experimental films include "Untitled 02: Infinity," "4-D Softcore Sweaterporn," "Ultra Love Ninja" and trailers for the Resfest film festival. Characterized

by a constant reexamination and development of motion, depth and juxtaposition, MK12's unique style best lends itself to explanation visually and viscerally.

musa collective

www.musacollective.com

A design project formed by Portuguese designers Raquel Viana, Paulo Lima and Ricardo Alexandre. After completing a degree in graphic design they became head and new media designers at major design agencies in Portugal. In the summer of 2003, they had a dream with an ambitious objective to promote and showcase the Portuguese design scene nationally and worldwide. The Musa project then started with "Musabook." At that point the project started to grow fast and to different approaches. MusaTour came up with an exhibition to present Portuguese designers through 15 canvas that moved to several cities; The-Pack and other Musa products and merchandising to divulge the Portuguese design; and then MusaWorkLab, a design studio of graphic experiments that aim for the innovation and search of excellence. Musa have also worked on other independent projects and initiate magazine such as "NothingLastsForever" and "ElephantMotion."

norm

www.norm.to

Founded in 1999 in Zurich, Switzerland by Dimitri Bruni and Manuel Krebs, Norm designs books and letters. They recently released the book "Bruce Lee – his life and his death."

panism

www.panism.com

A comprehensive website launched by Pan in 1999. Panism encompasses photography, video and graphic design. Pan has worked in graphic design, web design, advertising, art direction for movies, and as a radio DJ. He is now the creative director for lomographic society Asia.

pee & poo

www.peeandpoo.com

A product and design agency based in Stockholm, Sweden, Pee&Poo was founded by Emma Megitt in 2004. Pee&Poo focused on developing characters and designer toys. They have also produced a clothing line, games and more. Pee&Poo's name in Swedish is Kiss&Bajs.

pill and pillow

www.pillandpillow.com

A Hong Kong digital artist and interactive web designer, Henry Chu finished his engineering degree at the University of Auckland, New Zealand. After graduation he came back to Hong Kong and started his digital design career in 1998. In 2004, Chu set up his own design studio Pill & Pillow to help clients to create interactive online experience. In 2005, Pill & Pillow was interviewed by Web Designing Japan, and received awards from HKDA awards 05 in the New Media Category. Chu is also a guest lecturer at the Hong Kong Polytechnic and the Art School.

potipoti

www.potipoti.com

A brand inspired by underground illustration from Berlin and the sweet but vicious lyrics of Vainica Doble, an all-female Spanish music duo. In Potipoti, Nando and Silvia developed a collection of characters that they first let loose in Berlin by staging a series of mini actions and exhibitions throughout the city. Later they developed their own line of clothes, giving a touch of irony and fun to its designs. They're the cute little figures with the big crazy eyes from an apparently happy childhood world. The two have been working in close cooperation since they moved to Berlin in 2001. The aim of their projects is to bring a bit of color into our lives.

pulco mayo

www.pulcomayo.com

Vincent Béchet, aka Pulco Mayo, is based in Clermont Ferrand, France. He has been an art student for five years and now he works as a graphic designer on web projects, illustration and animation. Pulco Mayo combines cartoon, contempory design and street art to produce his own style. The world of Pulco Mayo is populated by some strange creatures, ugly monsters and funny cute characters. He is inspired by the supernatural, religions, product design, music, monster film, manga and tattoo art.

rex koo

www.rex-air.net

After graduating from the University of Salford in 1999, majoring in graphic design, Koo has worked as a graphic designer in Shya-la-la workshop until 2001. Since then he established his personal website. His work include graphic design for Wong Ka Wai's movie "In The Mood

for Love" (1999), "Store" Magazine, "Cream." Magazine, "I Love Sticker Graphic and The Place" project organized by Vasava Workshop. He has also produced a large number of album covers.

rinzen

www.rinzen.com

Australian design collective Rinzen is best known for the collaborative and illustrative approach of its five members, having formed as a result of their RMX project in 2000. In addition to their own book published by Germany's Die-Gestalten Verlag, Rinzen's work has appeared in numerous design and art books and in magazines such as "Nylon," "Relax" and "Tokion." Their large-scale artwork has been installed in Tokyo's Zero Gate. Their posters and record covers have been exhibited at the Louvre and their visuals have been incorporated into shows of electronic musicians such as Kid606. Rinzen are currently working from Sydney, Brisbane and Berlin.

rolitoland

www.rolitoland.com

Rolitoland, universe Rolito creates, includes projects such as Rolitoboy and Rolitoland Safari, in which vinyl figures, books and animations are made. Rolito has been spending his time creating new imaginary world since he graduated from the school of Beaux Arts in France. He works in various fields from character design, toy design, advertising, animation, to motion pictures. His clients include Colette, Playstation, MTV, Passion Pictures, American Express, Nivea, Virgin and Sony. Together with Chick, Dany and Run, Rolito forms the Semper-Fi French design team. He loves pre-Colombian arts, toys, arts & design books and listening to music all day long.

shellmoonsite

www.shellmoonsite.com

Lee Man Chung, a.k.a. SHELLMOONSITE, was born in Hong Kong in 1976. He studied multimedia and maya at the Vancouver Film School, where he graduated in 1999. He began to work as a web designer shortly thereafter. In 2001 Lee joined the design force for "IdN" magazine, and started his career as a graphic and book designer. From April 2004 to July 2005, he was the art director of Hong Kong culture and art magazine, "CREAM." Lee is now the art director of the creator's lifestyle magazine, "RMM." In 2003, Lee conceived, organized and promoted a few exhibitions,

such as "WE" exhibition held in Cattle Depot, Hong Kong Artists Village; "A2" exhibition in Basheer bookshop, Hong Kong; and "Artists" exhibition in Newburgh, Hong Kong. He is also a contributor to the Japanese creative e-zine www.shift.jp.org. His works fall in many other different media, such as NEUT–006, Tokyo Re-mapping, SonyStyle x Levi's Campaign and Lomography fisheyes camera.

simon oxley

www.idokungfoo.com

A 35-year-old graphic designer, illustrator and dreamer from Britain, Oxley travelled to Japan in 1999 where he worked at a web design agency in Harajuku, Tokyo, for three years. Then he returned to the UK for one year from March 2002, where he freelanced at a couple of London based agencies. In April 2003, he returned to Japan and continued freelancing in graphic design while also practicing photography, illustration, Japanese and English. In January 2005, Oxley produced an online store containing merchandise branded with both his illustration and photographic imagery.

sixstation

www.sixstation.com

A Hong Kong-based web and graphic design studio, Sixstation incorporates a mix of global culture with the appreciation for science fiction.

stapelberg&fritz

www.stapelbergundfritz.com

A graphic design studio working in the fields of art direction and design for corporate and cultural clients, Stapelberg&fritz was founded in 2002 by Daniel Fritz and Maik Stapelberg. Working in their office in Stuttgart, Germany, their works emphasize on corporate and editorial design.

stefan marx

www.livincompany.com

Born in 1979, Marx is an artist who lives in Hamburg. The first and the last thing he does in his day is drawing. He tries to describe his world, his thoughts and his views on the real world with his drawings and paintings. He loves to work on the streets and publishes his work unasked in his environment. He learned to work this way during his time as a graffiti writer and learned to see things differently while spending some time on his skateboard. He loves to publish small magazines, which comes from his love of sketchbooks and all things

in books. Marx runs a small label called The Lousy Livincompany. Under this name he works on his favorite t-shirt designs and produces them in small editions, so his friends can wear them too.

superdeux

www.superdeux.com

Sebastien Roux, a.k.a. Superdeux, was born and raised in the south of France. He worked and studied in Paris, and currently resides in Lille, France. Roux began his career as a designer over eight years ago, working in interior design for two years and later developed his career in multimedia design. In 2001, he launched his career as a freelance graphic designer. He currently produces work in motion graphics, character design, identity design, and toy design. Urban and pop culture, and its ever-changing faces are the inspirational elements for his project development and designs. Superdeux has worked in collaboration with talented forces including Phunk Studio, 123Klan, Stardust, Geneviève Gauckler, Bill McMullen, Staple design, Interspectacular and Pictoplasma to pursue his goal of exploring various mediums of communicating the urban sensibility.

sweden graphics

www.swedengraphics.com

Established in 1997, Sweden Graphics has worked with graphic design for all kinds of clients and purposes. They are also active partners in the publishing house Pocky.

swigg

www.thisisswigg.com

Stephanie Wenzel is a graphic artist living and working in Brooklyn, New York. In April 2004, she founded Swigg Studio, a multidisciplined design firm and Swigg Products, which creates tactile goods for human enjoyment. Most recently her website thisisswigg.com won an Interactive Design Award from "HOW Magazine." Her work has been shown internationally in the "Neighbourhood" exhibition at the Pictoplasma conference in Berlin, the "Sneaker Pimps World Tour," the Riviera Gallery in Brooklyn, as well as in the graphic design publications "Novum" and "Items Magazine."

takora kimiyoshi futori

www.graphictakora.com

Born in Kobe in 1972, Kimiyoshi Futori, a.k.a. Takora, is a visual creator based in Tokyo. He works as a freelance creator. His works cover

biographies&info

a broad cultural range from textile design for Comme des Garconz Homme to contributing to hip magazine "Vision." He does work for objects that bring new lives with new pop taste in the broad commercial scene from illustration to visual design. He has also joined and held exhibition in Japan and abroad. "Catchy is everything" is his motto.

tom merckx
www.flink.be

Merckx has been drawing all his life and graduated with a degree in advertising and photography. However he got more enamored with graphic design. He has done work for graphic and advertising agencies in and around Antwerp. He has also been seriously involved in graphic propaganda of all kinds.

tomoaki ryuh
www.headz-mag.com

Born in 1980, Ryuh graduated with BA in graphic design at Central Saint Martins College of Art and Design. He has worked as freelance graphic designer and artist. Ryuh likes to do any sort of creation from graphic design to illustration, painting to motion graphics and also clothing design. He thinks that design should catch the viewer's attention without losing the original message and at the same time trigger the viewer's imagination. He has worked with "Shift" (Japan), "Plus81" (Japan), "Dazed & Confused" (Japan), "Grafik" magazine (UK), "Spunky Clothing" (UK), "Three" magazine (UK), "A Book For Freedom-Amnesty" (Sweden) and "Viewpoint" magazine (UK). His exhibition works include the "Hello Kitty EX" project (Hong Kong), "Shift meets Tomoaki Ryuh" solo exhibition (Japan), the "Spunky Group Exhibition" (UK) and the "Vision of Speed" at Gallery Mouson in Frankfurt (Germany).

tönky
www.tonky.fr

Franck Valayer, a.k.a. Tönky, is a French graphic designer. He worked at an agency for six years, but he prefers to make graphics alone where he can enjoy much more freedom. Valayer considers graphics as personal as painting or sculpture. He often works from passing on the memory of things and events. He thinks that graphic is a detail of memory and that is why he also works on photography, video and music.

upnorth
www.discover-upnorth.com

Currently based in New York City, and hailing from the bitter north of Wisconsin, Upnorth is Steve Green and Justin Kay. It blends clean graphics and type that have been inspired by a rich history of skateboarding, Black Sabbath and the 1982 Milwaukee Brewers. Upnorth also publishes the zine "oneonenine" — www.oneonenine.org.

von r. glitschka
www.vonglitschka.com

Accolades came on early for Glitschka at the age of five when he won a contest and was awarded a Speed Racer coloring book. That was when he realized a career could be made from drawing. Nothing has really changed since then. Glitschka still creates award-winning illustration and design, only now for major ad agencies, corporations and national publications. He has given up the footed pajamas, but in his spare time enjoys driving like Speed Racer in his PT Cruiser.

viction:design workshop
www.victionary.com

Founded by Victor Cheung in Hong Kong in 2001, viction:design workshop provide a broad range of design services to maximize the true potential of their clients, building sophisticated and innovative solutions that enable them to develop deeper and more personalized relationships with their customers.

wig-01
www.wig-01.com

A young and dynamic graphic design agency based in the UK, Wig-01 was founded by Andrew Townsend and James Warfield. They specialize in art direction, print design, branding, interactive design, film and animation.

yield

In 2001, three students at the Royal College of Art, London, got together and started working on graphics. They were Megumu Kasuga from the Communication Art & Design Department, and another two from the Product Design Department and the Computer Related Design Department. After moving its base from London to Tokyo, Kasuga has been undertaking various activities with new members while the other two original members have left the group and are doing inspiring activities in their own

field now. YiELD mainly has clients in Europe, but recently they have started working for clients from Japan and Hong Kong as well.

zion graphics
www.ziongraphics.com

A multifaceted design agency based in Stockholm Sweden, Zion Graphics was founded by Ricky Tillblad in 2002. Zion's work crosses over vast disciplines including corporate identity, fashion, interactive media, packaging and print. Their clients are J. Lindeberg, Sony BMG, Universal Music, EMI Music, Pee&Poo, Peak Performance and more.

zip design
www.zipdesign.co.uk

Making through intelligent design, Zip's main objective is to progress and celebrate mainstream image. Art direction and print campaigns for the music industry have kept Zip continually busy, but the company has proved themselves equally capable in other areas. In recent years their clients have diversified, and the projects they now undertake have widened to embrace branding, websites, motion graphics, books, brochures and television titles.

Tattoo Art & Design

Edited by Viction:ary

First published in the United States of America in 2007 by
Universe Publishing
A Division of Rizzoli International Publications, Inc.
300 Park Avenue South
New York, NY 10010
www.rizzoliusa.com

Originally published in Hong Kong as "Tattoo Icons" in 2006 by

viction:ary™

viction:workshop ltd.
Room 2202 22nd Floor, Kingsfield Centre
18-20 Shell Street, North Point, Hong Kong
www.victionary.com

ISBN-13: 978-0-7893-1528-1

Library of Congress Control Number: 2006937040
Fourth printing, February 2009
2009 2010 2011 2012 / 10 9 8 7 6 5 4

Edited and produced by viction:workshop
Preface by Shirley Surya

Concept and art direction by Victor Cheung
Design by viction:design workshop
Cover design by Linda Pricci
Front cover: Farmer Bob's Farm
Photograph by Michael Chandler
Back cover: (clockwise from top left) Beat13, Rolitoland, Furi Furi
Company, Viction:design workshop

Printed in China

Acknowledgement

We would like to thank all the designers and companies who
made a significant contribution to the compilation of this book.
Without them this project would not have been possible.

We would also like to thank all the producers for their invaluable
assistance throughout the making of this book. Its successful
completion also owes a great deal to many professionals in
the creative industry who have given us precious insights and
comments. We are also very grateful to many other people whose
names do not appear on the credits but have made specific input
and offered continuous support during the entire process.

Special thanks to FontShop for providing Kursivschrift, available
at FontShop.com.